STREETS OF LONDON

STREETS OF LONDON

The story behind London's most famous streets

Lucy McMurdo

NH
NEW
HOLLAND

For my parents, who inspired my love of London.

CONTENTS

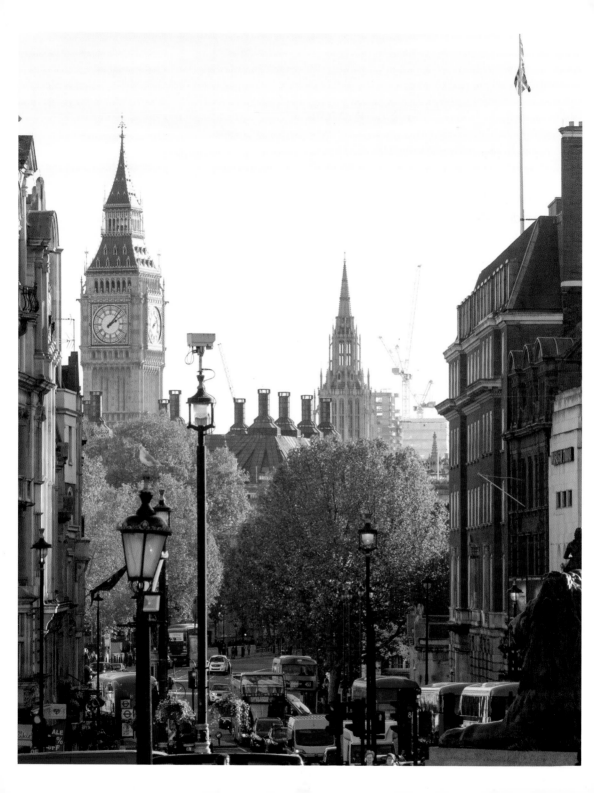

INTRODUCTION

With a history going back 2000 years it is hardly surprising that so many of London's streets are known throughout the globe. Even today several Roman roads pass through the capital, and London's financial center, The City of London, is full of winding alleys and ancient ways with names from times gone by. Over the years, the City's streets have become less familiar than roads in and around the West End, and for this reason *The Streets of London: the Story Behind London's Most Famous Streets* is primarily about roads in the City of Westminster and the Royal Borough of Kensington and Chelsea.

With such a rich past it is hardly surprising that street names often reflect the capital's heritage whether by period such as Roman, Saxon, Danish or Norman, or named after an important event or person. Names like **Aldwych** (from the Saxon, meaning old dwelling, settlement), **Trafalgar Square**, that commemorates the 1805 Battle of Trafalgar, **Regent Street**, named after the Prince Regent (later, George IV), and **Downing Street** that takes its name from its builder, Sir George Downing, clearly illustrate London's growth and development over time.

Most dictionary definitions of the word 'street' describe it as a public thoroughfare, with buildings or housing on one or both sides, and usually with paved walkways. Although this applies to the great majority of London's streets many are referred to as Road, Terrace, Square, Yard, Court, Gardens, Avenue, Corner, Hill, Row and so on, which confuses the issue. Furthermore, there are streets that have one name only like **Piccadilly, Whitehall** and **Strand** – all the more perplexing!

In the 1930s when the board game Monopoly first appeared, London was quite a different place to what it is now, eight decades later, and naturally included roads that were important or notable at the time. The game confirmed the gravitas of the board's streets and although many of the original names appear in this book they might not now carry the same weight as they once did; other roads have since become popular or have taken on greater status in the intervening period. Two good examples of this

are **Carnaby Street** (celebrated for its Flower Power days in the 1960s and its trendy fashion boutiques), and **Abbey Road** (made famous by the Beatles on their 1969 album cover). You will find both within the book: covered in the Regent Street and Baker Street chapters.

Each chapter finishes with a section entitled 'Environs of…' and this gives the reader an account of other streets, squares and districts that have not been included earlier in the text. With such an abundance of fascinating streets it is not feasible to cover them all but it would be unthinkable to omit such famous spots as **Leicester Square, Kensington High Street, Chinatown, Shaftesbury Avenue** and **Piccadilly Circus.**

As streets lead into one another and are also often part of a particular area, each chapter covers much more than the heading would suggest. For example, **Baker Street and Marylebone** describes Baker Street, as well as The Regent's Park, Marylebone Road, Marylebone High Street, Manchester Square, and 'Medical London': Harley Street and Wimpole Street. The **King's Road** not only walks you down the main street but also visits roads nearby in the village of **Chelsea,** of which it is a part. The walk takes you to the Chelsea Embankment and Cheyne Walk beside the river Thames and along to the Physic Garden, the Royal Hospital Chelsea and the adjacent grounds where the annual Chelsea Flower Show is held.

Within the book you will hear mention of blue plaques and Royal Warrants. The former are awarded by English Heritage and placed outside buildings that are associated with famous people such as the composer, George Frideric Handel, the writer George Eliot, and the suffragette, Sylvia Pankhurst. The latter, take the form of a badge and are displayed on the façade or window of a shop. These are granted in recognition of continued good service by Her Majesty The Queen, His Royal Highness The Duke of Edinburgh, and His Royal Highness The Prince of Wales, to tradesmen who supply their needs. In order to qualify for a Royal Warrant there are a number of rules that need to be met, but once a warrant has been awarded the trader is entitled to display the Royal Arms on the firm's products and delivery vehicles and to use

the legend 'By Appointment'. In cases where traders supply all three Royal Warrant grantees you will see all three displayed individually.

As mentioned earlier London has a long and well-established association with other peoples; throughout its history foreigners have visited, lived, and worked in the capital city, bringing their own traditions and culture. Since the Roman invasion in 43 AD, the city has always accommodated tradesmen, merchants, artists, artisans, immigrants, and refugees and remarkably this situation persists into the 21st century. In every respect it is the most international of cities and is not only the seat of government and politics, home of royalty and a major global financial hub, but also where major media, technological, cultural and arts institutions are found. Its multicultural nature makes it all the more interesting and more often than not you will come across a lively festival (such as Diwali, Eid, Africa in the Square) providing wonderful exotic foods and entertainment along London's many streets and squares.

HOW TO USE THE BOOK

Most chapters are laid out as a walk, beginning and ending at or near an underground (tube) station. Information about the stations is **highlighted** and directions from one stop to another are given in *italics* throughout the text. Each chapter opens with a map showing the main road and area being covered and provides detail about major landmarks en route. The numbers in circles on the map correspond to the numbers in bold square brackets e.g. **[8]**, found throughout the text.

Detailed information about London's transport is provided at the end of the book in the Travel section. At the time of writing, the UK's major transport engineering project, Crossrail, is still in the throes of construction throughout central London, which means that work is often carried out on weekends, affecting underground and overground timetables. It is therefore advisable to look on Transport for London's website: *www.tfl.gov.uk* to find out up-to-the-minute information about any closures or engineering work.

Crossrail, once complete, will provide fast links across the capital extending from Reading and Heathrow in the west to Abbey Wood and Shenfield in the east, and is due to be renamed the **Elizabeth line**, in honor of Her Majesty The Queen.

Certainly, it is very easy to navigate the city using public transport, but in many respects walking is by far the best way to get around. This gives you the opportunity to really see and experience a street's history, understanding what makes it tick today.

In writing this book it has been my intention both to share my knowledge of London's most famous streets as well as to encourage you to turn off the main trail to discover more of the capital's fascinating back doubles and alleyways, so often passed by and ignored. You will never be bored exploring, for every street has its own individual story to tell.

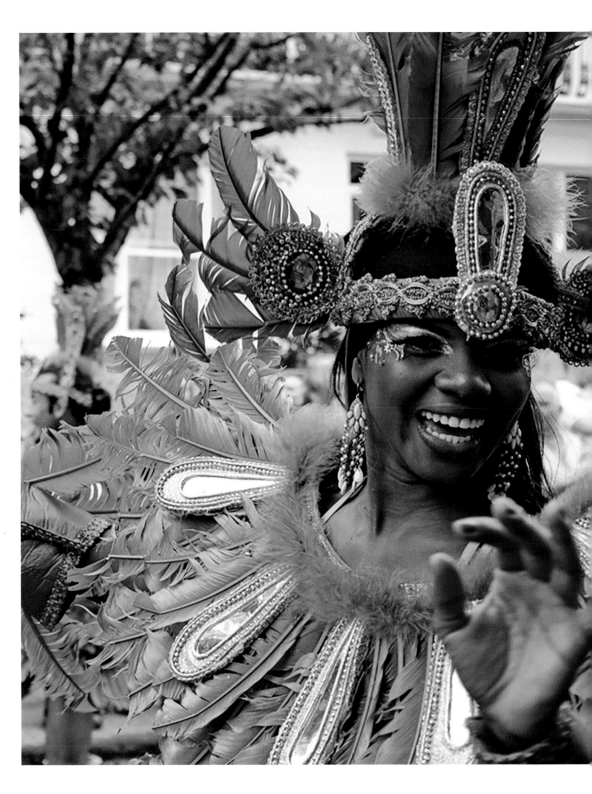

CHAPTER ONE

PORTOBELLO ROAD & NOTTING HILL

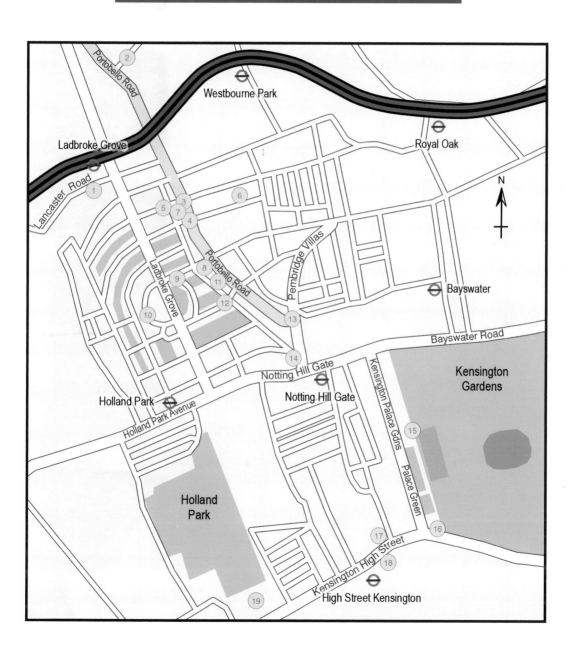

PORTOBELLO ROAD & NOTTING HILL

Portobello Road conjures up so many images: vibrant and noisy streets, market stalls, antique shops, stalls and arcades, street musicians, and people of every class, nationality, age and background. Here, you find the very rich as well as the poor jostling at the stalls stacked high with clothing, household goods, tempting foods, exotic fruit and vegetables, cheeses, home-baked breads and cakes. The road changes in character according to the time of day and the day of the week, and also between its northern and southern ends. It is certainly never boring, and has its own very special charm. A little of this was captured in the movie, *Notting Hill* (1999), starring Julia Roberts and Hugh Grant, filmed in and around the road with its colorful street market.

Its name, Portobello, refers to a Spanish ruled town on the Gulf of Mexico, which had been captured in the 1730s by the British during the War of Jenkins' Ear. Portobello Road itself came into existence in the 19th century, taking its name from

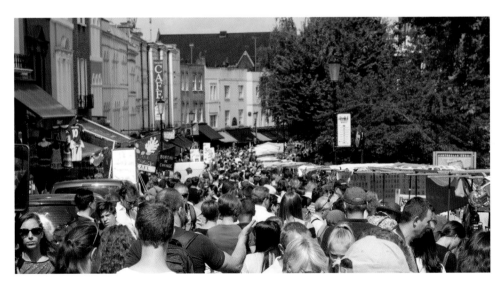

Portobello Road on Saturday

the nearby Portobello Farm (now the area near Golborne Road). The whole district had, until Victorian times, been rural in character, dotted with orchards and hayfields. Development and housing came with the introduction of first the canal, and then the railway in nearby Paddington, and shortly there was very little evidence of its past existence. The new, affluent residents required places to shop, to buy their food provisions and domestic furnishings, and Portobello Road met this need. Independent shops lined the street along with market stalls – really, no different from today.

When Ladbroke Grove underground station opened in 1864, north-west of the street, more accommodation was constructed, with many large terraced houses. Ladbroke Grove lay almost parallel to Portobello Road, stretching between Kensal Rise in the north and Notting Hill and Kensington in the south. This road was the hub of a newly built housing estate, the Ladbroke Grove Estate, and aimed at the upper classes. Splendid Italianate stucco villas and semi-detached houses were built here in radiating crescents and boasted large, communal, leafy gardens. No wonder the area became so popular, attracting the rich and famous, being close enough to the West End of London yet remarkably green and peaceful too.

The lower classes, in contrast, were catered for in the small cramped terraces that sprung up in the area. These provided homes for the many domestic servants, tradesmen, market-stall owners and navvies (the men constructing the canals and railways) who served their prosperous neighbors.

Wartime bombing resulted in much of the housing stock becoming neglected and the area looked shabby and run-down. It developed into bed-sit land. Poor West Indians moved into the district, attracted by low rents, and formed their own community here. Many of the properties were overcrowded, in awful condition, and managed by unscrupulous landlords like Peter Rachman, who was continuously increasing rents and failing to maintain his properties. It could not have been easy for Caribbean immigrants adapting to post-war Britain, the British climate, and the very different way of life to what they were accustomed to, so it was not surprising that 1958 witnessed the greatest race riots of the 20th century in and around Portobello

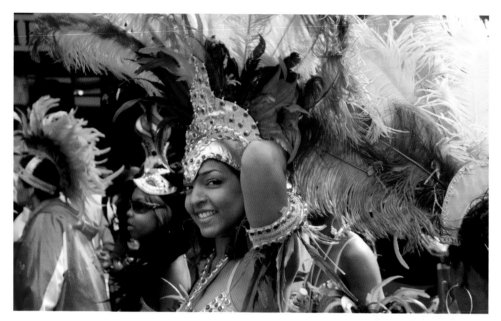

Notting Hill Carnival

Road. Fortunately, tensions subsided and major attempts were made to move forward. A very positive result was **Carnival**, introduced by the Caribbean community in the mid-sixties, and still going strong 50 years later. Initially, it was run on a much more modest scale than today and brought a whole new culture into British streets for the first time, with exciting strange foods, loud Caribbean music and dancing. A two-day event held over the August Bank Holiday, **Notting Hill Carnival** is still just as lively and certainly flamboyant. There are numerous floats, and participants from the local community and schools can be seen wearing remarkably vivid and elaborate costumes. The event takes place in and around Portobello Road and spills out onto the streets around Notting Hill, yet in recent times here have been calls for it to be moved into Hyde Park where there is more space and it would impact less on local residents. But, how can you hold Notting Hill Carnival elsewhere? In many respects, its main appeal is that it is a huge street party – albeit somewhat crowded. It is heavily

policed to prevent petty crimes such as pickpocketing in the crowds, and to prevent violence due to excessive drinking and drug usage, yet this does not interfere with the crowd's enjoyment of the event, which continues throughout the entire day and night. The website, *www.thenottinghillcarnival.com* is full of useful information about the event and how best to reach the area (there are many tube stations nearby), but in any case, you will not lose your way if you just follow the throng!

Since the 1980s the entire neighborhood has become much more gentrified and housing costs have soared. It is considered to be a very cool part of town and attracts actors, movie makers, politicians, media professionals and celebrities, but also is very multicultural with large Portuguese, Moroccan, Caribbean, Spanish and Irish communities living on its northern extremity close to the Westway and North Kensington.

As you would expect the area abounds with cafés, bars and restaurants. It even boasts its own Michelin two-star restaurant, The Ledbury, and is home to the Electric

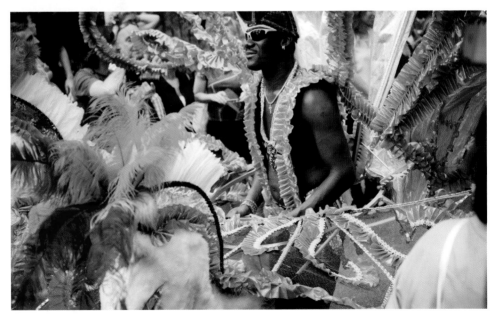

Notting Hill Carnival

and Gate cinemas, and a fringe theater, The Print Room at the Coronet.

The Portobello Road market you will come to see is not just one market but in fact five – each offering visitors different goods and experiences. On any day of the week you are likely to hear music playing; street musicians will just get out their instruments and play to anyone who cares to stand and listen. Several very well-known music labels (Virgin, Island and Rough Trade) started up in premises in the district, promoting musicians like Mike Oldfield, and bands such as Fairport Convention, Jethro Tull, Culture Club, Hawkwind, The Smiths, as well as soloists, including Cat Stevens. The music industry was decidedly part of the area's ethos during the latter half of the 20th century with Caribbean and reggae at the forefront in the 1970s and new modern genres in the 1980s and 1990s. Nowadays, you still find music stalls and shops along the street but the record labels have moved away.

Portobello Road has appeared in numerous movies, in books and has also featured in the lyrics of songs such as Donovan's, 'Sunny South Kensington' and Cat Stevens' single, 'Portobello Road'. In the 1968 film, *The Italian Job*, the main character, played by Michael Caine, lived in a mews house in the street, and scenes were filmed in and around Portobello Road in *Performance* (1970), *Absolute Beginners* (1986) and *10 Rillington Place* (1971).

Martin Amis describes life in and around the street in *London Fields* and even children discover its wonders from *Paddington Bear* who goes to the market most days meeting up with his friend Mr Gruber, the antiques shopkeeper, for morning elevenses of buns and cocoa.

Portobello Road lies within the village of Notting Hill and is part of the Royal Borough of Kensington and Chelsea, one of London's premier districts.

The walk around Portobello Road begins at **Ladbroke Grove underground station *(Hammersmith & City, Circle lines)*** and will finish at **Notting Hill Gate underground *(Central, Circle and District lines)*** (or if you have the stamina, **High Street Kensington**)

LADBROKE GROVE

The station exit leads directly on to Ladbroke Grove, today a bustling area full of people, shops, cafés, cars, trucks and red buses. It is always busy, noisy and vibrant and like much of London, a great place for people watching. Constructed in 1750 the road is named after a banker, Richard Ladbroke, but the surrounding area was developed in the early 19th century by his descendant, James Weller Ladbroke.

It was in a terraced house at 10 Rillington Place, near the railway, that eight murders took place in the 1940s and 1950s, which shook the nation. Initially thought to be the work of Timothy Evans (who was found guilty at his trial and later hanged), the true facts came to life once John Christie, the actual serial killer, had sublet his house, and human remains were then found by one of his tenants. Christie was hanged at nearby Pentonville Prison and women were able to breathe freely once again, but the serial killer gave the area a bad reputation, and subsequently the house, and then the street itself, was demolished and replaced by Bartle Road. Nowadays, this area is becoming gentrified, new shops and restaurants continue to appear and the district is certainly one of the capital's desirable villages.

Goods on sale in Portobello Market

Leave the station and turn right stopping at the traffic lights at the junction with Lancaster Road.

Depending on how much time you have available you might like to take a small detour to visit the **Museum of Brands, Packaging and Advertising [1]** before embarking on your tour of Portobello Road and market.

You will need to turn right at Lancaster Road, cross the road and walk about 100 metres (330 feet) along the street.

Museum of Brands, Packaging and Advertising

The museum, recording consumer history and trends since the 1800s, is totally unique, and contains a collection of over 12,000 artifacts, many of them gathered together by its creator, Robert Opie. The very great variety of objects, ranging from cosmetics, alcoholic spirits, stock cubes, breakfast cereals, chocolate bars and household cleaners, to vinyl records and electrical goods is astounding. Here you get to see how the branding and advertising of consumer products has changed over time and it is particularly fascinating to stand in front of the glass cabinets seeing how many styles and names (some since lost) you recognize.

There are also collections of royal memorabilia with souvenirs from coronations, jubilees and marriages.

The museum has a peaceful garden, a shop and caféteria, and opens 6 days a week (closed Monday, except on Bank Holidays). Information about opening hours and admission charges can be found on its website *www.museumofbrands.com*.

As you leave the museum turn right, cross Ladbroke Grove and continue walking along Lancaster Road. Turn right at the next junction, into Portobello Road.

PORTOBELLO ROAD

The first thing that is likely to strike you is what a cosmopolitan neighborhood it is. The stall-holders are of every nationality as are the shop-workers, local residents and visitors. Come here on a Saturday and the street just buzzes with tourists taking photos of the area, people in search of genuine antiques, bric-a-brac, clothing and food. It can be quieter during the week but there are always people around buying fresh food at one of the market stalls, eating and drinking in local pubs or cafés, or perhaps shopping for vintage clothes and household wares.

Although referred to as Portobello Road Market, the road incorporates a plethora of markets, all specializing in different items. Where you are standing now is the area to purchase clothing and fashion goods.

If you were to pass under the bridges to your left, this stretch of Portobello Road

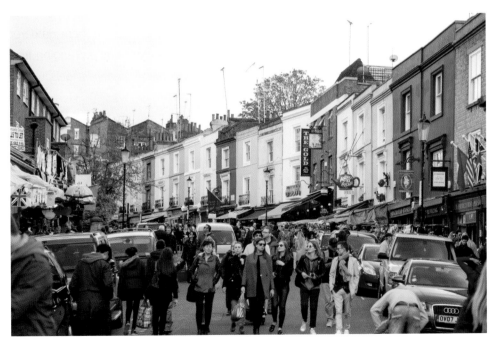

Portobello Road on a weekday

to **Golborne Road [2]** is where you will largely find second-hand goods. The middle section of the market as you walk south (towards Talbot Road **[3]**) is the place to find household goods, and from here to Elgin Crescent **[4]** it is mainly food stalls. At one time these stalls were all run by generations of the same family but sadly this has practically died out as the stall-holders have had to compete with supermarkets and changes in consumer buying habits. The southern end of the road between Elgin Crescent and Chepstow Villas is where the antiques and bric-a-brac stalls and shops are concentrated.

All along its length the street is lined with small shops, many of them independent and selling specialist goods, but in recent years high street shops have increasingly made their presence felt here too. The fashion chains, All Saints and Jack Wills have shops on or close to Portobello Road, and there are also branches of Whittard tea and Office.

There are a number of vintage clothing shops, several art galleries, a wonderful Spanish food emporium, R Garcia & Son, La Cave à Fromage selling cheeses from around the globe, a print and map shop, bakeries and specialist accessory shops selling leatherware, silk and cashmere. It is no wonder that so many are attracted to the area and it is difficult to leave without buying something!

Now, walk south (right) along the street. Cross over the next junction with Westbourne Park Road and turn right when you reach Blenheim Crescent.

BLENHEIM CRESCENT [5]

This is where three of Portobello's secret treasures, namely **The Spice Shop, The Notting Hill Bookshop** and **Books for Cooks,** are located. It would be very easy to pass them by, but a travesty if you did. Furthermore, this unassuming side street is home to a delightful children's sweet shop, a couple of cafés, a specialist toy shop and a bespoke pottery shop, Ceramica Blue.

The Spice Shop is the first shop you reach. Stand outside and your senses will tingle. Spices and herbs from every part of the globe are stocked here and their perfumes permeate the air. Have a browse inside and you could be wafted to any North African souk!

The Notting Hill Bookshop with its striking blue painted façade is impossible to miss and looks very similar to the bookshop featured in the film, *Notting Hill*. It was most probably the inspiration for the film's screenwriter, Richard Curtis, who lived in a nearby street, but the actual shop used in the movie was located on Portobello Road itself (no. 142), not a bookshop, then or now. Both shops never fail to attract film lovers and are frequently swamped by tourists taking photos.

Inside, the shop is stocked with an enormous selection of books, maps, travel

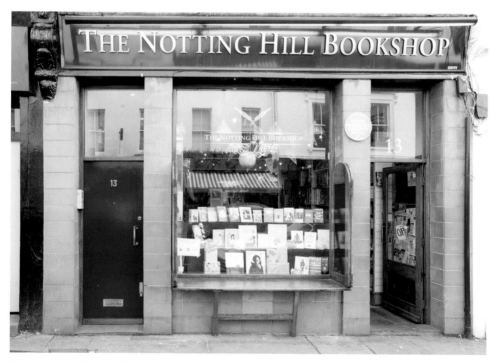

Notting Hill Bookshop

guides and travel literature. Unlike most other bookshops where guidebooks and travel literature are kept separate, here the books are categorized by country, and books, maps and travel writing, placed side by side on the shelves.

Across the street is a foody's delight, **Books for Cooks.** This surely stocks the greatest number of food and cookery books anywhere in London! The website states that they have in excess of 8000 titles and regularly test some of the cookbooks in their own café within the shop. For seriously interested cooks there is a kitchen on the first floor and regular workshops, cookery classes and demonstrations are held.

Blenheim Crescent is also known for being the home in the late 1960s and early 1970s to Marc Bolan, lead singer of Tyrannosaurus Rex (later to be renamed T. Rex). It was at no. 57 (west of Ladbroke Grove), living in very modest accommodation, he wrote lyrics for the band's early albums before becoming recognized as a global pop star.

Now, return to Portobello Road

The road directly in front of you is Talbot Road, with housing typical of many in the area; tall, five-storey, Victorian terraced houses, often painted in pastel or bright colors, bringing warmth and character to the street. Talbot Road leads into **Powis Square [6]** and **Powis Terrace.** This was where some of the very worst racial riots took place in the 1950s, when the area was horribly downtrodden. It was also where some of the flats, owned by the notorious Peter Rachman were condemned as 'unfit for human habitation'. Walking around the square today it is very hard to imagine how neglected it once was and how people lived in such shocking conditions. Despite its reputation, by the 1960s the area became home to many bohemian and artistic types, and artists such as David Hockney set up his studio on Powis Terrace.

Back on Portobello Road you will shortly pass by one of Britain's oldest cinemas. Cross over to get a better look at the building. This stretch of the street is often busy with fruit and vegetable stalls and they too are worth looking at, overflowing with some unusual produce and interesting ethnic foods.

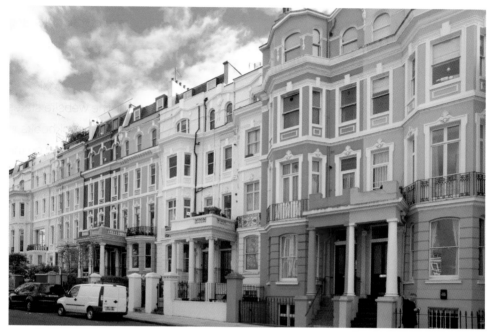

Houses on the side streets of Portobello Road

The Electric Cinema [7]

This lovely old cinema is now owned and run by the Soho House group. Over a 100 years since it first opened in 1911 it remains a most popular venue, shows both mainstream and art house films, and is frequented by Londoners and visitors alike, not just the local population. From the very start it was the most luxurious Edwardian cinema and Soho House have continued that tradition with comfy leather armchairs, footstalls and side tables as well as double sofas at the rear of the auditorium and double beds in the front row! In case you are not warm enough the cinema even provides individual cashmere blankets on request.

Alongside the cinema you will find Electric Diner open from 8 am for breakfast, with an all-day French-American menu. Also on site is a bar, library, snug and a covered roof terrace.

Continue walking and just past Elgin Crescent you enter the antique district. Before exploring this turn right opposite the Earl of Lonsdale pub into Ladbroke Gardens [8].

THE LADBROKE GROVE ESTATE & THE HIPPODROME

Had you been walking here a little over 200 years ago the entire area would have been farming land and dotted with tenant farmers. In 1819 this all changed when the new landowner, James Weller Ladbroke, began to develop it as a residential area. It was his vision together with that of his designer, Thomas Allason, to build an estate for the wealthy, comprising a circus, crescents and terraces, a few churches, and landscaped with trees and communal gardens. This came to pass over several decades so that by the mid-to-late 19th century much of the street pattern in evidence today was in situ. But, for a short while before the development was fully developed the site was used as a horseracing course known as The Hippodrome. Ladbroke had leased out land in 1837 to be developed as a racecourse intended to be a match for the much older and well-established courses at Ascot and Epsom. Sadly, the whole enterprise lasted a mere four years. From the start it was dogged by a footpath dispute that meant only half of the original course could be used (as clay soil it was not suitable for the purpose). It seems strange to think that Ladbroke Grove Estate might never have progressed any further had the racecourse been a success, as it is such a delightful oasis to visit today. Interestingly, the racecourse is not entirely forgotten as two roads in the estate bear the name 'Hippodrome' in their name.

Ladbroke Gardens leads into Ladbroke Grove, which acts as a north-south artery and actually divides the two sections of the estate. Before reaching Ladbroke Grove turn left into **Stanley Crescent [9]**. This is one half of the central circus and is mirrored on the other side of Ladbroke Grove by **Lansdowne Crescent [10]**. You will immediately understand why the housing is not cheap. The area is wonderfully tranquil, green and

leafy and the white stucco Italianate villas, imposing Victorian terraces and substantial semi-detached houses are very pleasing on the eye. They also have the advantage of possessing large communal gardens, popular with the residents.

It was on the other side of the circus back in 1970 that rock guitarist, **Jimi Hendrix**, died in the basement of the Samarkand Hotel at 22 Lansdowne Crescent. The building still exists but there is no memorial or plaque commemorating him. If, however, you are a Hendrix fan, you might like to visit the **Handel & Hendrix in London** museum just off Bond Street (See Chapter 8 for more details).

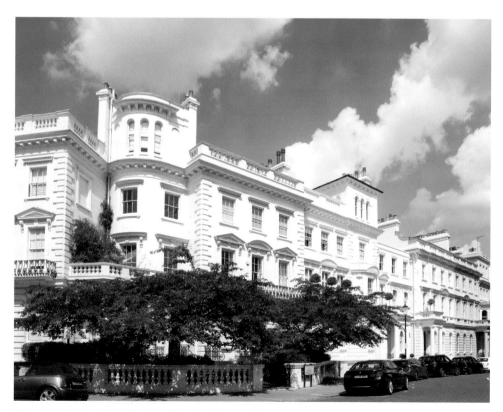

A typical street in the Ladbroke Grove Estate

Now, retrace your steps back to Portobello Road and turn right. As the road starts to climb you will find yourself in the heart of the antiques market and bric-a-brac stalls.

Antiques Market

As mentioned earlier, the atmosphere of Portobello Road changes as you walk along the street. The area between **Elgin Crescent and Chepstow Villas [11]** (roughly 800 metres/half a mile), is where all the antiques dealers trade either on street market stalls (for which they have a licence), or in deceptively small-looking shops and arcades on the right-side of the street. The main Antiques Market takes place on Saturday, and is always a real hive of activity. Come here on a weekday and you will have a very different experience; it is much quieter and many of the antique shops and arcades may be closed.

The Antiques Market became established on Portobello Road after World War II from the late 1940s and is not only the largest of its type but one of the country's best-known and loved markets. The dealers are a close-knit community. If you're out and about early enough you'll see them helping one another set up their stalls about 7 am, and experience first hand their camaraderie and friendship. There is always so much to see and, surprisingly, as you browse the shops and stalls you tend not to notice the street becoming steeper. As you walk towards the southern part of the street look back at the pretty, pastel-colored terraced housing above the shops, which makes this stretch of the road so attractive.

Nearly all the shops here are related to antiques, some very pricey, others quite cheap, but there is generally something for everyone. Don't be taken in by what looks like a very small shop from the outside, as there are several antique arcades that extend both sideways and backwards, a bit like Aladdin's cave, made up of booths bursting with antique goods. Here, you will find paintings, silverware, porcelain, jewelry, clothing, furniture, old cameras, ornaments – the list is endless.

Camera shop in the Antiques Market

Trading goes on here all day from 9 am and the arcades start shutting up shop around 4 pm. By 5 pm most dealers have finished for the day and the street once again takes on a different persona.

Set between the antique shops not far from Elgin Crescent you will find a lovely old hostelry with a grey façade and green tiles. This is **The Portobello Star**, which has been located here for around 270 years and is still a very popular haunt. On its website it claims that it has been 'frequented by Royals, scallywags, urchins, beggars, scarlet ladies, drunkards, intellectuals, popular musicians of the day and the occasional association football player', and no doubt many of these remain customers today! Not only serving food and drink at the downstairs bar, The Portobello Star also sells its own bespoke gin and runs a Gin Institute for those interested in learning how to make the spirit. Classes are regularly held upstairs

where participants are taught about the history of gin and will make their own unique blend. Alternatively, you can attend a Gin Masterclass and learn how to prepare perfect gin cocktails (*www.portobellostarbar.co.uk*).

The antique shops peter out towards the top of the hill near the junction with Chepstow Villas and Kensington Park Gardens **[12]** and you will now walk along a very pleasant street of mainly small, two-storey terraced cottages. Turn right and continue down Pembridge Road **[13]** with its quirky boutiques, cafés and eateries, and pub, The Prince Albert (named after Queen Victoria's husband). **Notting Hill Gate** is now directly ahead, a busy thoroughfare full of traffic, people and activity! Here you will find the Gate Cinema **[14]**, a little older than the Electric Cinema yet still going strong. It has changed ownership a number of times in its lifetime, but now is an independent art-house cinema. Like its counterpart, it too has just the one screen,

One of the many shops in Portobello Road

has a wonderfully restored Edwardian interior and good, comfortable seating.

The tube station, **Notting Hill Gate** *(Central, Circle, District lines)* is just across the road and you can be sure to find a good selection of cafés and restaurants in the vicinity.

ENVIRONS OF PORTOBELLO ROAD & NOTTING HILL:

KENSINGTON PALACE GARDENS & PALACE GREEN

Located on the south side of Notting Hill Gate, **Kensington Palace Gardens [15]** runs adjacent to Kensington Gardens, and is a total contrast to the bustle of Notting Hill, so close by. Often referred to as 'Billionaire's Row' it is said to be *the* most expensive road in the capital and many of the buildings are either occupied by foreign embassies, used as ambassadorial residences or belong to the exceedingly wealthy. The iron and steel magnate Lakshmi Mittal, Russian oligarch and Chelsea Football Club owner, Roman Abramovich, China's richest man and property tycoon, Wang Jianlin, and Formula 1 heiress, Tamara Ecclestone, all have properties in the road.

Kensington Palace Gardens, as its names suggests, was built on land owned by the royal palace and the Crown Estates still remains the freeholder, selling leaseholds for the properties here. The most recent sale was in December 2015 when a ten-bedroom mansion was purchased for £80 million.

Due to its wealthy and important diplomatic residents it is a private street, closed to traffic, with security gates at either end staffed with armed police. Furthermore, each building employs its own security personnel, as I experienced one day when innocently walking along the street; stopping by a gatepost whilst taking in the stunning architecture of one of the grand houses, I jumped out of my skin when I

was addressed by the gatepost (it had an intercom built in), asking if I required any assistance. I had obviously been 'seen' on a screen within the grounds and appeared to be up to no good!

Right from its beginnings in the 1840s this was a road built especially for wealthy owners. Its early residents included people in banking and the media such as Paul Julius Reuter and Lionel de Rothschild; the very large and splendid houses were advertised for about £3000 (in accordance with the development's regulations), demonstrating their exclusivity and preventing anyone without significant wealth from purchasing a house here.

As you walk along the broad, tree-lined street you might notice how the architecture starts to change from Italianate in the north to Queen Anne style in the south. About two-thirds of the way along its length, it becomes **Palace Green,** and the houses on the east side actually back on to Kensington Palace Green, part of the Royal Estate and London home to the Duke and Duchess of Cambridge and family, as well as to cousins of the Queen: Prince and Princess Michael of Kent, the Duke and Duchess of Gloucester, and the Duke and Duchess of Kent.

It was in Apartment 8 in Kensington Palace that Diana, Princess of Wales, lived from 1981–1997, while the Queen's younger sister, Princess Margaret, had rooms here too for over 40 years until her death in 2002.

If you fancy a short walk in Kensington Gardens or perhaps want to visit Kensington Palace, take the path at the end of the fenced stretch on the left, which leads into Kensington Gardens. Alternatively, continue walking to the end of the street until you reach **Kensington High Street.**

KENSINGTON HIGH STREET

This is an area always popular with the 'Chelsea' set, full of bars, clubs, shops and restaurants. If you are here in the evening (Wednesday–Saturday) you might want to visit the Austrian chalet bar-restaurant, **Bodo's Schloss [16],** which is located just beside

Kensington Gardens (*www.bodosschloss.com*) and the Royal Garden Hotel. Decked out to look like an Austrian ski resort and with staff clothed in lederhosen and dirndl, it is perhaps a little different to other more conventional London night-time venues.

Practically across the street is another landmark of the area, **St Mary Abbot's Church [17]**. The fourth church on the site, it was designed by master architect, George Gilbert Scott. It is famous not only for its interior, and for the quality of its musical recitals, but also for being the church that Diana, Princess of Wales, attended with her sons when she lived at Kensington Palace. The church over time has included Sir Isaac Newton, William Wilberforce and William Thackeray amongst its parishioners, as well as the ex-Conservative Prime Minister David Cameron and his wife, Samantha.

Another popular spot is **The Roof Gardens [18]**, on the corner of Derry Street on the same side of the street as High Street Kensington underground station. High up, on the sixth floor, The Roof Gardens were originally opened to the public in 1938 and took two years to build. The landscaper, Ralph Hancock, planted over 500 species of trees and shrubs some of which are still in evidence today. Now owned by Sir Richard Branson, founder of the Virgin group, the space is split into different themed areas: the Tudor Garden, Spanish Garden and English Woodland Garden (where you can see the resident flamingoes) and is open to the public, free of charge. Always check online (*www.virginlimitededition.com*) before visiting as the venue closes at times for private events. On the seventh floor there is also a bar and restaurant, Babylon, where you will get some stunning views of London and enjoy superb, contemporary British cuisine.

The underground station, **High Street Kensington,** *(Circle, District lines)* is a moment away, but if you still have stamina then a five-minute walk along the street will bring you to the **Design Museum [19]**, located just inside Holland Park. Until very recently sited beside Tower Bridge, the museum has now moved into the former Commonwealth Institute building, where over £80 million has been spent on renovation. Offering free entry, the museum space includes a permanent gallery,

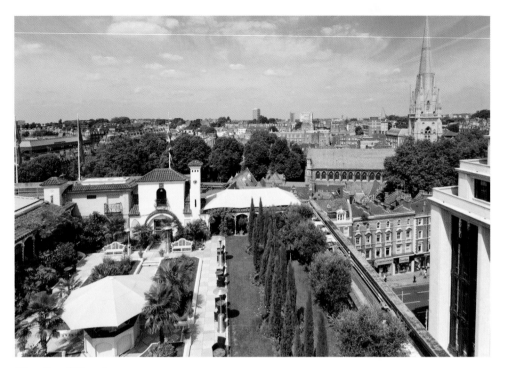

The Roof Gardens

temporary exhibition space, a library, two shops, café, restaurant, events space and auditorium.

Holland Park is right on your doorstep and ideal for a short stroll through its large woodland area or to see the beautiful Japanese garden. In the summer, music lovers might enjoy a visit to the Opera Holland Park Season, held in an outdoor theater within the park *www.operahollandpark.com*.

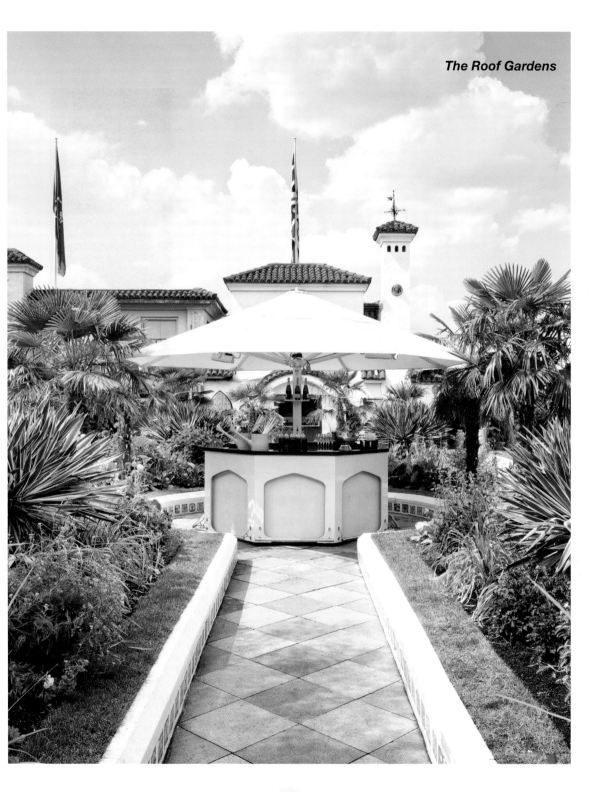

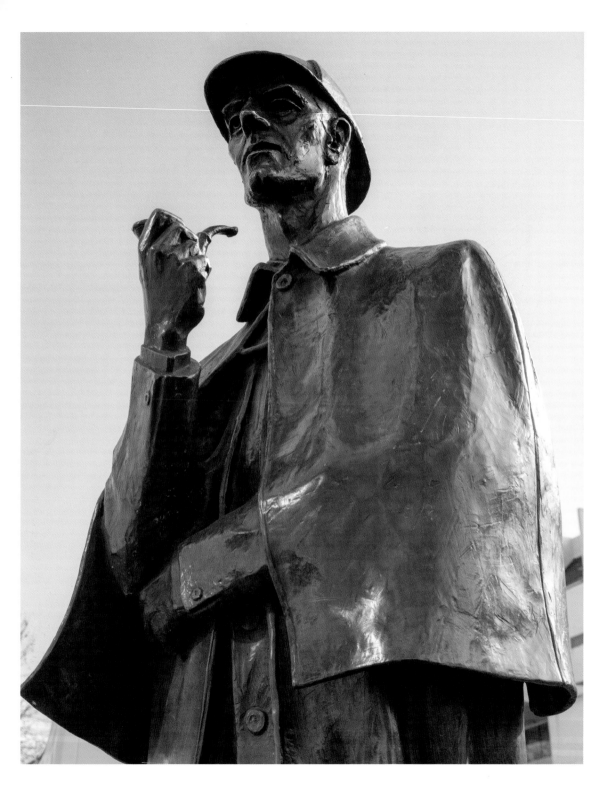

CHAPTER TWO

BAKER STREET & MARYLEBONE

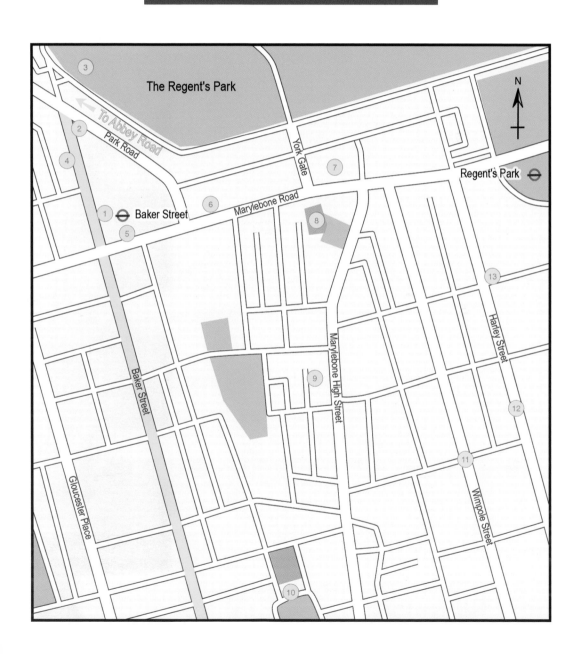

BAKER STREET & MARYLEBONE

Baker Street is one of London's most famous streets on account of its most celebrated, though fictional, inhabitant **Sherlock Holmes**. Today the street is fairly unassuming, mainly lined with offices, a hotel, casino, retail outlets, restaurants and cafés. Only comparatively few of its original 18th and 19th century houses remain, yet in places it is still possible to conjure up times gone by and imagine the street full of carriages and hansom cabs and the overwhelming stench of horse manure.

Baker Street is situated north-west of central London, within the village of Marylebone, and is bordered by one of London's most beautiful royal parks, The Regent's Park, built in the early 19th century. If you are traveling with children you may well want to wander into the park and visit the celebrated Zoological Society of London (ZSL) London Zoo, go boating on the lake, visit the Open Air Theatre, picnic, eat at one of its many cafés or have fun in one of the playing fields or playground areas.

The street runs at right angles to London's very first bypass, the Marylebone Road (known originally as the 'New Road'), opened in 1756 to alleviate congestion of traffic and cattle along Oxford Street en route to Smithfield Market in the City of London. More than 250 years later it too suffers badly from traffic problems and is full of cars, buses, trucks and bicycles 24/7.

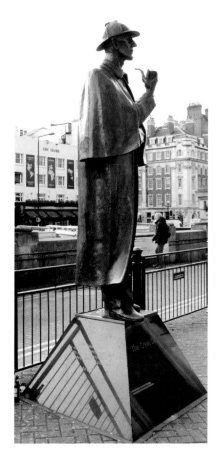

Sherlock Holmes Statue

Up until the 18th century, most of the land north of Oxford Street was rural and mainly undeveloped, in the hands of landowners like Edward Harley, the Earl of Oxford, Henry William Portman and the Church Commissioners. The Great Fire of London in 1666 had been the impetus for many Londoners to move west out of the City of London, and that, together with the ever-increasing growth in London's population led to the need to build housing on London's northern edge. Development took place throughout the 1700s and by the end of the century, land that had once been meadow and pastureland was replaced by streets full of grand residential properties that became home to the upper and professional classes. Over three centuries later, Marylebone is still largely owned by the same three estates, although it is now the Howard de Walden family that owns and manages the Harley estate. All of the de Walden's 1200 houses now have planning permission for use as offices, so few are used solely for residential purposes. Even so, Marylebone remains a very fashionable address and many people have homes within its locale.

Our walk starts at **Baker Street underground station**, which with five tube lines passing through makes it one of the West End's most accessible stations. Leaving the station you will first explore the northern section of Baker Street up to the Regent's Park. Returning to Marylebone Road you will then pass into the 'village' of Marylebone, finishing the walk just behind Oxford Street.

BAKER STREET

Baker Street Station

This station was built in 1863 on the very first of London's underground railways. The line connected Paddington in the west with Farringdon, in the City of London, a length of 5.6 kilometres (3.5 miles). At that time, the trains were powered by steam, and the carriages were little more than open-top carts. The railway lines were only 6–7 metres (20–23 feet) below ground and the platforms at Baker Street were lit by gas in hanging

globes. Further along the line there were regular openings in the tunnels, resulting in the system being coined 'cut-and-cover'. It couldn't have been a very pleasant ride for the passengers, but thousands used the service from its introduction, both for its usefulness and speed in crossing London as well as for its novelty factor.

If you stand on the Circle and Hammersmith & City line platforms today you will find little has changed in over 150 years. The fittings and fixtures are surprisingly similar but the trains themselves have gone through a number of design alterations. No longer are passengers subjected to steam, dirt and noise on their journeys, but they have comfortable, covered, even air-conditioned carriages. There is no conductor aboard but instead a recorded voice gives information as to the route and next station and the doors open automatically. What a change from the underground's early years when you had to wait for the conductor to announce the stop and open up the carriage doors on arrival at the station.

Although the original line going east–west (the Metropolitan/Circle) is still very much in operation, you can now travel north to south through Baker Street and it connects with the regenerated area of Docklands and Canary Wharf, a major hub of the financial and newspaper industries.

Leave the station at the Baker Street exit (look for signs to the Lost Property Office). Pass through the arcade of shops until you reach Baker Street. Then turn right, stopping outside the Lost Property Office.

Lost Property Office – 200 Baker Street [1]

Situated here since 1933 the Lost Property Office (LPO), not only collects lost property from the tube, buses, black taxis and Docklands Light Railway (DLR) but also from Victoria Coach Station. Its offices open Monday to Friday 08.30 am–4 pm and a small reclaim charge is made; for example, £1 for umbrellas. Items unclaimed are either given to charity or auctioned off after three months and all monies received

help to pay for the staffing of the office and rent for the storage space in such a prime London district.

This office stores a remarkable medley of goods ranging from hats, scarves and caps to schoolbags, lunch boxes, false teeth, crutches, mobile phones, laptops and has even been known to be home to an urn of ashes! It seems incredible but people leave behind their groceries, as well as toys and sometimes clothing – even an expensive ballgown was found. There are fortunately quite a lot of honest people who ride on London's transport as it is not unusual for money to be handed in as well: from as little as a £1 coin to much larger denominations of paper notes.

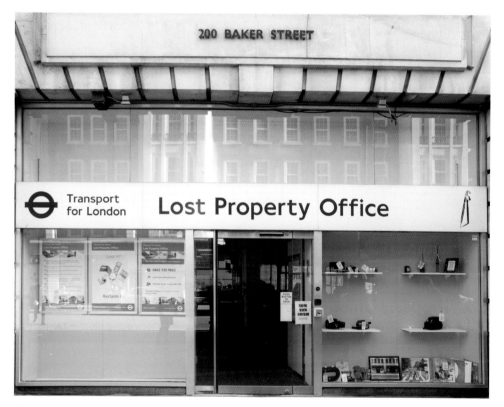

Transport for London Lost Property Office

In many cases, the lost articles are successfully reclaimed when an enquiry is made. Sometimes the LPO will initiate proceedings if an address is visible or they can easily trace the owner. So, if you happen to mislay any of your belongings whilst traveling around London's transport network be sure to pop in or contact the office online at *www.tfl.gov.uk/help-and-contact/lost-property*. Alternatively ring 0845 330 9882.

Turn right up the street and stop outside the apartment block, Chalfont Court.

Sarah Siddons [2]

This building would have been no. 27 Upper Baker Street, and it was here that the famous actress, Sarah Siddons (1755–1831), lived from 1817 until her death. She was the most acclaimed tragic actress of the late 18th and early 19th centuries, renowned for her portrayal of Shakespearean heroines.

Siddons was born into an acting family, daughter of Roger Kemble, the actor-manager, initially appearing in her father's touring theater company. She was respected by all her contemporaries and painted by the leading portrait artists of her day including Joshua Reynolds, Thomas Gainsborough, and Thomas Lawrence. Gainsborough apparently had some difficulty painting her nose (on account of its length) but nonetheless she was considered a great beauty. Joshua Reynolds in particular, was much taken with her; in his painting, *Mrs Siddons as the Tragic Muse* he signed his name on her dress hem ensuring that his name would remain in posterity on Mrs Siddons.

Sarah Siddons's acting career took off at the Drury Lane Theatre in the 1780s playing Portia in Shakespeare's *Merchant of Venice*. She retired from the stage after three decades, but her popularity never waned and when she died in 1831, there was a crowd of over 5000 mourners at her funeral at St Mary's Church, Paddington Green, the largest ever seen in the district. Her portrait is on display at Tate Britain in Pimlico, or if you are interested in seeing a very fine statue of her, there is one carved

from white marble on Paddington Green, unique in being the first memorial in London to a woman who was a commoner (non-royal).

Siddons's house is no longer in Baker Street, demolished by the railway company to make way for Chalfont Court (236 Baker St). However, if you look in through the entrance door of the luxury apartment block today you will see a memorial commemorating her inside the lobby.

Continue walking to the road junction. You will see the park over to the right.

THE REGENT'S PARK [3]

Once a hunting ground of King Henry VIII, the land was later leased out for dairy farming until the early 1800s. At the expiry of the lease in 1811 the Prince Regent, the eldest son of King George III, along with his favorite architect, John Nash, decided to build a splendid park and summer palace on the site. It was their intention for it to be connected by a processional route to Carlton House, the Prince Regent's London mansion, close to St James's Park.

Nash built the route (Portland Place and Regent Street) and designed and landscaped the park, surrounding it with very elegant residential terraces. A canal was added on the park's northern edge but his summer palace never came into fruition. The terraces remain standing today and are some of the area's most expensive accommodation, but many of the buildings are now used by large institutions such as the London Business School, Regent's University and Winfield House, the US Ambassador's London residence. The park is also home to St Katharine's Danish Church, ZSL London Zoo and the Open Air Theatre. From the start the grand and imposing houses attracted the rich and famous and in the 1930s, Wallis Simpson was living in a flat here when her affair with King Edward VIII became public knowledge.

Today, Regent's Park is renowned for its mix of formal gardens and parkland and really offers something for everyone. Queen Mary's Gardens, in the Inner Circle, with

The Regent's Park

their wonderful displays of roses, as well as the Japanese and Alpine Gardens are simply glorious. You can stroll beside the Regent's Canal passing by ZSL London Zoo or alongside the Y-shaped lake, stocked with a variety of wildfowl. There are rowing boats and pedalos for rent as well as a boating lake specifically for children.

*Now, retrace your steps a little and look across Baker Street. In the middle of the terrace of houses you will see **221B Baker Street [4]**, the 'home' of Conan Doyle's fictional detective, Sherlock Holmes.*

Sherlock Holmes

Sometimes it seems hard to believe that Sherlock Holmes was not a real person, only a figment of the imagination of Sir Arthur Conan Doyle. So many radio broadcasts, plays and films have been produced of the books and in so many parts of the world, that Sherlock Holmes, Dr Watson, Mrs Hudson and Baker Street, are all very true to life. In reality there has never been a 221B Baker Street, yet you find a **Sherlock Holmes Museum** in situ at the top end of the street, bearing this address. The museum opens daily (there is a small entrance fee), and gives a very good feel for Holmes's lodgings and the rooms he supposedly worked and lived in.

There have been many actors who have played the part of Holmes on screen and in TV series. The most recent, and possibly the most popular, being Benedict Cumberbatch. Four series have been shown on British television since 2010 reaching

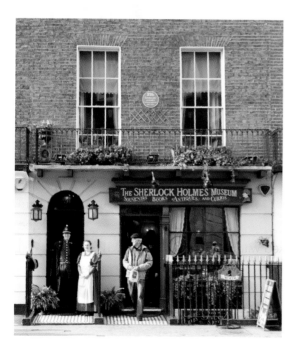

The Sherlock Holmes Museum

audiences of 7.5–10 million, and have confirmed Cumberbatch as a leading actor. The character, Sherlock Holmes, first appeared in Conan Doyle's 1887 *A Study in Scarlet* and the author then went on to write four novels, and 56 short stories about the detective. The stories appeared each month in *The Strand* magazine and Victorian society was captivated right from the very beginning. The tales were published over a period of 40 years, in a similar fashion to the stories of Charles Dickens, Agatha Christie, Rudyard Kipling and P.G. Wodehouse. When

Conan Doyle killed off Holmes in *The Final Problem,* after the fight with his archrival, the Napoleon of Crime, Professor Moriarty, at the Swiss Reichenbach Falls, it was because he had become bored with this character! However, the public outcry was so exceptional that he had to resurrect Holmes from the dead. He explained in *The Adventure of the Empty House* that only Moriarty had fallen over the cliff, and that Holmes had allowed the world to believe that he too had perished while he managed to get away and ultimately survive.

Now walk back towards Baker Street Station and at the traffic lights turn left into the slip road behind the main **Marylebone Road***. Walk along a few metres, passing by the station entrance, until you reach a familiar statue.*

This bronze memorial to **Sherlock Holmes [5]** was placed here in 1999 and is inscribed 'The Great Detective', a fitting tribute to the character who made such a mark on the area. He is hard to miss, decked out in cape, deerstalker hat and carrying his pipe – his trademark appearance.

Early Madame Tussauds at The Penny Bazaar

Located about halfway along Baker Street but long since gone, the Penny Bazaar was originally a horse bazaar owned by a Member of Parliament (MP), John Maberly. Whilst the lower floors sold carriages and furnishings, the upper rooms became the first permanent home of Madame Tussauds waxworks (1835). Marie Tussaud had learnt her trade in France towards the end of the 18th century, and became noted for her casts of guillotined heads of victims of the French Revolution. After a disastrous marriage she came to England in 1802, touring the country with her display of 35 wax figures.

The life of a traveling show-woman was exhausting and precarious, moving from town to town with her caravans, and yet still introducing new figures. Her 'Chamber

of Horrors', including the guillotine believed to have been used in the execution of Marie Antoinette, contained artifacts associated with the 1789 French Revolution, and brought in crowds of visitors, all for a fee of sixpence!

As the attraction grew in popularity, new premises were sought, resulting in a move to Marylebone Road in 1884, where the venue has stayed ever since.

MARYLEBONE

Madame Tussauds, Marylebone Road [6]

Since the late 1800s Madame Tussauds in London has received many millions of visitors and the attraction has always moved with the times. As a youngster I remember visiting when the waxworks were roped off from visitors and you could only enjoy them from a distance. Fortunately, this has long since changed and visitors now stand amidst royals, celebrities, iconic faces from the world of sport, music, fashion, culture and world politics as well as actors and movie stars. Since the 20th century the attraction has been more about the famous than about imparting news and nowadays there are a number of dedicated themed sections. In the Royal area, you will see the twenty-third rendition of the Queen, which was created to celebrate her Diamond Jubilee in 2012, as well as remarkably lifelike waxworks of members of her immediate family and the late, Diana, Princess of Wales. Over in the Culture area writers, artists, and scientists are displayed with Madame Tussaud herself seen working on a wax figure in her studio.

In addition, and included in the admission ticket, visitors can experience a ride in a black taxi whizzing through 400 years of London's history, visit the modern day Chamber of Horrors, take part in an interactive adventure in the Sherlock Holmes Experience, or become immersed in the Star Wars Experience, which includes many favorite characters from Star Wars Episodes I–VI. To find out more about the personalities that appear at Madame Tussauds, its nine themed areas and interactive

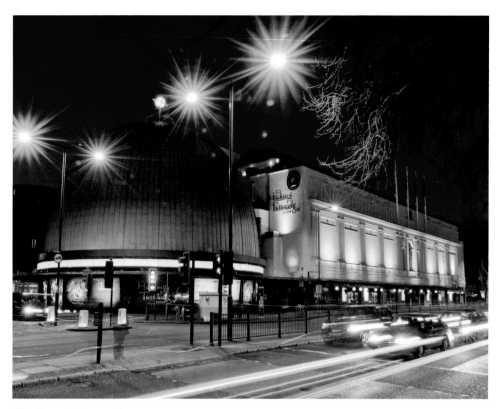

Madame Tussauds

attractions visit its website *www.madametussauds.co.uk/london*.

It may be of interest to know that each wax figure has a dedicated team of about 20 skilled artists working on it, and the figures take about four months to complete at a cost of around £150,000 each. Very little modern technology is used and sculptors still employ the techniques passed down by Madame Tussaud more than 200 years ago!

A short stroll east from Madame Tussauds brings you to York Gate, a road that leads into Regent's Park. Cross the road to reach one of the leading music institutions in the world.

Royal Academy of Music and Museum [7]

The Royal Academy of Music is Britain's senior conservatoire, founded in 1822.

The York Gate building, designed by John Nash in 1822 as part of the main entrance to Regent's Park, hosts the Academy's 'living museum' and is open to the public free of charge, seven days a week.

A visit to the collections is to experience the vibrant working environment of the Royal Academy of Music. The museum is an integral part of Academy life; regular concerts, seminars, workshops and other events take place in the galleries, including performances and demonstrations on some of the instruments on display. The

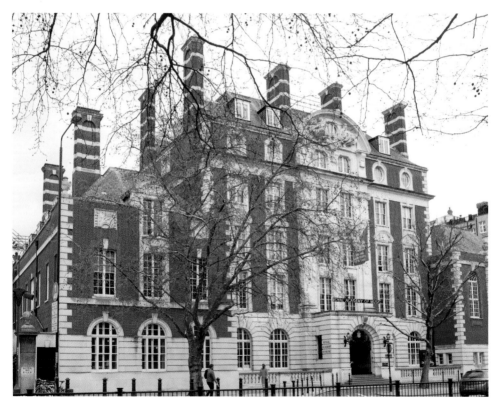

The Royal Academy of Music

museum has three permanent galleries where instruments such as violins and pianos from the 17th century onwards are on show. It also puts on temporary exhibitions such as Yehudi Menuhin: Journeys with a Violin, and the Spencer Collection highlighting 16th century lutes, guitars and manuscripts.

If you visit on the first Wednesday of the month you can join a tour of the whole museum at 1 pm (free, but donations are welcome).

Many famous musicians and singers have received their training at the Academy including Elton John, Annie Lennox, Lesley Garrett, Simon Rattle, Arthur Sullivan, Henry Wood, John Barbirolli, Harrison Birtwistle and John Dankworth.

Look directly across the Marylebone Road and you see one of Marylebone's treasures, St Marylebone Parish Church.

St Marylebone Parish Church [8]

The very imposing church, designed by Thomas Hardwick, was built just 200 years ago in 1817 and replaced an earlier church that then became a 'chapel-of-ease' beside it. It was in this earlier church that the scene of the marriage in Hogarth's *A Rake's Progress* (1735) is set (see the actual painting at Sir John Soane's Museum in Lincoln's Inn Fields). The earliest church, built around 1200, was actually sited closer to Oxford Street, next to the Tyburn River. Due to its position it became known as St Mary by the Tyburn church, and later gave the river's name, Tyburn, to the area.

It was in the present church that poets Elizabeth Barrett and Robert Browning secretly took their marriage vows in 1846. Elizabeth's father, a somewhat tyrannical and possessive man, strongly opposed their relationship and thus, immediately after her wedding, Elizabeth returned home as though nothing had taken place. A week later Elizabeth and Robert eloped to Italy taking with them Elizabeth's dog, Flush, and her maid. Elizabeth's health had been poor for many years; in fact, she was practically an invalid after the death of her brother, and Robert hoped that the

Italian climate would improve her well-being. The couple settled in Florence where Elizabeth continued to write. *Sonnets from the Portuguese* and *Aurora Leigh* were both published at this time and have become some of her most celebrated works. Sadly Elizabeth died and was buried in Florence in 1861. She is still remembered within the church in the Browning Chapel and Browning Room – used for social activities and meetings.

The church also has associations with other famous personalities; the playwright, Richard Brinsley Sheridan, married here in 1773 (another secret marriage), and both Lord Byron and Horatia Nelson (the illegitimate daughter of Lord Nelson and Lady Hamilton), were baptized here in 1788 and 1803 respectively.

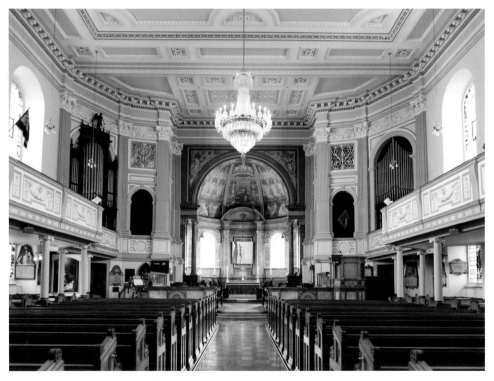

St Marylebone Parish Church

Outside the church in the garden you will find the graves of Charles and Samuel Wesley (Methodists), James Gibbs (architect), John Rysbrack (sculptor) and George Stubbs (painter).

MARYLEBONE HIGH STREET

Today, the High Street is the heart of Marylebone's village community and is a winding street that follows the course of the underground Tyburn river. Many of its buildings date from around 1900, when much rebuilding work was undertaken on the estate that had first been constructed in the 18th century by the Earl of Oxford. The estate continues to be owned and managed by his descendants, the Howard de Walden family, and contains both commercial and residential properties. Marylebone High Street services the local residents and has the feel of a real village high street yet is full of interesting, small, independent shops as well as some excellent artisan food stores, cafés, pubs and fine restaurants. It is a select shopping area with a clientele and atmosphere comparable to Chelsea. Halfway along its length is one of Marylebone's hidden delights:

Daunt Books [9]

Not only a superb, independent bookstore with a wide-range of new and second-hand books, Daunt's is located in original Edwardian premises boasting oak shelves, wonderful skylights and wooden galleries. The store is now one of six Daunt bookshops in London, but without a doubt, the Marylebone shop tops them all. It is dominated by a long, narrow main room graced with galleries on two sides and a stained glass window at the far end. Go inside to explore its stock – fiction and non-fiction, especially the travel sections – and you may stay longer that you intended!

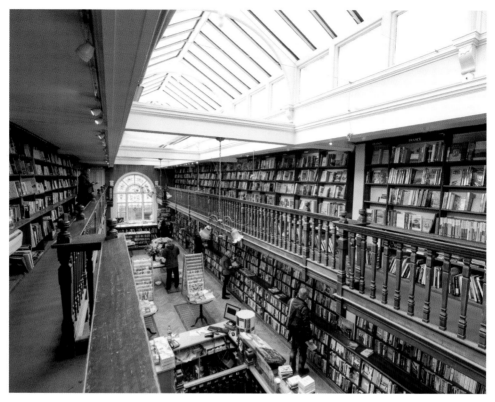

Daunt Books

The Wallace Collection, Manchester Square [10]

The Wallace Collection *(www.wallacecollection.org)* is a National Museum displaying in its 25 galleries the wonderful works of art collected in the 18th and 19th centuries by the first four Marquesses of Hertford and Sir Richard Wallace, the son of the 4th Marquess.

Displayed at Hertford House, the main London townhouse of its former owners, the Wallace Collection is probably best known for its paintings by artists such as Jean-Honore Fragonard (*The Swing*), Frans Hals (*The Laughing Cavalier*) and Velázquez (*The Lady with a Fan*). It is renowned too for its superb collections of

18th century French paintings, porcelain, furniture and gold boxes, splendid medieval and Renaissance objects, including Limoges enamels, as well as the finest display of arms and armour in Britain, featuring both European and Oriental objects.

Sir Richard Wallace had the house redeveloped in the 1870s and created a range of galleries on the first floor. After his death the house was converted into a public museum by the Office of Works and first opened in 1900.

Still going strong, the Wallace Collection opens daily (10 am–5 pm), without charge. In recent years the museum has added a wonderful glass-covered courtyard restaurant, which opens for breakfast, lunch and afternoon tea during the week, and for dinner on Friday and Saturday evenings. It is probably the perfect venue for al fresco eating yet in a protected environment!

MEDICAL LONDON: HARLEY STREET & WIMPOLE STREET

These two streets were created during the early decades of the 18th century as Edward Harley, 2nd Earl of Oxford, developed his land north of Oxford Street. Whilst Harley Street took its name from its ground landlord, Wimpole Street was named after the landlord's Cambridgeshire estate, and many streets in the estate were given names relating to family members, their titles or their country seats, such as Henrietta, Cavendish, Wigmore, Margaret, and Holles.

The houses were substantial Georgian properties built to a high standard and from the start attracted aristocratic and well-to-do residents, but the early 19th century saw their usage change; before long Wimpole and Harley Street became associated with the medical profession. Doctors and consultants converted the large terraced houses so that the upper floors were used as living space, whilst the downstairs rooms became the consulting and waiting areas. The location was excellent; close to the West End and within easy reach of the railway. In fact, by the end of the century, four mainline stations were built on the nearby Marylebone Road, bringing clients from all parts of Britain.

The medical connection has continued to flourish and today, in addition to doctors and consultants, the district is full with dental practices, private hospitals, and medical laboratories. The breadth of medical procedures and services on offer is forever increasing as technology advances and new treatments are developed.

Wimpole Street [11] has associations too with three well-loved writers, Arthur Conan Doyle, Elizabeth Barrett Browning and Wilkie Collins. Conan Doyle established an ophthalmic practice at 2 Upper Wimpole Street in 1891, the same year that the first six of his *Adventures of Sherlock Holmes* were published in *The Strand* magazine. Shortly after, having difficulty combining both careers, he made the decision to stick to writing and moved to south London and became a very successful author.

Wilkie Collins, famous for *The Woman in White* and *The Moonstone*, died at no. 82, whilst poet and writer Elizabeth Barrett Browning lived at 50 Wimpole Street in her family home until eloping to Italy with Robert Browning in 1846. An English Heritage blue plaque commemorating this can be seen on the façade of the property.

Wimpole Street was also home for a short while in the 1960s to Paul McCartney when he lived at no. 57 with Jane Asher and her family.

Harley Street [12] too is associated with a number of famous names: artists, J.M.W. Turner and Allan Ramsay, and astronomer Sir John Herschel, had homes here but possibly the most celebrated resident was Florence Nightingale, who ran a nursing home at no. 90 (1 Upper Harley Street) **[13]** in 1853 before being recruited as nursing administrator to Scutari Hospital in the Crimea. A tireless worker and campaigner her work had a major impact on health care in her own lifetime. It is due to her efforts that both the standing of nurses and their training improved and she was awarded the Order of Merit in 1907 for her very valuable contributions to the medical profession.

You have now reached the end of the walk and transport can be found nearby at **Regent's Park, (*Bakerloo line*), Great Portland Street *(Circle, Hammersmith & City, Metropolitan lines)* and Oxford Circus (*Bakerloo, Central, Victoria lines*).**

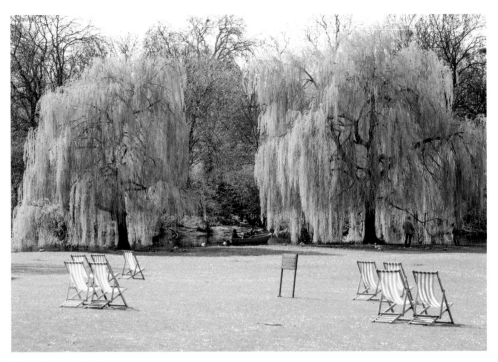

The Regent's Park

ENVIRONS OF BAKER STREET & MARYLEBONE:

ABBEY ROAD

Abbey Road Studios are about a mile or so north of Baker Street and can easily be reached by bus (82, 113, 139, 189) or by tube (nearest station **St John's Wood,** *(Jubilee line)* and then a three–five minute walk). If you have time, it is very pleasant to walk from Baker Street station through Regent's Park alongside the lake until you reach Regent's Park Mosque, where you exit the park. From here it is a short walk past Lord's Cricket Ground, Cavendish Avenue, where Paul McCartney has a home,

along Wellington Road and ultimately turning left at Grove End Road until you reach the junction with **Abbey Road** and its very recognizable **crossing [14]**.

Thousands of tourists pay homage each day to the **Abbey Road Studios [15]** at 3 Abbey Road, possibly the world's most famous recording studios. Originally a large villa in leafy St John's Wood, it underwent conversion and was then sold on to EMI who formed three main studios on the site.

Although celebrated for being the studios where the Beatles recorded their first hit single 'Love Me Do', many other British and internationally acclaimed classical artists, jazz and pop singers have made their names here too in the period since it

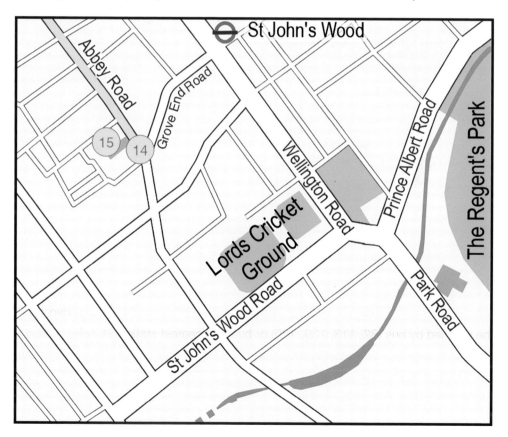

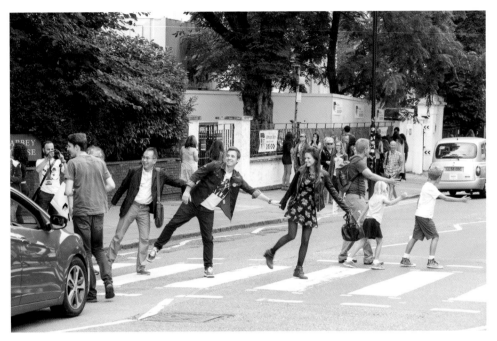

Abbey Road zebra crossing

began operating. The first recording at Abbey Road took place in November 1931 with the composer Edward Elgar, conducting *Land of Hope and Glory*. Shortly after, the young Yehudi Menuhin recorded Elgar's *Violin Concerto* at the studios whilst Artur Schnabel recorded all 32 of Beethoven's piano sonatas here in the following decade. In the late 1950s, the young and fairly unknown Cliff Richard recorded his first single at Abbey Road, and many famous albums and artists have since been associated with the studios. These include *Dark Side of the Moon*, which went on to become one of the best-selling albums of all time (Pink Floyd, 1973), *Hounds of Love* (Kate Bush, 1984), *The Bends* (Radiohead, 1995), as well as recordings by Adele, Queen, and Spandau Ballet.

The studio soon established itself as a top recording studio and so has always managed to attract exceptionally talented musicians, bands and singers. **Studio 1**, the

largest of the three studios, was designed to accommodate an entire orchestra and has been recording full orchestral works and film scores ever since it was set up 86 years ago. In recent times the musical scores for *Harry Potter* movies, *The Hobbit: the Battle of the Five Armies* and *Star Wars* films have all been recorded here.

In the 1960s, **Studio 2** was largely home to the Beatles. Having been signed up to the studios by George Martin in 1962, the group went on to record a single every three months and an album twice a year, a really gruelling schedule. In the seven years they performed together they recorded 90 per cent of their output at the studio, often taking it over for months on end. During this period Abbey Road almost became their second home, a place where they not only recorded their material but wrote the lyrics and music as well.

In 1969 the Beatles recorded the tracks of their final album here calling it *Abbey*

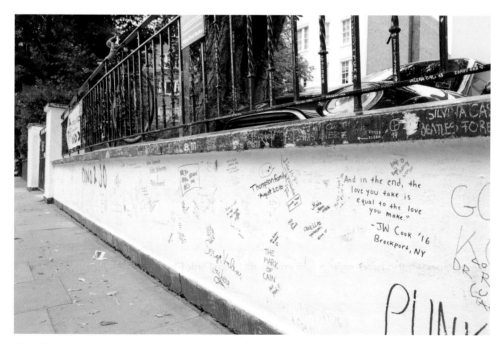

Graffiti on Abbey Road Studios' garden wall

Road in recognition of the importance of the studios to the group and of their very productive years together. The famous pedestrian crossing right outside the studios that featured on the album cover for *Abbey Road* has always attracted hordes of tourists to the site. Even though the studios themselves are not open to the public, it has not deterred Beatles' fans from every corner of the world making the journey here and having the obligatory picture taken on the iconic crossing. So many attempts have been made to take the Abbey Road sign that it is now fixed high up on a wall, and the fans' graffiti that adorns the wall outside the studios is cleaned away by the local council staff every three months!

To gain more of an insight into what the studios look like now, take a look at *www.insideabbeyroad.withgoogle.com* for a tour around the building and for more information about its long and fascinating history.

*Retrace your steps along Grove End Road back to **St John's Wood underground station (Jubilee line)** or take a bus from Abbey Road (139,189) or by the station (82, 113) to return to Baker Street.*

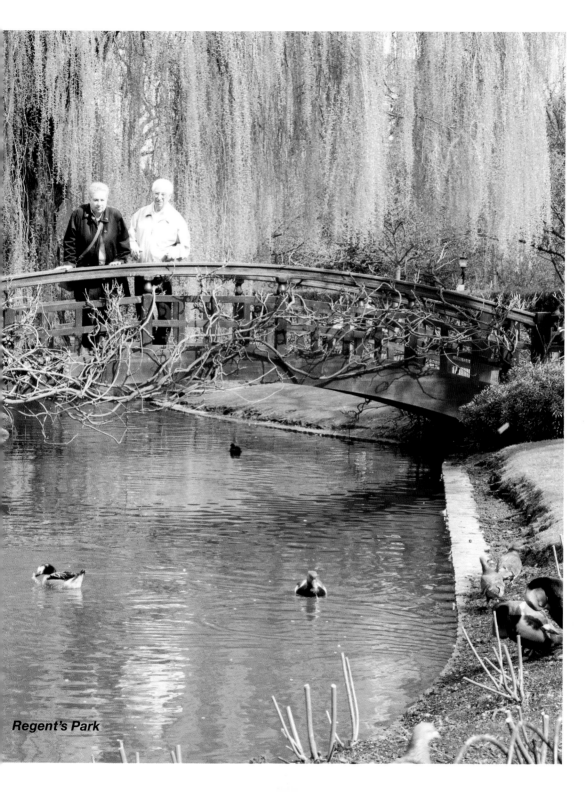

Regent's Park

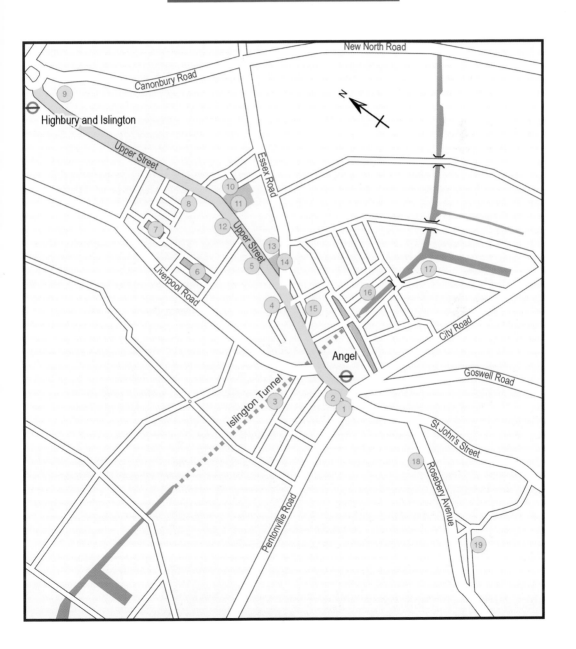

THE ANGEL, ISLINGTON

Worth a mere £100 on the original 1930s UK Monopoly Board, and as such one of the game's least expensive locations, the Angel, Islington today is a decidedly more prosperous area, within striking distance of both the City of London and the West End.

The Angel refers not to a road at all, but to a coaching inn that was located at the junction of five roads on the outskirts of the capital city. As such, it was a major intersection and became the main stop for stagecoaches leaving London during the 18th and 19th centuries. It's hardly surprising then that the Angel's main road,

The Angel building

Upper Street, was lined with inns and taverns for hundreds of years. Alas, the Angel inn disappeared long ago and has had a variety of reincarnations since, the most recent, and its present incumbent, being the Co-operative Bank. William Hogarth, the 18th century painter and engraver and great observer of humanity, recorded it in *The Stage Coach*, a print of which is held at the Victoria and Albert museum.

Originally the area was just a small hamlet known as 'Yseldon', not more than a village, mentioned in the Domesday Book of the 11th century. It was forested and inhabited by bears and wild bulls and scarcely developed. In time, religious houses took over much of the land ownership and then after the Dissolution of the Monasteries in the 1530s, it passed into the hands of the king and his favored nobles. At this point, it was largely a recreational area, a rural retreat near to the City of London and famed for its springs, brooks, meadows and ponds. It was here that the nobility came for leisure and sport, good clean air and it was noted for its fine mansions. By the 17th century the land was used for arable and dairy farming, and cattle that had been herded down to London from the north would halt their journey here, get fattened up and then move on to nearby Smithfield Market for slaughter.

Dairy farming became Islington's main industry and at this time, the village provided London with much of its milk, cream and butter. However, agriculture declined as the Industrial Revolution took hold in the 1700–1800s, the population expanded hugely and land was needed for housing. Within a hundred years the entire landscape had changed and much of the district around the Angel was covered with streets of terraced housing as well as elegant Georgian residential squares. The 19th century saw great changes in transport with the arrival of the canal and railway, and the building of new roads. In this new industrial age older housing stock was demolished to make way for warehouses, depots, workshops, and industrial buildings. This in turn led to a housing shortage, which resulted in great overcrowding and slums, and the area became run-down and shabby. The once stylish squares became neglected and fell into disrepair and furthermore, during World War II the area suffered a good deal of bomb damage. This meant that in the post-war years it was easy to buy up

cheap properties in and around the Angel and reinforced the 1930s image of the area being down-at-heel.

The 1960s saw the beginning of a reversal of its fortunes as **Camden Passage Antiques Market** was established and brought both visitors and a renewed interest in the area. Speculators bought up the old, neglected properties and with the construction of the Victoria underground line in the late 1960s the area was better connected making it a far more attractive place to live. As expected, property prices soon rocketed and over the years many famous people moved in, including ex-Prime Minister Tony Blair, ensuring Islington's inclusion as one of London's more select and pricey areas!

The Angel has always been a center of entertainment. Royal hunts took place here in Tudor times. Visitors took delight in its bowling greens, practiced archery and would stroll in the fine meadows. Then, from the late 17th century, spa resorts appeared offering 'healing' medicinal waters as well as outdoor entertainments, firework displays, trapeze

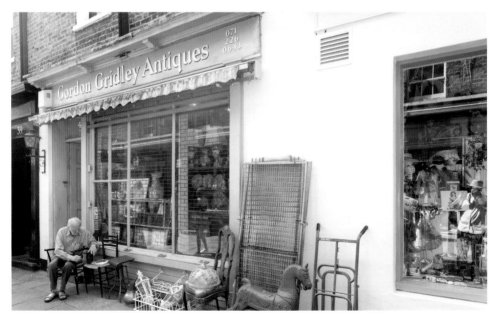

Camden Passage antique shop

acts and refreshments. In later years theatrical productions, ballet and opera were staged at Sadler's Wells and in the early 1900s the street was full with music halls, and then cinemas. The Screen on the Green, which was built in 1913, is one of the district's hidden gems both for its interior and range of arthouse movies that complement the more conventional program on offer at the nearby ten-screen Vue cinema.

Upper Street even has two theaters; the Almeida, which is one of London's most popular fringe theaters and attracts the very best playwrights and actors, and a children's puppet theater, the Little Angel Theatre. You will also find several 'theater pubs' such as The Old Red Lion, King's Head, and The Hope with their small and intimate performance spaces.

Inns and taverns have been the backbone of the area for hundreds of years and still dominate Upper Street. With so many restaurants, bars, pubs, cafés and clubs along its length the street today has surely earned its nickname, 'Supper Street' and you will definitely never go hungry here.

The following is a **circular walk** beginning and ending outside **Angel underground station *(Northern line)*** on Islington High Street.

ISLINGTON HIGH STREET/UPPER STREET

It is quite difficult to believe that this noisy busy thoroughfare was once little more than a rural area, albeit on the main route north from London. Now very much a thriving district, it is all the more appealing for its enormous variety and number of restaurants and bars, entertainment, antique shops, markets, an exhibition center, galleries and canal walks. People flock here from all over town making the Angel and Upper Street one of London's favorite villages. The Angel is part of the London Borough of Islington that covers a mere 15 square kilometres (6 square miles), most of which is steeped in history. Visit at any time of the day and there are people about, but as the cocktail hour approaches, bars and restaurants fill and the street never seems to empty.

The walk around Angel begins immediately in front of the underground station and

Islington High Street (which a little further along becomes Upper Street) will be right in front of you. Look across the street to your left and just by the traffic lights on the corner is a domed building **[1]**. This is where the **Angel Inn** was sited until the end of the 1800s. There had been several earlier inns on this spot over the centuries which provided food and lodging to travelers. Due to its position the inn was always famous and mentioned in many books including Dickens's *Oliver Twist*, and *Nicholas Nickleby*. When it was rebuilt as a coaching inn in the late 17th century, the building had a double gallery and plays were performed in its coach yard. The audience, standing either in the yard or up above in the galleries would pay money into a box, the equivalent of buying a ticket today. Once the play had started the box would be taken to a room or office away from the entertainment – the Box Office, which is where it is thought that the modern term was penned.

Right outside the inn was The Islington Turnpike, where travelers paid a toll and during the heyday of the dairy farming industry it was where thousands of sheep and cattle would pass on their way to market in London.

By the early 19th century over 4000 passengers were known to pass the Angel each day on omnibuses and when the stagecoaches disappeared they were replaced by trams, horse-drawn buses and later, trolley buses. The Northern line underground first opened in 1901 and this made the area even more accessible and may well have contributed to the move to build a number of music halls and cinemas here in the late 19th and early 20th centuries. Sadly, almost all have disappeared with the passing of time, but you can still get an idea of the exterior appearance of the **Angel Picture Theatre** if you look at the building that Starbucks **[2]** occupies now. When it was built in 1913 it was the most enormous and fabulously ornate cinema with marble floors, a fine plasterwork ceiling, its own orchestra and a copper-domed roof. Its white tower and green cupola remain a local landmark and are a reminder of Islington's music hall past and connection with early silent movies and cinematography.

Chapel Market (just off Liverpool Road) [3]

This vibrant market, located in the heart of Angel opens every day except Monday and sells everything from specialist cheeses, meat, fish, fruit and vegetables to household goods, plants, shrubs and clothing. It is based in the town center and filled with a mixture of market and street-food stalls as well as small boutiques and cafés. Manze's Eel Pies and Mash Shop with its 19th century façade, is a popular long time resident at no. 74, whilst at no. 97 is Alpino's, a family-run café that seems to have been here forever and is consistently lauded for both its breakfasts and ambience.

The street was originally built in the 1780s for the growing middle class moving into the area and was where sibling writers, Charles and Mary Lamb, famous for their children's *Tales of Shakespeare*, lived briefly between 1799 and 1800.

Return to Liverpool Road, and cross into Angel Central Shopping Centre. Walk straight through and turn left onto Upper Street, past the parade of shops and turn left at the traffic lights.

Royal Agricultural Hall – Business Design Centre [4]

This rather grand building began its life in the latter part of the 19th century as a purpose-built home for the Smithfield Club's annual agricultural and livestock exhibitions, and was originally known as the Agricultural Hall. Built on the site of a former cattle enclosure it covered an enormous area and over 1000 tons of cast iron were used in its construction. With a very wide-spanned vaulted roof and cast iron gallery and railings the building bore a striking resemblance to many of London's Victorian railway stations and continues to do so even now.

In 1885, the Prince of Wales (later, King Edward VII) extended his patronage to the building and the hall became known as the 'Royal' Agricultural Hall. Despite this change of title locals referred to it as 'The Aggie', a name that it bears to this day.

Apart from its association with agriculture and cattle, the hall always hosted a huge

medley of events and exhibitions which included walking races and marathons, the Naval and Submarine Engineering Exhibition 1882, the World's Fair, horse shows, military tournaments, circuses, revivalist meetings, motor shows, and even Crufts Dog Show!

Visitors came from every walk of life. It was the place to be seen. Charles Dickens wrote about it and Walter Sickert captured it in art. Even politicians like Gladstone and Churchill were seen enjoying themselves here.

In World War II, the government requisitioned the building and exhibitions ceased. When the General Post Office's premises were destroyed by a fire-bomb its offices moved here and stayed put until 1971! By this time, the Aggie's previous role had been taken over by other London exhibition centers at Olympia and Earl's Court, and sadly the building fell into neglect. A public campaign to save it was launched

The Business Design Centre

with many suggestions proposed for its future use (ranging from a Dickens London Theme Park, an ice-skating rink, residential housing, to a hypermarket) but none were deemed suitable. Ultimately, a local businessman, Sam Morris, fell in love with the site and despite its terrible condition purchased the building and began a program of restoration to return the hall to its former glory. After major renovation it was renamed the Business Design Centre (BDC) and Morris ensured that the space was not only let to start-ups and small businesses, but also used as exhibition space. By 1986 the work was complete and the building was once again in business.

The BDC now mainly functions as a conference, exhibition and event venue playing host to many art, food and design exhibitions as well as trade fairs. The Centre also provides space for showrooms and offices. If you are passing by when the BDC is not in use for an exhibition, do pop your head inside just to see the very beautiful interior and marvel at its grand Victorian architecture. Details of its program can be found on *www.businessdesigncentre.co.uk*.

Return to the main road and turn left.

As you walk along you will pass by a number of eateries and bars and then arrive at the **Screen on the Green [5]** cinema, recognizable by its iconic semi-circular stone façade. Back in the mid-1970s the building was used as a concert venue when The Clash performed here on a bill with the Sex Pistols and Buzzcocks.

At Theberton Street turn left and after passing a pretty row of restaurants, you are transported into an unexpected backwater. Within easy earshot of frenetic, noisy Upper Street you find yourself in the midst of some very attractive, genteel Georgian terraced housing. Even though the houses are packed closely together, they are spacious and extend over four and sometimes, even five floors. Many of them have been converted into individual flats, and are a very attractive buy for professionals working nearby in the City of London.

In a short while you reach a junction where you will turn right into Gibson Square.

GIBSON & MILNER SQUARES

Both Gibson **[6]** and Milner Squares **[7]** were constructed in the first half of the 19th century to house the area's growing middle classes and are excellent examples of the fine Georgian architecture typical of the district. Gibson Square was built first in 1831 and named after the MP for Ipswich and President of the Board of Trade, who happened to be a friend of both Charles Dickens as well as the politician, Benjamin Disraeli.

The Square contains a range of houses, some of which look particularly grand with pilasters and pediments, and all are graced with typical features of the time; flat stucco façades, basements, railings, sash windows and fanlights above the front door. The attractive gardens in the middle of the square contain an unusual building that looks a little like a Grecian shrine. In fact, it turns out to be a ventilation shaft for the London underground and replaced an earlier planned functional concrete tower.

Gibson Square is much sought after, both for its architectural beauty and also for its proximity to Upper Street and its wealth of amenities. So, it is not surprising that the writer, Penelope Lively and comedian, broadcaster, actor and presenter, Stephen Fry have had homes here.

At the end of the square continue walking into Milner Place until you reach Milner Square.

Although this square was constructed only about ten years after Gibson Square it is markedly different in shape and appearance. Long and thin and more uniform in style, its terraces are lofty and the houses narrower than its neighboring square. It is surprisingly peaceful here and yet you are still only a stone's throw away from Upper Street and constant flow of traffic. Walk along the right hand side of the square and

you will shortly see a passageway off to the right. Go through this, then cross the road. Stop towards the end of the street outside the Almeida restaurant.

The Almeida Theatre [8]

The building opposite has been home to the Almeida Theatre since 1980 and initially hosted touring companies including Kenneth Branagh's, Not the Royal Shakespeare Co.

Over the years many noted as well as debut playwrights have had their plays staged in the theater and some of these have met with such success that they have subsequently transferred from here to the West End. Always providing a varied and international programme with strong casting and direction, the theater has earned the acclaim of not only British, but overseas audiences too. Performances of Shakespeare, Greek tragedy, Molière and Chekhov have been staged in recent years to much acclaim. As you would expect, productions here have included many famous actors including Claire Bloom, Kevin Spacey, Juliet Stephenson, Ralph Fiennes and Juliette Binoche.

The building itself has an interesting story and like many others in and around Upper Street moved away from the purpose for which it was built. It was first erected in 1832 as the **Islington Literary & Scientific Institution** and owed its design to Gough & Roumieu, the architects responsible for nearby Milner Square. The original building housed a 12 metre (36 feet) long reading room, a theater seating 550 and had a foyer with the most impressive Portland stone staircase. Lectures were offered on a broad range of themes from magnetism to music and appealed to the Institution's largely middle class audience.

After the Institution moved out of the premises in the 1870s the building went through several transformations ending up as a warehouse and factory of children's toys.

The factory closed down following a local scandal when the manager was killed by his son-in-law, after which the property remained empty for some time. Plans were

proposed for a theater on the site in the 1970s and finally the Almeida Theatre opened offering a rather avant-garde programme.

It was thought appropriate to name the theater after the street in which it was located – which, itself had been named in memory of a battle that had taken place in 1811 on the border of Spain and Portugal, and was part of the Duke of Wellington's campaign in the Spanish Peninsular War.

Return to Upper Street, and cross the road at the traffic crossing.

Just before you move on take a quick look around you to see the variety of shops nearby. There are so many estate agents, restaurants and clothing shops and as one closes down new outlets appear almost immediately. In the last century and during the late 1800s, the range of shops was generally associated with clothing, such as milliners, corsetieres, shirt-makers and fitters, and high-class costumiers. Rackstraw's Drapery Emporium, at the north end of the street was an extremely popular department store and by the end of the century, one of the largest in North London. Horse-drawn carriages waiting to pick up its shoppers were regularly parked outside its entrance and this end of Upper Street was considered to be the 'Bond Street' of the borough until the store finally shut its doors in the mid-20th century.

If you walk north today you find a good selection of boutiques, artisan bakeries, and specialist shops. These are interspersed between houses and apartments as well as the iconic red-brick **Union Chapel [9]**. A non-conformist church it has the most unusual dramatic interior: octagonal in shape and said to be modeled on the church of St Fosca near Venice. Totally unique when it was built, the design of the church made the reputation of its architect, James Cubitt.

Turn right and walk towards St Mary's parish church. Make a short detour down Dagmar Passage, the alleyway on the left, just before you reach the church and walk a few metres until you arrive at a redbrick building.

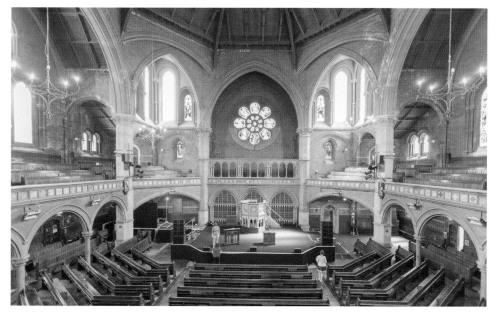

Inside the Union Chapel

Little Angel Theatre [10]

This charming children's theater has been operating since 1961, in what had originally been built as a temperance hall. It is one of only three such permanent theaters in the UK today and ever since its first performance it has been delighting young children and their families with a constant program of puppet and marionette shows.

The Little Angel Theatre (LAT), was founded by John Wright, a master puppeteer from South Africa. Under his direction, audiences enjoyed a range of inventive and pioneering shows both at the theater in Dagmar Passage as well as on tour across the country. Always trying to produce ground-breaking material, he stimulated future puppeteers to follow in his steps so that after his death in 1991, the theater was able to continue and grow. Nowadays, the productions are put together and puppets created and carved in the workshop that sits alongside the theater. Naturally it is important that such specialist skills are not lost in future generations and to prevent

Inside the Little Angel Puppet Theatre

that from happening the LAT runs regular training courses for puppeteers and puppet makers in its premises. The theater is also greatly involved with local schools and community groups and provides regular activities such as a Saturday Puppet Club, holiday clubs and Kids Fun Days. To find details of the theater's program look at its website *www.littleangeltheatre.com*.

Retrace your steps back to Upper Street.

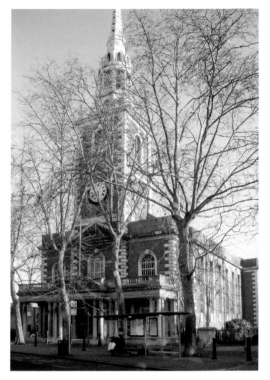

St Mary's parish church

Just a short distance away, surrounded by some tall plane trees, is **St Mary's parish church [11]** with its impressive portico, church tower and spire. It has been at the core of village life for at least 900 years and maybe even more. Charles Wesley, younger brother of the Methodist leader, John Wesley, Donald Coggan and George Carey have all worked as curates at St Mary's and the latter two (during the 20th century) went on to become Archbishop of Canterbury, the highest religious figure in the land.

Now, look across the road to the glass, curved-fronted pub, the King's Head.

King's Head Theatre Pub [12]

The theater-pub was the brainchild of New Yorkers, Dan and Joan Crawford, who founded it in 1970. It was a novel idea at the time, and said to be the first of its kind since the Shakespearean era. Nowadays, the theater is a popular venue for the staging of a range of shows, plays, musicals and even opera. Like the Almeida Theatre nearby, some of these productions have been so successful that they have subsequently staged in the West End. Whilst actors such as Victoria Wood, Maureen Lipman, Mel Smith, Anita Dobson, and Hugh Grant launched their career at the King's Head Theatre, it has seen performances from many other loved thespians such as

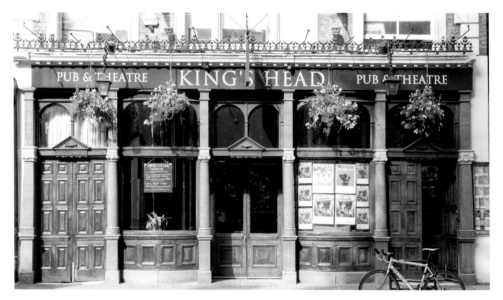

The King's Head Theatre Pub

Tom Conti, Joanna Lumley, Ben Kingsley and Janet Suzman.

The pub itself has a typical Victorian interior with marble pillars, a central oak bar, a high ceiling and walls covered with pictures of famous stage personalities. Towards the back of the bar you find the tiny theater, in a separate room that was once used as a boxing ring and a pool hall.

From here, turn left and walk along Upper Street until you come to Islington Green. Turn left and stop outside Waterstones book shop.

Collins Music Hall [13]

In the mid-19th century this was the site of one of Islington's most popular music halls, run by Londoner and former chimney sweep, Sam Vagg, also known as Sam Collins, who had made his name singing Irish songs touring pubs and music halls.

The institution went through a succession of redevelopments over its lifetime and saw its usage change from music hall to repertory, variety and even a strip joint in the 1950s! In its heyday the music hall attracted all the major names and was celebrated throughout London. Marie Lloyd, George Robey, Charlie Chaplin, Harry Lauder and Tommy Trinder all performed on its stage and played to packed audiences here. Sadly, a major fire gutted the dressing rooms and rear of the building in 1958, bringing an end to almost 100 years of music hall tradition.

The building was redeveloped in the Regency style and nowadays is home to a Waterstones bookstore, and is a much-loved landmark beside Islington Green. There is a blue plaque above the canopy that marks its use as Collins Music Hall from 1862–1958.

Waterstones, formerly Collins Music Hall

Islington Green

Just across the road is a welcome triangular open space and wonderful oasis, Islington Green **[14]**. These are public gardens, and in the center there is an interesting modern war memorial, a large twisted ring of stone fashioned in the shape of a wreath, the work of Royal Academy sculptor, John Maine.

At the end of the path just outside the gardens you will see an imposing statue of the 17th century jeweler, local benefactor and MP, Hugh Myddelton. It was due to his efforts that the New River was built in the early 1600s, bringing much-needed water to London's growing population. The memorial was a gift of local people and the New River Company and unveiled in 1862 by William Gladstone, then Chancellor of the Exchequer.

Turn left and cross over to Upper Street. Walk a little way until you reach Charlton Place where you turn left into:

CAMDEN PASSAGE [15]

This little street is really the jewel of Islington; a totally unexpected gem and its reputation is famous throughout the globe. Ever since the antique trade established itself here in the latter part of the 20th century, it has been a busy enclave and visitors have come from far and wide to buy, browse or simply stroll along the narrow, atmospheric passageway.

Turn left and you will find the **Camden Head pub** with its typical 19th century Victorian interior full of wood paneling, an oak bar and etched glass, so typical of pub architecture of the period. A popular pub with a large exterior terrace, it opens daily, offering British food, drink and entertainment in its upstairs room, home to the Camden Comedy Club. If you enjoy stand-up comedy, or want to try your hand at becoming a comedian, this is the place to come.

Over to the right, in addition to the antique shops and small independent boutiques there are also arcades and market stalls. The main market days are Wednesday and

Saturday and most of the shops open all week long. Pierrepont Arcade Market, at the north end of the Passage, runs its own market on Sunday and Monday as well as a book market later in the week (Thursday and Friday).

Recently, a number of the antiques shops have been replaced by small fashion boutiques, restaurants, brunch outlets and cafés and Camden Passage is changing its focus, adapting to modern trends. New specialist food shops have opened giving the street a fishmonger, Moxon's, as well as high-quality cheese and coffee stores.

Before the antique dealers settled here in the 1960s the area's shops and housing were in a sorry, almost decrepit state, but once Camden Passage became an established antiques center the adjacent streets and neighborhood gradually became gentrified and subsequently changed the face of the Angel and Upper Street. Camden Passage soon became the 'in' place to visit, not only for the antiques but for its quirky shops and market. When Frederick's restaurant opened here in 1969 it was an overnight success and it too brought in many visitors and helped to place the Angel back on the map. As a consequence, famous personalities began to move into the area. Authors Salman Rushdie (*Midnight's Children)* and Douglas Adams (*The Hitchhiker's Guide to the Galaxy*), both had homes here in the 1980s, and many actors, writers, singers, musicians and even politicians live and have lived around these streets. The politician Boris Johnson, has a family home at the northern end of Upper Street, and ex-Labour Prime Minister, Tony Blair, lived in Richmond Terrace just north of Angel before taking up his prime ministerial office. With so many 'names' associated with the locality it is hardly surprising that Islington and the Angel's profile and value as one of London's most attractive addresses just continues to rise.

When you reach the end of the passage continue along a short stretch of residential housing and then turn left into Duncan Street. At the end of the street, cross over two minor streets until you reach some black railings. Straight ahead of you is the Regent's Canal and you will need to pass down the ramp to the left of the railings to reach the canal towpath.

THE REGENT'S CANAL [16]

The canal is undoubtedly one of the area's main draws, almost a rural idyll in an area of fairly dense population. No longer will you see industrial barges in the water, laden with cargoes of corn, sand, gravel, timber or refuse, but instead pretty, brightly colored, narrow boats will pass up and down on the waterway and canal folk will wave as you pass them on the towpath.

When the Regent's Canal was built between 1812 and 1820 it acted as a major transport route from Paddington in the west of London over to London's docklands in the east, passing through Regent's Park, Camden and Islington and ending at Limehouse. Initially, the industrial barges were powered by horses walking along the towpath and attached to the vessels by strong rope. When the animals reached a tunnel they would be un-harnessed and led over ground, meeting up with the boat once it had gone through to the other side of the tunnel. In order for the boat to pass

City Basin Lock

through without any power, the bargees used a procedure called 'legging it' to propel the boat along. This required them to lie on a plank on either side of the boat and, using their legs, push against the side of the tunnel. This was a real athletic feat and must have been exceedingly tiring. By the late 1820s, a steam tug was introduced for this purpose, but although it halved the time it took to get the barge through the tunnel, the tunnel filled with poisonous fumes. Understandably, this new method was not very popular and many commercial barges continued to be pulled by horses up until the 1960s.

After a period of neglect in the latter part of the 20th century there has recently been a resurgence of interest in the canal. Every September a festival is held on the waterway and come here any weekend and there will be a constant flow of people, dogs and cyclists along the towpath.

Walk a short way along the path, through a short tunnel and you reach a lock at **Diespeker Wharf [17]** on the edge of the City Road basin. The building just beside the lock with the tall chimney was originally built as a factory for an Italian terrazzo and marble company. Now occupied by an architectural practice, it has been sympathetically and tastefully converted into offices that have a wonderful view over the canal and lock.

If you walk past the lock you will reach City Road basin which today is mostly surrounded by residential housing. It was not always so however: in Victorian times the area was covered with warehouses, wharves and depots and goods were unloaded from vessels and stored in these nearby buildings before distribution around the capital.

It is now time to return to Upper Street, so retrace your steps along the towpath until it runs out by the Islington Tunnel. Exit on the right side, walk up the staircase and then cross the bridge, turning right into Vincent Terrace. At the road junction ahead turn left along Colebrooke Row, and then right at its junction with the City Road, towards Angel junction. You will see a sign of a Red Lion hanging on the right, advertising one of the area's noted pub theaters.

A left turn at the intersection ahead brings you to the **Pentonville Road** that later leads to the **Euston Road**. Both streets might sound familiar as they feature on the Monopoly board, with similar values to the Angel. The former is now made up mainly of residential houses, shops, cafés, offices and a hotel, whilst the latter is a major thoroughfare that takes traffic west across London. Euston Road is famous for its three railway stations, King's Cross, St Pancras, and Euston as well as being home to the British Library and the Wellcome Foundation. When the road was built in 1756 it was London's very first bypass. Still a major route it is renowned for its heavy traffic day and night.

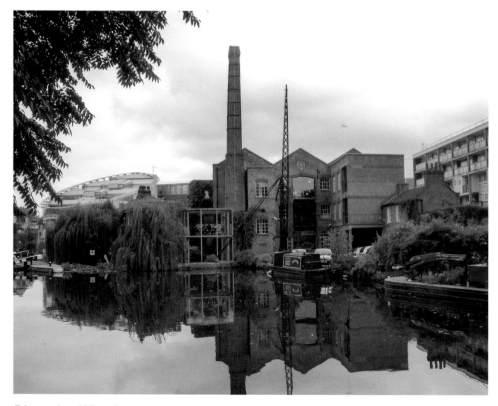

Diespeker Wharf

On reaching the Angel junction look up at the left-hand corner building with its striking dome and try to imagine the stagecoach era when vehicles crowded the Angel Inn's courtyard and travelers ate, drank and were entertained here. In reality, nothing much has changed around Angel today, with Upper Street jam-packed with diners in search of restaurants offering mouth-watering cuisine, and so many diverse entertainments available. The Angel has really come full circle and would surely be awarded a much higher property valuation now on the Monopoly board than when the board game first hit the shops over 80 years ago.

You are now in sight of **Angel underground station *(Northern line)*,** which is where the walk ends.

ENVIRONS OF ANGEL, ISLINGTON:

ROSEBERY AVENUE

You may not know the name of this street but if you are interested in dance, contemporary music and the performing arts then you are likely to have heard of **Sadler's Wells Theatre [18]**. It has a long history, having been on the site since the late 17th century, first as a music house then as a spa resort and theater.

Sadler's Wells today is one of London's great performance venues that specializes in contemporary dance, showcasing internationally renowned visiting companies and presenting new works. Here you will see South American dance troupes, Spanish flamenco dancing, Chinese dance theater and Peking Opera, circus acts, as well as classical and contemporary ballet. Fans of choreographer Matthew Bourne eagerly await his next Sadler's Wells production, when well-known ballets and operas such as *Swan Lake*, *Carmen* or *Sleeping Beauty* are staged, with unusual, alternative and occasionally dark choreography and interpretations, as well as wonderful scenery and costumes.

The theater has gone through many changes during its lifespan: starting off in 1683 as a timber built 'music' house, it was named after its owner, Richard Sadler. Within a century it was where the public came to see pantomime, tightrope walks, feats of strongmen, singers, rope-dancers and clowns. It was here in 1781 that Joey Grimaldi, later to become known as the 'father of clowns', began his career as a three year old. He acted here throughout his lifetime

Sadler's Wells Theatre

and even managed the theater for a while in the early 19th century. For a period in the mid-1800s, when Samuel Phelps was the theater's actor-manager, more than 30 Shakespearean plays were staged and Phelps greatly improved the theater's reputation. His production of Hamlet played to packed audiences for 400 nights, but after he'd retired, Sadler's Wells turned its back on highbrow productions and the building was subsequently used as a skating rink, a boxing venue and even a pickle factory! By 1906 the theater had closed, although it was turned into a cinema for a short time in 1914–15.

Lilian Baylis, the theatrical producer and manager saw the theater's potential and in the 1920s started a fundraising campaign to have it rebuilt. On its opening night in 1931 she staged a performance of *Twelfth Night*, starring a couple of then fairly unknown actors, Ralph Richardson and John Gielgud. She was also instrumental in attracting dancers Robert Helpmann, Anton Dolin, Margot Fonteyn and Alicia Markova to the theater and the first British performance of *Swan Lake* took place

here in 1934. By this time Lilian Baylis was working closely with Ninette de Valois, the Anglo-Irish dancer, choreographer and director of ballet. Sadler's Wells now devoted itself entirely to opera and ballet, and de Valois founded a ballet company which was later to become The Royal Ballet company and move home to Covent Garden.

The opera company also moved its base out of Sadler's Wells in the 1960s but dance, music, and performance continued as the backbone of the theater's productions. In 1996, the 1930s theater was demolished and replaced by the most technologically advanced, state-of-the-art building, with a much improved auditorium and stage, and it is this, as much as the actual programs, that makes a visit to Sadler's Wells so very special. Performances now take place in both the main theater and the intimate, cosy Lilian Baylis studio theater, which is mainly used for smaller works.

Interestingly, the actual well from which the theater takes its name, is still in situ deep beneath Sadler's Wells and continues to offer natural spring water.

Just across the road from the theater is the Spa Green Estate, a 1940s public housing development that also sits on the site of a former spa resort, the Islington Spa. With medicinal springs discovered here in the 1680s, it was laid out with walks, arbors, lime trees, as well as rooms for gambling, dancing and dining. All its clients were given free spring water, which apparently smelled and tasted quite foul, in the hope that they would be induced to pay for entertainments such as ballooning, fireworks, music and freak shows. It became the most fashionable of venues in the 1730s, and frequently played host to King George II's two daughters. Despite its record of success the resort ultimately closed in 1840 and the land was built upon. A hundred years later the Georgian émigré modernist architect, Berthold Lubetkin, built the flats you see today. Lubetkin became involved with social housing throughout the district and built radical buildings for the time. The flats, with rubbish chutes on the roof and facilities for clothes drying, were considered to be a wonderful example of good local authority housing practice and to have raised standards in public housing.

Exmouth Market [19]

One of the area's trendiest hubs for bars and restaurants, this narrow street is really a food-lover's delight. Only a short walk from Sadler's Wells and the Angel, it has the most wonderful selection of restaurant food: Moroccan, Italian, Japanese, Indian, Vietnamese, Mediterranean as well as its own artisan bakery, tapas bar and Victorian pub, the Exmouth Arms. If you visit on a weekday between 12 pm and about 2.30 pm, you can also taste the many interesting and sometimes unusual market foods on offer. Perhaps sample some Ghanaian stew, vegetarian Indian dishes or Mexican burritos. The food looks and smells great and must be good as crowds of office workers queue to buy their lunches here daily. Exmouth Market also has a good mix of eclectic shops where you can pick up anything from a gift through to books, tools, artisan foods, clothing or even bicycles!

The street is at its most attractive after dusk when restaurants are full, and the place just buzzes until late.

*Walk to the end of the street and turn left into Farringdon Street. A short, five-minute stroll brings you to **Farringdon underground station (Metropolitan, Hammersmith & City, Circle lines).***

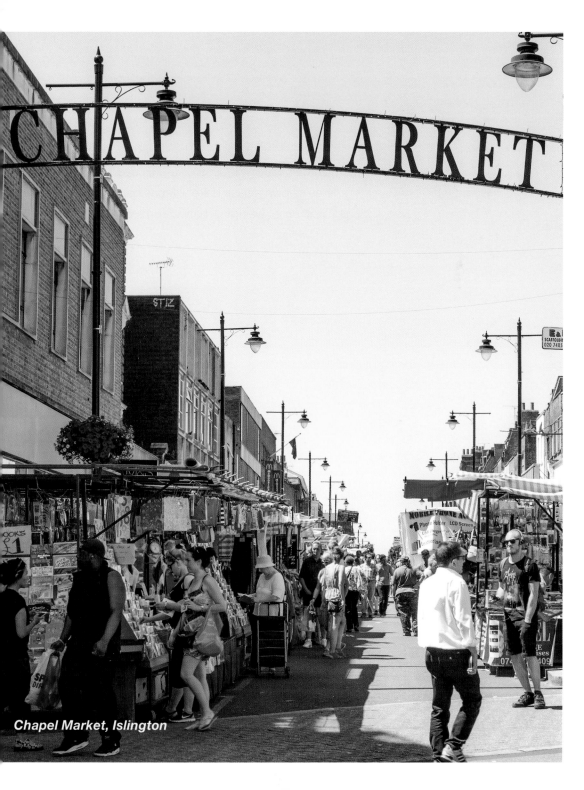

Chapel Market, Islington

CHAPTER FOUR

STRAND & FLEET STREET

STRAND & FLEET STREET

These two wide streets have been part of the major ceremonial route from the Tower of London to Westminster and Parliament since medieval times. Up until King Charles II's coronation in 1661 kings would stay in the Tower of London the night before their coronation ceremony and be cheered along the street by crowds of wellwishers on their way to Westminster Abbey. **Fleet Street** today falls within the City of London whilst **Strand** (popularly referred to as **'The Strand'**), comes under the auspices of the City of Westminster, two quite separate London boroughs. It is often said that while money is made in the 'Square Mile' (City of London), it is largely spent in Westminster, with its huge array of shops, entertainment, restaurants, hotels, and tourist attractions.

The Strand is the road that links the City of London to the West End and stretches from Temple Bar (the boundary of the City) in the east to Trafalgar Square in the west. Its name is derived from the Old English word for 'shore' or 'river bank', and was so-called as the street used to run directly alongside the River Thames. Until the late 19th century when the Victoria Embankment was constructed there was a riverside community living here, and the area was characterized by its wharves, jetties and narrow alleyways. In earlier times, from the 12th century, the Strand had been lined with beautiful mansions and palaces owned by the aristocracy and clergy. Among these great houses was the medieval Savoy Palace, now the site of the Savoy Hotel, and the 16th century Renaissance palace of the Dukes of Somerset, replaced in the 1700s by Somerset House. The street was full of huge residences such as Suffolk House, York House and Northumberland House, all of which had their own river gates and landings directly onto the river.

Today, you find a broad and busy thoroughfare full of shops, offices, theaters, churches, restaurants, cafés and pubs, and at its eastern most point, the Royal Courts of Justice. The famous music hall song says: 'Let's All Go Down the Strand' – and that is what we shall now do starting our journey on the forecourt outside **Charing Cross underground and railway station *(Northern, Bakerloo lines)*** near to Trafalgar Square.

STRAND

Eleanor Cross [1]

Right outside the station is a splendid carved stone monument dating from 1863, the Eleanor Cross, full of figures, an angel, heraldic shields, and finials. The monument commemorates the earlier medieval cross, constructed in 1290 by King Edward I following the death of his beloved wife, Eleanor of Castile. The cross originally stood in Trafalgar Square but was destroyed during the Civil War in the mid-17th century. It was the last of 12 commemorative crosses erected by the grieving king to mark each stopping place of the funeral cortege of his queen, as it made its way from Lincolnshire in the Midlands to Westminster Abbey. It was Victorian enthusiasm for the Middle Ages that inspired the new cross to be built and was designed by E.M. Barry, the son of Charles Barry (responsible for the Palace of Westminster).

Walk away from Trafalgar Square going east along the street and stop just opposite the Adelphi and Vaudeville theaters.

Theaters in the Strand

Across the road you will see two theaters that started life in the 1800s and have stood the test of time: the Adelphi and Vaudeville theaters. The **Adelphi [2]**, built in 1806 gained notoriety as the theater where, in 1897, William Terris, the most melodramatic and popular actor of the day, was stabbed to death by a jealous fellow actor. During its history it has sported seven different names and undergone several restorations (in fact, it is the fourth theater to have been built here) and is noted for its Art Deco furnishings. Throughout its life it has been host to many musicals including *Sunset Boulevard, Chicago, Evita* and *Stomp,* as well as drama, farce and comedy. Today it is one of six London theaters run by the Really Useful Theatres Group, owned by impresario Sir Andrew Lloyd Webber. Two of

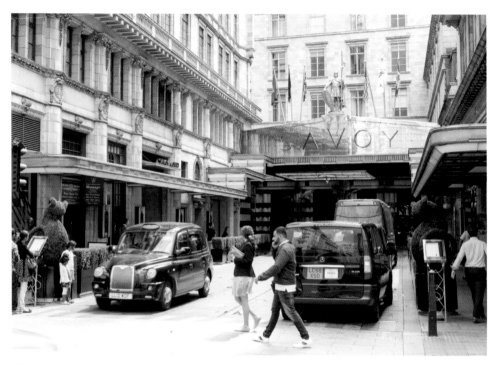

The Savoy Hotel

the Group's most successful musicals showing in town currently are *Matilda the Musical*, and *Charlie and the Chocolate Factory*.

Looking a little to your right you will see the façade of the **Vaudeville Theatre [3]**. Built about 60 or so years after the Adelphi it too has been revamped several times and today boasts the most elegant auditorium, which is decorated in the Adam-esque style. As its names suggests, the theater began life putting on vaudeville and musical shows, but in recent years the emphasis has veered more to drama and comedy.

Now, walk further along the street and you will see a small turning on the right, **Savoy Court [4]**, *which leads into the* **Savoy Hotel** *and* **Theatre.**

The theater, established in 1881, was so successful, that the owner, Richard D'Oyly Carte built a hotel beside it from the profits of the Gilbert and Sullivan operettas staged there. Interestingly, vehicles turning into the tiny private road leading to the theater and hotel drive on the right side, allowing theater patrons and hotel guests to alight from their vehicles directly onto the pavement alongside the entrances.

The original theater on the site is noted for being the first public building in the world to be lit entirely by electricity, a distinct advantage over gas lighting, which was both oxygen burning and also heat producing! Like its neighboring theaters, the Savoy has undergone a couple of redevelopments (one due to a major fire in 1990), and has now has been returned to its former Art Deco glory.

Right next door to the theater is the Savoy Hotel that opened in 1889 and was considered to be avant-garde with its 70 bathrooms, electric lifts, lights and own power generator. Naturally, the hotel attracted the wealthy and famous; including in its time, Dame Nellie Melba (after whom the dessert Peach Melba is named), Claude Monet, Sarah Bernhardt, Henry Irving, Oscar Wilde, Rupert Murdoch, Robert Maxwell and Robert Harris.

Two men, César Ritz (the hotel's first manager) and Auguste Escoffier (first chef) were largely responsible for its initial success, catering for the tastes of their individual guests, and the hotel still owns Escoffier's original pots and pans. If you want to stay at a very luxurious and 'English' five-star London hotel, then the Savoy is the ideal establishment. With butlers on hand for your every need, wonderful dining, lounge and bar facilities as well as a spa, swimming pool and gym, the hotel markets itself as one of London's finest destinations.

Now, to sample the delights of one of London's best-known entertainment districts, cross over the Strand into Southampton Street and walk up the hill to Covent Garden.

COVENT GARDEN [5]

Covent Garden is not in fact one street, but a collection of streets within a discrete, 16-hectare (40 acre) site north of the Strand, and is possibly London's best loved and most visited tourist area. It is surrounded by numerous theaters as well as the Royal Opera House and is a major center of entertainment. Life in Covent Garden revolves around the main piazza with its Apple and Jubilee Markets, St Paul's Church, the London Transport Museum and many and varied street entertainers. Children and families gather on the cobbled stones outside St Paul's Church entranced by jugglers, acrobats, and street performers whilst opera singers and musicians give wonderful free recitals in the basement of the Apple Market nearby. With its shops and market stalls, abundance of restaurants, cafés, pubs and bars, it is one of London's liveliest quarters. It also has a long and interesting history.

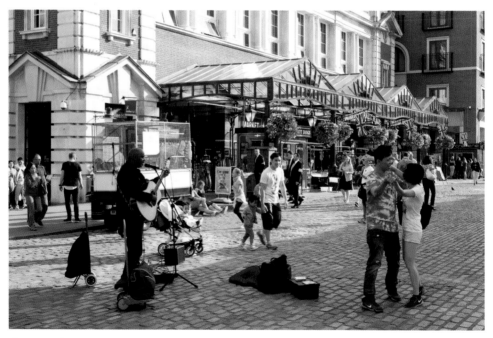

Covent Garden piazza

Initially an Anglo-Saxon settlement, Lundenwic (6th–9th centuries), the land was passed in the 11th century to the monks of Westminster Abbey who used it for growing food and herbs. It was thus the 'Convent' garden – which later became known as 'Covent' garden.

The monks lost their land in the 1530s after the Dissolution of the Monasteries, and the estate passed to the 1st Earl of Bedford, John Russell. Almost a century later, the 4th Earl decided to develop part of the estate as a profit-making housing speculation and commissioned the architect Inigo Jones, to design it for him. Jones used his knowledge of formally designed piazzas in Italy, as well as the Place des Vosges in Paris, to create London's first public square, the framework of which still exists today. The piazza was laid out in 1631, with Palladian-style houses on two sides of the square built in uniform, arcaded terraces. The houses became immediately fashionable and were quickly snapped up by court society. However, the nature of the piazza changed once market traders established themselves here after the Great Fire of London in 1666, causing the aristocracy to move out of their homes. In their stead came coffee houses and taverns, and later, brothels and prostitutes. The market, selling fresh fruit, vegetables and flowers grew and became very successful but with its popularity came a great increase in petty crime, pickpocketing and a buoyant red-light district. A guide to the prostitutes on offer came in the form of *Harris's List of Covent Garden Ladies* (still in print today!), describing the ladies in question and where to find them!

By the early 19th century the reputation of the area had worsened and it was then that the 6th Earl commissioned Charles Fowler to design a building to house the market (today's Apple Market) and to restore it to its previous respectable state. Further buildings were constructed for the flower markets towards the end of the century, and Covent Garden market continued to flourish. However, by the 1960s the market had really outgrown itself and the area was no longer able to handle all the market traffic resulting in Covent Garden Market's closure. In 1974 the market relocated south across the Thames to Nine Elms at Vauxhall.

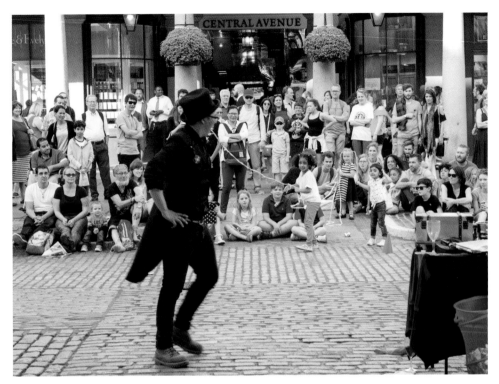

Magician entertaining tourists in Covent Garden piazza

Many proposals were put forward for redevelopment of the site, but after a prolonged campaign to retain Covent Garden and its buildings, the plans were thwarted and permission was given to create the wonderful attraction we have today.

Now return to the Strand, go past the entrance to the Savoy Hotel and turn right down Savoy Street. Stop outside the Savoy Chapel.

Savoy Palace and the Queen's Chapel of the Savoy [6]

Savoy Palace gets its name from its first owner, Peter, Count of Savoy, who was given the land in 1246 by King Henry III. He built a palace here which remained for just over a hundred years, until it was burnt down during the Peasant's Revolt of 1381. Despite some rebuilding Savoy Palace was never restored to its former splendor and changed its use to become first a hospital to accommodate the poor, and later a military barracks and prison. By the 19th century most of its buildings had disappeared but new buildings replaced the former palace-cum-hospital housing the Institution of Electrical Engineers. A new street, Savoy Place, was constructed and it was from here, in 1923 that the initial BBC broadcasts were made.

The Savoy Chapel, dating from the 16th century and built in the late Perpendicular Gothic style, is the only reminder of the Palace that used to stand here. Restored by Queen Victoria after a fire in 1864, it contains stalls of the knights of the Royal Victorian Order marked by small copper plates that carry the arms of the holder, similar to those found in Westminster Abbey and St George's Chapel, Windsor (Knights of the Order of Bath and Knights of the Garter respectively).

The chapel opens Monday to Thursday from 9 am to 4 pm and also on Sunday morning but closes during August and September.

Back on the Strand, turn right. Cross the junction of Aldwych and Lancaster Place (leading onto Waterloo Bridge), over to the other side of the Strand. Continue along for about 20 metres (65 feet) until you reach a grand entranceway into:

Somerset House [7]

Come here on a summer's day and you will find children of every age splashing around in the 55 fountains that spurt out water in the main courtyard (Edmond J. Safra Fountain Court). It is always a source of great fun and everyone is sure to get a little wet. At other times of the year, the Court is similarly popular for its ice skating rink and

for the nightly Film4 Summer Screen open-air cinema. It also provides a wonderful setting for the variety of exhibitions and musical concerts held on its premises, when the beauty of Somerset House's neo-Palladian architecture is emphasized by well-planned illumination.

It is one of London's popular arts centers and has a host of ongoing exhibitions in its various galleries. The **Courtauld Gallery** (*www.courtauld.ac.uk*) is its most well known permanent gallery, located on the right side of the building as you enter through the stone gateway. Although a small gallery, it possesses the most fabulous collection of Impressionist and Post-Impressionist artworks, a Renaissance art collection as well as 20th century British and European art. It also has fine drawings, prints and sculptures. The works of Renoir, Gauguin, Van Gogh, Monet and Cézanne are all represented in the gallery along with Manet's *A Bar at the Folies-Bergère*, and

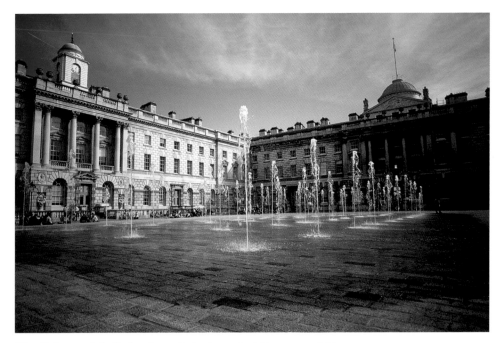

The Edmond J. Safra Fountain Court at Somerset House

The Family of Jan Brueghel the Elder by Peter Paul Rubens.

The gallery opens daily between 10 am and 6 pm and offers several types of tours as well as a Sunday Highlights tour; these are all included in the admission ticket charge.

Also in the complex and home to temporary exhibitions and installations are the Terrace and Courtyard Rooms, East and West Wing Galleries and The Embankment Galleries. The latter, is found by the Victoria Embankment riverside entrance, in the basement of the building. It is noted for its specialist exhibitions often relating to photography, fashion and architecture.

Although Somerset House is now an arts and cultural center it was not originally built for this purpose and has moved far away from the grand home that initially filled the site. In the 16th century during Tudor reign, it was a magnificent palatial town house, the home of the Duke of Somerset (protector to the boy king, Edward VI). It was such a fine house that in later years it became home to royalty; Queen Elizabeth I, then to the wives of the Stuart kings, Anne of Denmark, Henrietta-Maria and Catherine of Braganza. It was particularly renowned for the stunning masques (a form of drama/play) that were staged by Inigo Jones and Ben Jonson whilst Anne of Denmark resided at the house in the early 1600s.

The current building, the second on the site, was specifically developed as an office block, the very first in London at the time. Built in the last decades of the 18th century the building accommodated government offices, several learned societies including the Navy Office and was home to the King's Barge Master. The architect, William Chambers, had to ensure that a number of conditions were met: direct access to the River Thames for members of the Navy Board who needed to travel up to Greenwich and Deptford east along the river, as well as live-in accommodation for heads of department and other household staff. Thus was born the design of a quadrangle with separate vertical sections to cater for each department or society.

In time, the societies moved out and in 1837, the year that Queen Victoria ascended to the throne, the Office for the Register of Births, Deaths and Marriages took their

place. They remained in the building until 1970 but it took another 20 years before any major changes came about. First, the Courtauld Gallery moved into their vacated office space in the 1990s, and later other arts companies established themselves here too, enjoying the spectacular setting.

Exit through the main doorway of Somerset House onto the Strand. Turn left down the street stopping about ten metres (30 feet) on to look at:

Churches in the Strand

On islands in the middle of the road you find two churches with interesting history and architecture. Practically opposite Somerset House, **St Mary-le-Strand [8]** was built in the Baroque style by James Gibbs and was one of 50 new churches planned for London under the 1711 New Churches Act (although far fewer were ultimately built). It was Gibbs's first public building, upon which his reputation grew. It was in this church in 1809 that Charles Dickens's parents were married, and it is now the official church of the Women's Royal Naval Service.

About 100 metres (330 feet) further along the street you will see the **Church of St Clement Danes [9]**.

After the Romans left London in the 5th century, the population moved westwards to this area near Aldwych and remained there until attacked by marauding Danes in the 9th century. A peace treaty was eventually concluded between the Danes and King Alfred, and over the next couple of centuries Danes settled here, attending a church that was dedicated to St Clement (a 1st century pope who, on the order of the Roman Emperor Trajan, had been thrown into the sea, weighted down by an anchor). This lead to the church being called St Clement of the Danes, and in time to St Clement Danes. Very badly damaged in World War II, the church underwent complete restoration in the 1950s and was re-consecrated as the Central Church of the Royal Air Force.

'St Clements' may be familiar name if you know the old nursery rhyme:

'Oranges and Lemons' say the bells of St Clement's

'You owe me five farthings', say the bells of St Martin's

'When will you pay me?' say the bells of Old Bailey

'When I grow rich' say the bells of Shoreditch

'When will that be?' say the bells of Stepney

'I do not know' say the great bells of Bow

For almost 100 years, children from the local primary school have been given an orange and lemon following an annual ceremony held in March. It is mooted that this tradition refers back to a time when local youngsters were employed to unload cargoes for ships trying to avoid paying customs duty, the exotic fruit being given as a reward for their help.

Filming

Not surprisingly, many of the sites along the Strand and Fleet Street are popular with moviemakers. Somerset House in particular, has been the setting and backdrop for films such as Guy Ritchie's *Sherlock Holmes* (2009) and *The Duchess* (2008) starring Keira Knightley and Ralph Fiennes. Filming has also taken place for a number of fashion shoots such as Paul Smith and M&S. The Temple area too, with its atmospheric cobbled stones, quadrangles, gardens and Elizabethan buildings has been used in movies and TV dramas such as *Shakespeare in Love, Poirot, The Wolfman* and *The Da Vinci Code.*

Australia House [10], the building facing St Clement Danes church at the end of Aldwych, will certainly be familiar if you are a Harry Potter fan. Its wonderfully ornate hall was the setting for Gringotts Bank, the wizard's bank run by goblins, in two of the films (*Harry Potter and the Philosopher's Stone* and *Harry Potter and the Deathly Hallows Part II*). The building is, in fact, the Australian High Commission in London. If you stand outside the main entrance you may just catch sight of the interior, its hall and exquisite chandelier.

Continue along the Strand, past St Clement Danes church and then look across the road to the law courts.

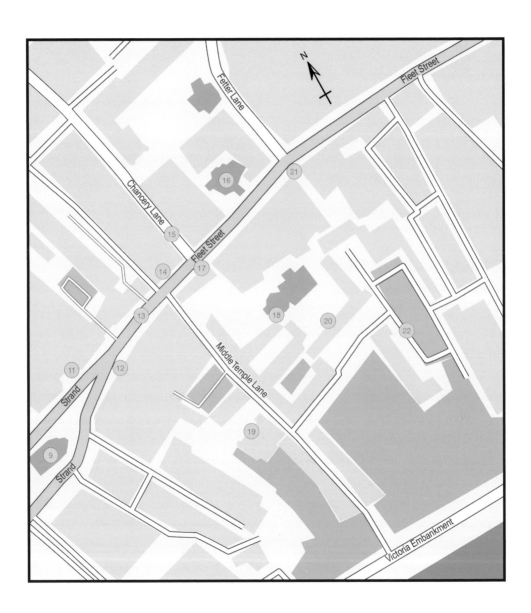

Royal Courts of Justice [11]

This building was opened by Queen Victoria in 1882 specifically to house a number of the courts that had arisen over the centuries and that had been previously scattered all across London. It meant that key civil cases (divorces, libel suits, and appeals) could be heard at one venue and gave a permanent home to the High Court of Justice and Court of Appeal. Nowadays it is also the home of the Crown Court, with its various divisions (Family, King's Bench and Chancery).

Like many public buildings of the time, its design was chosen through a competition. In this case, won by **George Edmund Street** (1824–81), whose career began in law but swiftly changed to architecture as a young man. His interest was mainly in Gothic architecture and on moving to London in 1844 he joined George Gilbert Scott's very successful practice (which was to become the largest in Europe by the middle of the century). Scott was the architect responsible for building much of Victorian London – the Foreign & Commonwealth Office, St Pancras Railway Station and Midland Hotel, the Albert Memorial, and work in Westminster Abbey. Scott himself was greatly influenced by Augustus Pugin, who had designed the Palace of Westminster with Charles Barry, and George Street, in turn, learned much from Scott in the five years he worked alongside him. On leaving the practice, Street established his own business in 1849 concentrating mainly on church design, and this accounts for why the Royal Courts of Justice, both on the outside and within, appear so ecclesiastical. The project to build the Courts began in 1867 but, sadly, Street died just before its completion and was buried in Westminster Abbey beside his mentor, George Gilbert Scott.

The building is open to the public on weekdays and it is certainly worth a visit, for its architecture and also, if you have time, to sit in on one of the many cases taking place. On entry you will go through airport-style security, and then find yourself in the main, capacious hall. Its size alone, width and height, is quite overwhelming and has the feel of the interior of a cathedral. Just as you enter you will see a noticeboard with details about the cases and location of the courts. Whichever case you sit in

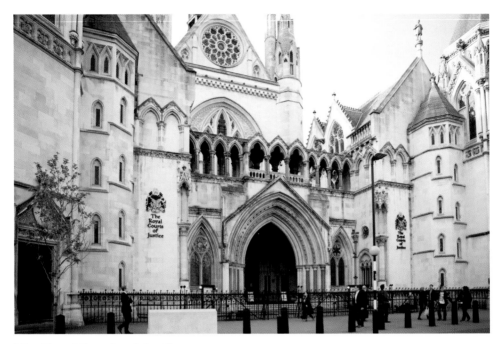

The Royal Courts of Justice

on, it is most interesting to see how British justice is carried out and to witness court procedures at first hand.

Many famous cases have been heard within the complex including the acrimonious divorce proceedings in 2008 between Sir Paul McCartney and Heather Mills. From 2001 to 2005, Catherine Zeta Jones and Michael Douglas brought several cases to the Royal Courts against *Hello* magazine for publishing unauthorized photographs of their wedding. Naturally, when the rich and famous are involved you are sure to find crowds of journalists and photographers outside the main entrance.

On the opposite side of the street you will come to a shop with a tiny frontage:

Twinings [12]

The shop claims to be the oldest London shop to be run on the same site and by the same family, as well as being the oldest taxpayer in London! It opened in 1706 as Tom's Coffee House, selling tea, coffee, brandy and spa waters at the sign of the Golden Lion in the Strand. The owner, Thomas Twining, realising the growing popularity of tea, concentrated his business on the tea trade and soon was supplying London's elite with the many varieties of the drink.

The present building is said to date back to 1787 – built by Thomas's grandson, Richard – and it was he who added the two Chinese figures either side of the lion in the pediment above the door, as a reminder of the origins of tea.

Step inside the shop today and you will be confronted with the greatest choice and number of teas; black, green, white, yellow, organic, Indian, Ceylon, fruit and

Twinings

herbal infusions, Darjeeling and rare loose-leaf teas from around the world. The tiny shop is filled with an enormous stock with staff on hand to guide you and help in your selection. It is worth keeping an eye on their website *www.twinings.co.uk* for information about the periodic Masterclasses that are run and learn all about the company's 300 years experience of tea selling and blending and why their Master Blenders are so exclusive.

Twinings marks the end of the Strand and you now move into Fleet Street.

FLEET STREET

The street's name is derived from the River Fleet, a river today that flows underground, but which was once a substantial body of water that became wider and navigable as it flowed into the Thames at Blackfriars. During Roman times it terminated in a large estuary that boasted its own tide mill, but the river today is hidden, flowing beneath Farringdon Road into the River Thames beside Blackfriars Bridge.

The street is famous for marking the division between the City of Westminster and the City of London and **Temple Bar [13]**, at its west end, is the spot that denotes where one stops and the other starts. The

Dragon on top of the Temple Bar Memorial

memorial is substantial, standing on a plinth in the center of the road, surmounted by a dragon. Beneath the dragon there are two niches; one contains a statue of Queen Victoria, the other is of her son, the Prince of Wales, later to become King Edward VII. This spot is of great significance as it is here that the monarch stops before entering the City of London. The Lord Mayor will offer the ceremonial sword to the monarch denoting the Mayor's authority within the City's precincts. This is one of Britain's many traditions and the sword is always returned.

The Street of Ink

From the early 1500s, when Wynkyn de Worde (William Caxton's apprentice) set up a printing press here, the street became home to the printing and publishing industries. The printed word in all its forms was published, from pamphlet, play and book to legal documents for the nearby Inns of Court, and in time Fleet Street became known as the 'Street of Ink'. Until the latter part of the 20th century a great number of daily newspapers, magazines and journals had their premises here and it was always an area full of great vitality, noise and energy, especially in the evening. As the newspapers rolled off the presses, they would be put on carts and trucks to be distributed around the country before morning. Journalists, printers and paper boys would all be rushing to get their work done and the street really buzzed. But after almost 500 years this changed when the new computer technology replaced the enormous printing presses and many skilled printing staff were laid off. A number of the national newspapers moved out of the area eastwards into Wapping and Canary Wharf, and many of their iconic buildings were taken over by bankers and other financial institutions. The street bustles again today and you can expect to see all types of business as well as restaurants, bars, banks, offices and shops, but only very few printing concerns remain.

Fleet Street, due to its position on the historic processional route, has always boasted a fair number of hostelries and taverns. Several still remain, providing a

necessary service to workers in the area. Interestingly, buildings that were first erected for entirely different purposes have been converted into pubs too. One such building is the Old Bank of England – just across the road and to the right of the Royal Courts of Justice.

Old Bank of England [14]

This started life as the bank for the Royal Courts and was a very ornate, distinguished structure. Dating back to the end of the 1800s, it was reinvented some years ago and converted into a highly decorated, spacious public house. It is certainly unlike most City pubs and is worth a quick look if not a stop for food and drink, just to see how a financial house can be transformed into such a magnificent watering hole!

Walk along Fleet Street, pass Temple Bar, and cross Chancery Lane.

Chancery Lane [15] has always been an important street in the City. If you walk down it you will see the former Public Records Office on the right (now, the Maughan Library, King's College London) as well as many buildings related to the legal profession, including the imposing Tudor gateway into Lincoln's Inn, one of the four Inns of Court.

A little further along Fleet Street brings you to:

St Dunstan's in the West church [16]

Established about 1000 years ago the church has been on its present site for about 180 years. Today it is both an Anglican city church and also provides regular services to the Romanian Orthodox Church, reflecting the changing nature of London's population. If you are passing by on a Wednesday lunchtime (1.15 pm), then try to

find time to listen to a recital inside and also to experience its rather unusual British and Romanian ecclesiastical interior.

Next door to the church at no. 186, is where the fictional character **Sweeney Todd** is supposed to have had his barber's shop, and this was where he killed his unsuspecting victims, pulling a lever whilst they sat in the barber's chair. Beneath the chair was a trapdoor which would open, they would fall through and either break their neck as they fell or were finished off by Sweeney with his sharp barber's razor. The gruesome story then takes another turn as Sweeney transported the dead bodies through underground passages to his friend's shop nearby. She, in turn, would use the flesh to fill her pies and then sell them from her shop!

As with Sherlock Holmes, Sweeney Todd has become rather an urban myth and from the start caught the public's imagination, yet no proof has ever been established that Todd was anything but imaginary. He first appeared in a tale entitled *The String of Pearls: A Romance* which was part of a 'penny dreadful' serialized in the 1840s. Penny dreadfuls, very popular at the time, were sensational weekly serials, printed on thin paper and aimed at the new industrial working class who could afford the penny charge. They were, in fact, a much cheaper version of what authors such as Dickens were offering around the same time, but inferior in every respect.

The appeal of Sweeney Todd has remained surprisingly robust, illustrated by the many shows and musicals that have been staged about him and his murderous acts. The Tim Burton horror-musical movie (2007), *Sweeney Todd: The Demon Barber of Fleet Street*, tells the tale all too well, with Johnny Depp and Helena Bonham Carter cast in the lead roles.

Now look across the road and you will see an unusual, half-timbered building directly in front of you.

Prince Henry's Room [17]

What you see here is very special as it is one of only a handful of houses in the City of London that survived the Great Fire of London (1666). Up until this time nearly all the buildings had been made of wood, wattle and daub. The Great Fire broke out in the early hours of 2 September after a long, hot summer, in a baker's premises on Pudding Lane close to the River Thames. These conditions, together with the effect of a strong easterly wind, meant that once the fire caught it spread at a furious rate amongst all the closely-packed buildings in narrow streets, ultimately destroying 80 per cent of London's housing stock, its halls, churches and major buildings within only a few days. Despite claims that it had once been the

Prince Henry's Room

palace of Henry VIII and Cardinal Wolsey, documentary evidence contradicts this. However, Prince Henry's Room does contain the most magnificent Jacobean plaster ceiling, certainly worthy of a royal residence. Sadly, the room is not open to the public but you can get an idea of its appearance by looking at the City of London website *www.cityoflondon.gov.uk*.

As mentioned already, the area around Fleet Street has been associated with the legal profession for many centuries. As with Lincoln's Inn to the north, land on its southern side was leased to lawyers from the mid-14th century and two of the Inns of Court, Inner and Middle Temples, are still located here today.

We are now going to cross Fleet Street and turn down the alleyway beneath Prince Henry's Rooms to see where barristers train and work.

Inns of Court and Temple Church

As you walk along the path you will see barristers' chambers (offices) on your right. Barristers, who are specialist legal advisors and court advocates, are often freelance practitioners, but will generally belong to a set of Chambers. It is common for them to obtain work through the Barrister's Clerk, the main administrator, who coordinates the Chambers' workload and has both financial and marketing responsibilities. Beside the doorways there are noticeboards containing the names of the members of the chambers and include both barristers and the more senior Queen's Counsel (QCs).

As the path peters out you will see on the left the west entrance to **Temple Church [18]**, notable for its 12th century Norman, highly decorated, dog-tooth carved design. The church owes its origins to the Knights Templar, who had their headquarters here almost a thousand years ago. It was they who built the church, based on the round church of the Holy Sepulchre in Jerusalem. These knights took vows of chastity, obedience and poverty and it was their role to protect and look after pilgrims on their journey to the Holy Land. They were, in fact, soldier monks, and were present in many European capitals, raising monies for their work. The Pope, however, abolished the Order in 1312 and passed their estates to another Order, the Knights Hospitaller of St John of Jerusalem. As these knights were already well established and owned much land, they chose to lease the buildings to lawyers, who were eager to find accommodation close to the royal courts at Westminster Hall. They subsequently became known as Inner and Middle Temple. These two Inns of Court have remained on the site, each with their own campuses, similar to those found in the university cities of Oxford and Cambridge.

Each Inn has its own dining hall, chapel, library, quadrangle, gardens and chambers, the latter originally used for boarding. The Inns are easily recognized by their symbols; the Lamb with a Staff for Middle Temple, and Winged Pegasus for Inner Temple, which are found on drainpipes, railings, above doorways, outside chambers and on all their main buildings and external furniture.

The Inns share Temple Church as their chapel and members of Inner Temple will

sit on the south side, whilst the north side is occupied by members of Middle Temple. The church itself is a Royal Peculiar and is led by a Master who is officially appointed by the Queen (although she devolves the oversight to the Dean of the Chapels Royal, presently the Bishop of London). The church is especially famous for its excellent music and runs a program of free lunchtime organ recitals on Wednesdays, which are always very popular. Refer to *www.templechurch.com* for further details.

If you are standing with your back to the church and turn right through the cloisters you enter the grounds of **Middle Temple**. Pass through Pump Court, across Middle Temple Lane into Fountain Court. The building on your left is **Middle Temple Hall [19]** and opens to visitors in the morning between 9.30 am and midday. The Hall was built more than 450 years ago and is quite magnificent. With one of the most spectacular double hammer-beam roofs in the country, it is here that dining, training and entertainment takes place. Not only have trainee lawyers conducted debates within its confines, but plays and pageants been performed throughout its lifetime. It is particularly noted as being the venue for the first ever performance of Shakespeare's *Twelfth Night* in 1602.

Just beside the Hall and sloping down towards the River Thames are some very beautiful gardens that are open to visitors on weekdays between 12.30 pm and 3 pm. It was in these gardens that Shakespeare professes (in Henry IV, Part II) that a white and red rose were plucked by representatives of the House of York and Lancaster, pronouncing the beginning of the War of the Roses (1455–87).

If you retrace your steps back to Temple Church you will see the Hall of **Inner Temple [20]** on the right opposite the church. Unlike its counterpart, it is quite modern, as it was rebuilt following World War II bomb damage. Although not usually open to the public, you might get to see inside if you visit in mid-September during the London Open House weekend (*www.openhouselondon.org.uk*).

This is a wonderful time to be in London as many buildings, some governmental, others private, will open their doors (free) to the public and may well offer tours as well. The only drawback can be the length of queues, but come well prepared with

Fountain Court in Middle Temple

food and drink, and you will get to see some amazing artwork and architecture, ancient and modern.

Leave Temple Court via the archway. In front of you is a courtyard and you will shortly turn left to exit the Temple precincts via **Old Mitre Buildings [21]** to Fleet Street. Before doing so you might like to take a slight detour along **King's Bench Walk [22]** which stretches down towards the river. Here you will see ex-Labour Prime Minister, Tony Blair's name written on the board outside no.11. Before turning to politics he was a barrister and member of the Inner Temple working from these Chambers. You can also see another famous name: Lord Irvine of Lairg, the Lord Chancellor in Blair's government, who had introduced Cherie to Tony when they were both pupil barristers. On giving a speech at their wedding he later referred to himself as 'Cupid QC'!

Note: On weekends you will need to exit through the gates on the right at Tudor Street, but at all other times you should leave via Old Mitre Buildings that are straight ahead of you.

Pubs and Architecture

Due to centuries' use as a ceremonial route and also because of its newspaper history, Fleet Street has always been full of taverns and inns. Writers, newspapermen and journalists have all frequented these ale-houses, and even though the clientele may have changed, the pubs are always lively and full of customers. Starting from the western part of the street you will come across The George, Ye Old Cock Tavern, El Vino, The Tipperary, and Punch, and all are worth a visit. The oldest pub is Ye Olde Cheshire Cheese, at no. 145, which has been in its present building for more than 350 years. It is famous for being the meeting place of writers such as Charles Dickens, Samuel Johnson, Mark Twain, Oliver Goldsmith, Sir Arthur Conan Doyle, and P.G. Wodehouse. Inside, it is very cosy consisting of a real warren of wood-paneled rooms located on several different floors. It is wonderful to spend some time here in its somewhat gloomy interior and imagine conversations that might have taken place throughout its lifetime.

In earlier times Fleet Street would have had many small buildings along its length but this has largely changed since the 20th century. Devastation caused in two world wars meant that many of its former buildings were lost and nowadays it tends to be dominated by large blocks of offices, occasionally interspersed with a hotel or two, shops, cafés and restaurants. When it functioned as the 'Street of Ink' the buildings were mainly associated with the print industry and housed national newspapers. Sadly, not much evidence of its past remains though you will still see some signs advertising daily or national newspapers on the sides and frontages of a few buildings close to St Dunstan-in-the-West.

Two buildings of note built in the late 1920s and early 1930s for *The Daily*

Telegraph and *Daily Express* are found towards Ludgate Circus at the eastern end of the street. The former, is somewhat Egyptian in appearance, a solid white Portland stone building with six huge fluted columns separated by windows. It is a complete contrast to the nearby *Daily Express* building that has a curved façade and is made of black glass and chrome. This building was constructed for Lord Beaverbrook, the press mogul, when the *Express* was the greatest selling global newspaper. Like its neighbor, it contained both the industrial printing presses as well as offices of the newspaper editorial staff. What remains quite remarkable here is the entrance hall: entirely decked out in Art Deco style with no expense spared. With its cantilevered staircase, chrome handrails designed as twisted snakes and wall sculptures it is quite exceptional. Unfortunately, it is not generally open to the public, but if you are passing, you might get a glimpse through the doorway and see its splendid interior.

Almost opposite the *Daily Express* premises you will see a gap between two buildings. If you look up you will see the spire of St Bride's church, Wren's tallest steeple when built in the early 18th century.

St Bride's Church and Foundation [23]

The church you are looking at is the eighth built on this site and is dedicated to St Bride, a 5th century Irish saint who was renowned for her warmth, hospitality and generosity. Quite understandably it is referred to as the 'Journalists' church'. This however is not a recent nickname, but has its roots back in the 1500s when William Caxton's assistant, Wynkyn de Worde set up his printing press here and made St Bride's his

St Bride's
Church steeple

119

focal point of print. Nowadays the church is the venue for many weddings, baptisms, funerals and memorial services for people working in journalism and the media.

St Bride's is particularly famed for its unusual shaped steeple with its four, octagonal, reducing tiers. In the 18th century a local baker's apprentice, Thomas Rich, used it as his inspiration to create a wedding cake when he married his boss's daughter. It was an immediate success and the style has been in use ever since!

The church was rebuilt after the Great Fire of London and Christopher Wren added a very graceful and tall steeple (71 metres/234 feet). When it was struck by lightning in 1764 the decision was made to put up a lightning conductor. The ensuing debate revolved around whether it should have a blunt or sharp end. Benjamin Franklin, the American printer, scientist, and diplomat, who had invented the device, preferred a sharp end but the king, George III, favored a blunt end. The two men almost fell out over the matter, but in the end the king conceded to Franklin's demands. People joked that the 'blunt, honest King George had given way to the 'sharp-witted American'!

Franklin is not the only American association with the church. The parents of Virginia Dare, the first English child to be born in North Carolina in 1587, were married at the church, and Virginia's grandfather, John White became the Governor of Roanoke colony. One of the Pilgrim Fathers, Edward Winslow had been a parishioner here and both he and his parents married at St Bride's. In 1620 he sailed on the Mayflower and later became Governor of Plymouth, Massachusetts. You can see a memorial to the Pilgrim Fathers located by the reredos.

Downstairs in the crypt you will find a Roman pavement, and remains of churches from the Saxon and Norman periods. There are also other relics found in the Fleet Street area on display here.

Exit the church and turn right through the churchyard. Descend the stairs.

City of London Distillery and bar, 22–24 Bride Lane [24]

Down a flight of stairs, just behind a green door in Bride Lane, a small distillery opened up in a basement in 2012, the first for nearly 200 years in the City of London. It is not greatly advertised so you will need to look out for the green door and a small sign bearing its name. At the bottom of the stairs directly in front of you is a long bar filled with an enormous variety of bottles of gin (over 200 types), a seating area and two copper stills positioned behind a glass case. The Distillery functions both as a bar and as a producer of London Dry Gin. It runs tours at midday on Wednesday and Friday where you can learn about the art of gin making, and find out about the flavors, the 'botanicals' added (such as liquorice and coriander seeds, and fresh citrus) to give it its distinctive taste. You will also be offered a sample of its gin at the end of the tour. If you are interested in making your own tipple then the Distillery also runs a Gin Lab experience where you design and distil your own bottle of gin.

City of London Distillery

Refer to the website: *www.cityoflondondistillery.com* for prices and further details about this and other events/courses available.

Blackfriars underground station *(Circle, District lines)* is a few minutes walk away on New Bridge Street.

ENVIRONS OF STRAND & FLEET STREET:

LUDGATE HILL & ST PAUL'S CATHEDRAL

Fleet Street ends at Ludgate Circus, a junction of four roads, and turns into **Ludgate Hill** on the other side of the circus. It is indeed a hill, albeit with a gentle gradient, and many of its buildings date from the 20th century as the area was practically razed to the ground during World War II. Amazingly, its largest and best known building, **St Paul's Cathedral [25]**, remained standing and escaped major damage, and so the Cathedral that looms up in front of you is very much as it was when first built in 1710.

The fifth cathedral on the site, the current St Paul's was built in the aftermath of the Great Fire and took only 35 years to complete, during the reigns of five monarchs. Sir Christopher Wren was its architect and he, together with a team of excellent craftsmen (Grinling Gibbons, Jean Tijou, the Strong brothers) were responsible for its design, and outstanding stone, wood and iron work, both in the interior and exterior of the building. Initially, very plain inside, with clear windows and no memorials, it changed in time, and now has some very colorful mosaics under the Dome and in the Choir areas and stained glass windows have been introduced since World War II in the American Chapel behind the Altar. Most of the memorials are found down in the Crypt along with the tombs of Sir Christopher Wren, and 19th century naval and military heroes, Admiral Nelson and the Duke of Wellington.

To get a wonderful view of the city skyline it is worth the 528-step climb up to the Golden Gallery outside the Dome at its apex. Or for an unusual experience visit the

St Paul's Cathedral

Whispering Gallery lower down the Dome. Here, due to its construction, a whisper can be easily heard from one side of the Gallery to the other.

St Paul's is often referred to as 'The Nation's Church', for it is here that Services of Thanksgiving and Memorial take place, as well as State and ceremonial funerals, such as Winston Churchill in 1965 and Baroness Thatcher (former Conservative Prime Minister) in 2013.

Most royal weddings take place at Westminster Abbey although the marriage of the Prince of Wales to Lady Diana Spencer was held here in 1981, breaking that tradition!

Visitors are welcome Monday to Saturday and sightseeing tickets are available on the cathedral website. Services take place daily and all are welcome.

The closest tube station is **St Paul's *(Central line)*.**

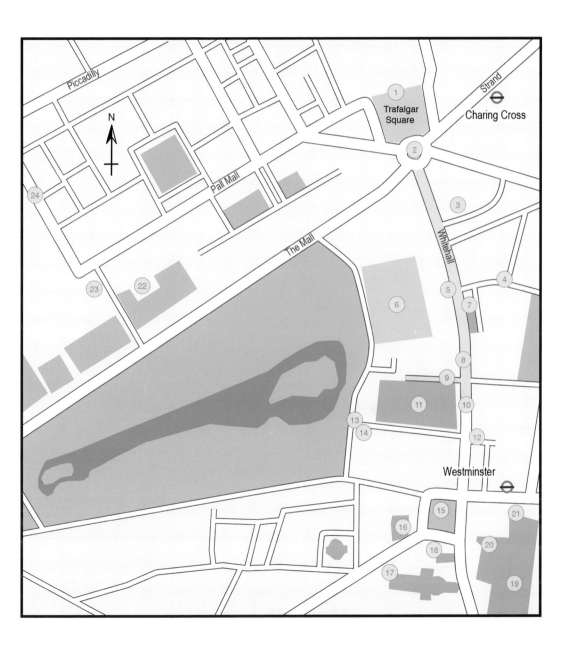

WHITEHALL & DOWNING STREET

This walk begins on the north terrace **[1]** of Trafalgar Square immediately in front of the National Gallery. The terrace is a wonderful location to view Whitehall and offers excellent views of Big Ben and the Elizabeth Tower.

The closest tube stations are **Charing Cross** *(Northern, Bakerloo lines)* and **Embankment** *(Northern, Bakerloo, Circle, District lines).*

TRAFALGAR SQUARE

At the north end of Whitehall is one of London's most well known squares, which has been the scene of many gatherings throughout its history. Framed by the National Gallery on its northern side and with Nelson's column in the center, it is a most imposing space. Like Leicester Square and Piccadilly, Trafalgar Square is a meeting place, not only because of its size but because of its location too, on the edge of Whitehall and Westminster, and yet central to the West End.

Trafalgar Square was built on the site of the former Royal Mews, where until the early 19th century, the king's horses were stabled. John Nash, the man responsible for creating Regent Street, was the original designer of the square (which underwent further development in the 1840s by Charles Barry). The Square was named after the victorious 1805 Battle of Trafalgar, where Admiral Horatio Nelson died when fighting against Napoleon and his men. All around the Square are memorials to generals and British monarchs and you will see that the fourth plinth on the north-west side displays contemporary artworks, often controversial but always interesting.

Trafalgar Square not only hosts political meetings but is also the venue for live concerts, the St Patrick's Day parade and festival, Pride London, Chinese New Year and Christmas and New Year's Eve festivities. On the Square's east side is the imposing St Martin-in-the-Fields church, today renowned for its work with the homeless and the local Chinese community. It is also a wonderful place to attend a concert (lunchtime or

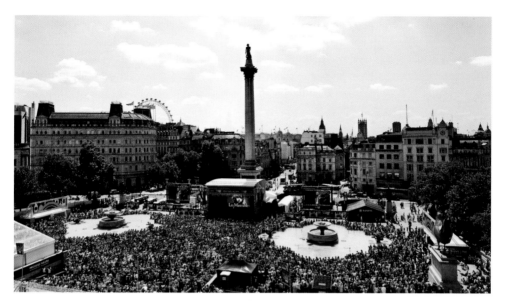

West End Live Festival 2015, Trafalgar Square

evening) or to eat in its atmospheric and well-priced Café in the Crypt.

As you leave the Square towards Whitehall you will see a traffic island with an equestrian statue of **King Charles I [2]** facing towards Westminster. He was the only English monarch to have been beheaded and it seems somewhat ironic that his statue faces towards Westminster and Parliament where the order for his execution was signed. Just by his statue, look out for a floor plaque. This measures road signage distances from the center of London (Charing Cross) to the rest of the country.

If you happen to be visiting London on 1 January it is worth making your way to the area to see the free New Year's Day Parade, which involves over 8000 performers from many of the London boroughs and countries of the world. It is a wonderful winter entertainment with large themed floats, cheerleaders, dancing, musicians and classic cars and vehicles. It is the most colorful affair and each year the crowds grow along the route. Starting about midday in Piccadilly, the parade makes its way down through Regent Street, Waterloo Place, Pall Mall to Trafalgar Square and then along Whitehall.

West End Live Festival 2015, Trafalgar Square

Now cross over from the island into Whitehall.

WHITEHALL

Whitehall today is the street connecting two important squares: Trafalgar and Parliament, and is regarded as the main home of government ministries and administration. Its name is derived from Whitehall Palace, which was the main royal London residence for English monarchs from the 1530s until the late 17th century. In

Tudor times, when King Henry VIII was on the throne, the palace was an enormous sprawling affair, practically a city in its own right, and boasted magnificent recreational facilities. There were indoor tennis courts, a jousting tiltyard, a cockpit and even a bowling green. It was the largest palace in Europe, even larger than Versailles, with over 1500 rooms spread over 9.3 hectares (23 acres) and full of buildings of every architectural style.

View down Whitehall from Trafalgar Square

Sadly, very little remains of Whitehall Palace today, although Horse Guards parade now sits on the site of the tiltyard and some of the indoor tennis courts remain beneath the Old Treasury and Cabinet Office at 70 Whitehall. There is one sole surviving building however; the Banqueting House, dating from 1622 (opposite Horse Guards), but more of that a little later in our tour.

The street nowadays is mainly lined with government offices such as the Admiralty, Ministry of Defence, Department of Energy and Climate Change, Scotland and Wales Offices, as well as the Ministry of Health, Treasury and Foreign & Commonwealth Office (FCO). Downing Street, home to the Prime Minister, radiates off Whitehall and is easily identified by the heavy black gates and police that protect it.

Walking on the left side of the street turn into:

GREAT SCOTLAND YARD [3]

This street originally was part of the Palace and was said to be where the kings and nobles of Scotland stayed in London. Comprised of Middle and Little Scotland Yard, this was home to the very first headquarters of the Metropolitan Police when the force was established in 1829. The term 'Scotland Yard' ultimately became used to describe the top detectives that worked for the police, and remains so today. As a matter of interest, the Metropolitan police moved from this building in 1884 to New Scotland Yard along the Victoria Embankment, then left these premises in 1967 and moved to offices in Victoria. Once again the force is on the move, its present building has just been sold for £370 million, and Scotland Yard is due to return to its previous roots on the Embankment in late 2016.

Return to Whitehall, walk along the street until you reach Horse Guards Avenue. Turn left and walk up to the Gurkha Memorial.

Gurkha Memorial [4]

This bronze memorial was erected in 1997 in the presence of the Queen to commemorate the contribution of the Gurkha soldiers who have fought alongside the British Army in both World Wars as well in Afghanistan, the Balkans and Iraq.

The statue, of a Gurkha dressed in World War I uniform, was the work of Philip Jackson and modeled on Reginald Goulden's 1924 memorial on display in Nepal. The following words are written on the front of the plinth: 'The Gurkha soldier/ Bravest of the brave/ Most generous/Never had country/More faithful friends/than you' (Professor Sir Ralph Turner MC).

Gurkha soldiers first served with the East India Company in 1815 (the time of the Nepalese war), then when the Company's army became the Indian Army, they were retained as members of that army. After India's partition in 1947 four regiments remained in the British army and have served with British troops ever since.

Gurkha Statue

Now turn back towards Whitehall and stop to look across the road at:

Horse Guards [5]

Easy to spot as the building is guarded by troops of the Household Cavalry: Blues and Royals in blue, Life Guards in red. Each day between 10 am and 4 pm two mounted cavalry troopers are posted outside astride their horses in sentry boxes and tourists flock to have their photos taken beside them! For those who enjoy pageantry there is

a Changing of the Guard ceremony each day at 10.30 am Monday to Saturday, and an hour earlier on Sunday.

Before you cross Whitehall to join the throngs of visitors, take a look at the building itself. Designed by architects John Vardy and William Kent it was constructed in the mid-18th century in the Palladian style of architecture that was extremely fashionable at the time. Its initial purpose was to house the British Army's general staff and included the offices of the Commander-in-Chief. An incumbent of this role on two occasions, 1827–28 and 1842–1852, was military hero and former Prime Minister, Arthur Wellesley, 1st Duke of Wellington. If you happen to be in London in September you will be able to visit his office (still with the same desk in it) when the building is open to the public during the annual London Open House weekend.

Nowadays the building acts as the headquarters of two major army commands: the London District and the Household Cavalry. Although you are permitted to walk through its main entrance gates, no-one apart from Her Majesty the Queen and her entourage drives through here. The entranceway is still considered to be the formal entrance into Buckingham Palace and St James's Palace, which were not accessible from any other road until Trafalgar Square was built in the 1840s.

Now cross the main road over to Horse Guards. Walk past the sentries and through the gateway, under the main building, and emerge on to:

HORSE GUARDS PARADE [6]

Built as the tiltyard of Whitehall Palace, this was where in the Elizabethan age the Queen's annual birthday celebrations were held with extravagant jousting tournaments. Similarly, today the parade ground is used on the Queen's official birthday in June for Trooping the Colour as well as for the Beating Retreat military ceremony, both wonderful displays of pageantry, precision drill and military music.

The parade ground is central London's largest open space and might appear

familiar if you watched the beach volleyball matches during the 2012 London Olympics. The area was transformed for the occasion: tons of sand were delivered, courts created and seating for a crowd of 15,000 erected.

An interesting and perhaps surprising fact is that the parade ground was used by senior civil servants as a car park in the latter part of the 20th century when not being used for ceremonial purposes. Considered to be a perk of the job it was said that the employees were not pleased when the ground was resurfaced in 1996 and the practice discontinued.

Retrace your steps, exit through the gateway and turn right. Stop a few metres along and look directly across the street.

Banqueting House [7]

This was the first building to be built in central London in the Palladian style, the work of architect, **Inigo Jones.** Although from fairly humble beginnings Jones lived and studied in Italy in the early years of the 17th century and was very much influenced by the buildings he encountered on his travels there, especially the work of Andrea Palladio. It was Palladio's style of white, symmetrical buildings, which were so solid and well-proportioned, that captured his imagination and was to influence his design of buildings when he was appointed Surveyor of the King's Works to King James I in 1613. It was a design that so contrasted with the Tudor, red-brick buildings that it seemed quite revolutionary at the time, rather like the Shard, Walkie-Talkie and the Gherkin might be considered today.

Jones began work on the Banqueting House in 1619. Despite being part of Whitehall Palace it was quite separate from the other buildings around it, common at the time as such buildings were used entirely for entertainment and were always isolated. Built as an enormous two-storey, double-cube single room, it lent itself to being used for ceremonies, masques (a form of play in Tudor and Stuart times)

and royal receptions, yet the building was without a kitchen and no food was prepared on the premises.

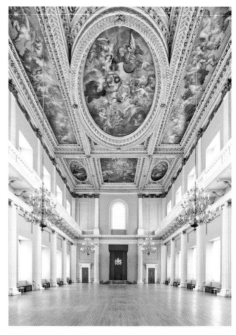

However, the room was far from plain with the most exquisite decorated ceiling panels, the work of the celebrated artist, Sir Peter Paul Rubens. These paintings, completed in 1635, extolling King James I and Stuart rule, were commissioned by King Charles I. It is therefore somewhat ironic then that he was to lose his head just outside this very building in 1649.

Here, on the 30 January 1649, King Charles I walked through the Banqueting House beneath paintings that highlighted the success and might of the Stuart kings, through a window onto the scaffold

Inside the Banqueting House

erected in the street. The King, courageous to the end, gave a brief speech then placed his head on the scaffold. Once beheaded, his head was shown to the crowd to prove that the execution had been carried out. Not only were the public shocked by the act but people throughout Europe were astonished that a king, and one that had been 'chosen by God' to reign, should be accused of treason and be executed.

Today, you can still see a bust of King Charles I in a niche just outside the main entrance into the Banqueting House. There is also a painting of him by Daniel Mytens above the grand staircase leading into the Hall. When you enter the building you might be surprised at the lack of furniture but the hall's sheer size and decoration is certain to fill you with awe. As will the fact that it was the only building to survive the fire that destroyed the entire Palace of Whitehall in 1698!

Although owned by the Crown, the Banqueting House is managed by Historic

Royal Palaces (HRP), which is also responsible for the operation and upkeep of Hampton Court Palace, the Tower of London, Kensington Palace and Kew Palace. A charity, HRP relies upon public donations and entrance fees, as well as monies earned from hiring out their venues – in this case, the magnificent Main Hall and stunning, vaulted Undercroft.

Continue walking down the street and in the middle of the road you will see a black, rectangular monument.

Monument to the Women of World War II [8]

This memorial, conceived in 1997 by a retired war general, was erected in Whitehall to remember the Women of World War II. The work of the sculptor, John Mills, it both commemorates and honors the essential work carried out by women in the period 1939–1945: in emergency services, hospitals, the military, manufacturing and on the land. Look closely and you will see their clothing and uniforms hanging on each side of the Memorial. At the time, women had to take over jobs formerly done by men and often work that they would not have been permitted to do prior to the war. They became involved in driving public vehicles, ambulances and growing food. Some were employed in the arms and ship industries whilst others went down the coalmines or were involved in maintaining crucial services.

Her Majesty the Queen unveiled the memorial 60 years after the end of World War II, in 2005. Funding was obtained through the National Heritage Memorial Fund, through the activities of Baroness Boothroyd (former Speaker of the House of Commons) who managed to raise £800,000 when she took part in the TV show *Who Wants To Be A Millionaire?* in 2002, and by the charity, Memorial to the Women of WWII Fund.

Just a bit further along you will come to some black gates. These are the entrance to:

DOWNING STREET [9]

Probably one of London's best-known streets, and certainly one which has an international reputation, Downing Street has been the home and office of British Prime Ministers since the 1730s when George II offered it to Sir Robert Walpole, the First Lord of the Treasury (a position more commonly known as Prime Minister today). At the time, Walpole accepted the house for his office but not for his personal use. Since then a great number of Prime Ministers have moved in to 10 Downing Street with their families during their term of office. It is in fact quite deceptive a building and is much larger inside than it appears from the outside, full of offices, dining rooms and larger 'State' reception rooms accommodating meetings, parties, visits from dignitaries, heads of state, royalty and Cabinet meetings. Although not open to the public, it is possible to gain an idea of the interior by looking on the government website *www.gov.uk*, where you can take a tour of the building. Since the latter part of the 20th century, the street has been protected by large black steel gates and armed police and with the move to increased security, visitors are vetted before entry is permitted.

The street itself was built over 300 years ago as a cul-de-sac, and the houses were cheaply built on boggy land. As a result, not all stood the test of time. Those that did underwent several reincarnations and today only a few of the original houses remain on the north side, the south side having been demolished and replaced by the Foreign & Commonwealth office in the 19th century. No. 10 remains the office and home of the Prime Minister, and no. 11, that of the Chancellor of the Exchequer, the Second Lord of the Treasury. No. 9 accommodates the Chief Whip's Office whilst no. 12 houses the Prime Minister's Press Office, Strategic Communications Unit and Information and Research Unit. Both Tony Blair and David Cameron, whilst serving terms as Prime Minister, swapped homes with their Chancellors, as accommodation in no. 11 was more spacious and suitable for their large and growing families.

George Downing (1623–84), after whom the street is named, and who was responsible for the housing development, was a most interesting character. A Harvard graduate, sometime spymaster and diplomat, he was a man who saw and took a

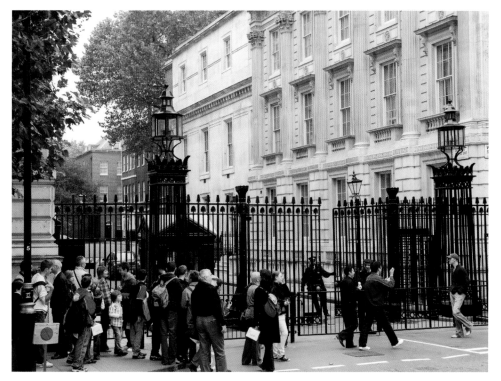

The entrance to Downing Street

chance, and in the turbulent years of the mid-1600s served both the parliamentarians and later, the restored monarch, King Charles II. He received his baronetcy from the King, probably as a reward for his spying activities, and was quick to see the benefits of moving into the property market. As he was inclined to be miserly and keen to maximize the profit from his development, the foundations were poor and the majority of his buildings did not stand the test of time.

In the early 1760s, James Boswell, biographer to Dr Samuel Johnson lodged in the street. His accounts of his time in residence can be found in his *London Journal*, personal recollections comparable to *The Diary of Samuel Pepys* a century earlier. Another notable resident was the Scottish novelist, Tobias Smollett (1721–71), and

George 'Beau' Brummell – great dandy and fashion trendsetter of Georgian society was born here in 1778 when his father was then the private secretary to Lord North (See **Jermyn Street** section in Chapter 6).

The Cenotaph [10]

Continue walking along Whitehall and you will notice an imposing white, Portland stone memorial in the middle of the street. The work of Edwin Lutyens, The Cenotaph is a war memorial to British and Commonwealth military and civilian men and women who died in conflicts around the world and was erected here in 1920. Its name is derived from the Greek – *Kenos* (empty) and *Taphos* (tomb).

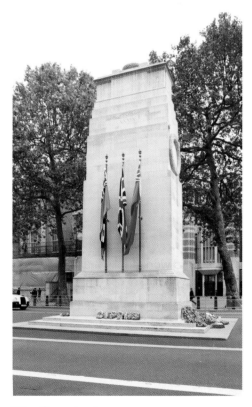

It is probably one of the country's most notable memorials as each year a Remembrance Day ceremony takes place here commemorating and honoring the war dead. A service takes place at 11 am on the Sunday nearest to 11 November and begins with a two-minute silence followed by the firing of guns on Horse Guards Parade. All members of the Royal Family, High Commissioners of Commonwealth countries, politicians, war veterans and members of the armed forces take part in the proceedings and Her Majesty the Queen is the first to set down a wreath of red poppies in front of the Cenotaph. After the wreaths have

The Cenotaph

been placed there is a short religious service, followed by a march-past organized by the Royal British Legion, including both cadets and veterans. Military bands play both before and after the ceremony and the occasion, although somber, is always very moving.

Foreign & Commonwealth Office [11]

Immediately opposite the Cenotaph and just a little further along the street, built in Portland stone, is the rather grand, imperial looking Foreign & Commonwealth Office (FCO). Originally built as the Home, Colonial, Foreign and India Offices by the architect, George Gilbert Scott, this Italianate building is decidedly different to the gothic style St Pancras station hotel which he designed at around the same time.

Unless you happen to work for the FCO it is unlikely that you will be able to see its extremely luxurious interior, mainly the work of Scott's partner, Matthew Digby Wyatt. However, if you visit in September you might gain access during the annual London Open House weekend.

To say the interior is grand is an understatement. It has the feel of a very opulent Italian palace, built to impress visitors, and with the distinct intention of highlighting Britain's might and influence at a time when the British Empire was at its height. The building is renowned for its lofty, domed Grand Staircase, its Corinthian columns, galleries and balconies, as well as Wyatt's masterpiece in the India Office, Durbar Court. With marble flooring and Doric, Ionic and Corinthian columns on its four sides, the Court is wonderfully majestic and must have been the most fitting venue for the 1867 reception for the Sultan of Turkey.

By the mid-20th century, after many years of neglect, this lovely complex of buildings almost disappeared when a plan was proposed to replace it with new offices. Fortunately, the monies needed were not forthcoming and there was great opposition to the idea, culminating in the FCO being given Grade I listed building status, and necessitating its complete restoration. Work was carried out throughout the 1980s and 1990s to bring the fabulous rooms back to their former glory.

Just before you move along the street, look across the road to a pub, the Red Lion (easy to see because of the Red Lion at the top of the front façade).

Red Lion public house [12]

This pub, being so very close to Parliament, is one frequented not only by tourists but also by politicians from every political party. As it is located close to both Downing Street and the Palace of Westminster, it naturally attracts those that work in those buildings as well as lobbyists and media staff and people employed in the nearby government offices such as the Ministry of Health, the Treasury and FCO.

There has been a pub on this site since the 1430s, when it was known as the Hopping Hall. By the 19th century it had changed its name to the Red Lion, when Charles Dickens was known to have been one of its customers.

Over the years it has served many British Prime Ministers including Sir Winston Churchill, Clement Atlee and Edward Heath and even today you may well catch sight of an MP or two chatting over a beer or grabbing a quick bite to eat before the Division Bell forces their return to the House of Commons to vote. The pub, because it is so close to Parliament, is one of several such establishments, restaurants and clubs in Westminster that has a Division Bell fitted on the premises. This is rung eight minutes before a vote is due to be taken in either the House of Commons or House of Lords and alerts the Members of the Houses within the pub that they need to return to Parliament and get to their respective Division Lobby in time to place their vote.

The Red Lion is larger than it first appears, with a cellar bar and an upstairs dining room, and has some attractive 19th century features with etched glass, mirrors and a long, mahogany bar, all reminiscent of bars of the Victorian era.

Now, turn right and walk to the end of King Charles Street and descend the stairs past the statue of Clive of India. To your right is a curved wall memorial:

Memorial to Bali bombings [13]

This striking globe, fashioned in granite, is carved with 202 doves and represents those who died in the 2002 Indonesian terrorist bombings in Kuta on the island of Bali. Twenty-eight of them were Britons, but the names and ages of all the victims are recorded on the curved stone wall beside the globe. The Memorial was placed here beside the FCO four years after the tragedy, in 2006. The inscription reads: 'You were robbed of life. Your spirit enriches ours.'

Turn towards the stairs and you will see the Churchill War Rooms on your right.

This is both a major part of London's heritage as well as a museum about Sir Winston Churchill. It is open daily and an admission fee is charged.

Churchill War Rooms [14]

Nowhere else in central London are you able to experience how senior politicians and aides lived and worked during World War II. For the War Rooms are a suite of 'emergency' underground rooms specifically built in the late 1930s to house the Prime Minister, his staff, the Cabinet and the military Chiefs of Staff to provide them with protection from air attack if and when war broke out.

The Cabinet War Rooms, as they were known, was where the War Cabinet convened during air raids, and was only fully functional one week before war was declared in September 1939. It was made up of a number of rooms accommodating several hundred people: sleeping quarters, offices, meeting rooms and kitchens. The 'Map Room', manned 24/7 and the hub of the military strategists, was the major operational room in the bunker and has now been restored to its wartime appearance. It was here that Churchill spent many of his hours underground and it remained as such until late summer 1945 when the bunker was closed and deserted following the cessation of war. The room remains as it was then with charts, notices and books all in the identical position.

Other important rooms in the underground HQ are the Cabinet Room, where Churchill's War Cabinet met over 100 times, the Transatlantic Telephone Room (with its direct telephone hotline to the White House), and the Prime Minister's office. It was in this small room, a converted broom cupboard, that Churchill made some of his broadcasts to the nation, worked, met Heads of State, and very occasionally slept.

Elsewhere in the basement in the Churchill Museum you will be able to find out more about Churchill's long and very full life, his strengths and weaknesses, his relationship with his wife Clementine (through their correspondence), and hear audio recordings of his wartime speeches. You can even see his iconic cigar, bow tie and other paraphernalia on display.

The museum is a real biographical gem and full of multimedia and interactive

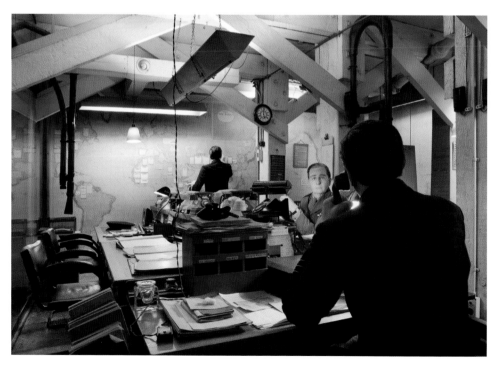

Churchill War Rooms

displays. Its pièce de résistance is the 'Lifeline' interactive table – an amazingly long, 15-metre (50 feet) table that dominates the entire space and contains data about every month of Churchill's life. It is laid out as a long filing cabinet and when you touch a date you gain access to papers, documents, images and materials, which is both fascinating and also highly illuminating about the man and his life.

Exit the museum and turn left. Walk along Horse Guards Road turning left at the junction into Great George Street and then Parliament Square.

PARLIAMENT SQUARE [15]

Not a street, but you cannot leave the area without visiting what is possibly London's most iconic square. Parliament Square itself is an island and is surrounded by political, religious and legal buildings. Each has played and continues to play a major part in the British way of life: royal coronations, weddings and funerals are held at Westminster Abbey on the south side; the final court of Appeal, the Supreme Court, is on its west side; the Palace of Westminster, the home of British Parliament, is on the east side.

Walking around the Square is a bit like studying Britain's history with memorials of English Prime Ministers such as Lord Palmerston and Benjamin Disraeli, as well as statues of Mahatma Gandhi, Nelson Mandela, Winston Churchill, Jan Smuts and Abraham Lincoln.

On its western edge is the **Supreme Court [16]**. Established in 2009, it is the highest court in the United Kingdom and the final court of appeal for all UK civil cases, and criminal cases from England, Wales and Northern Ireland. Previously, the Law Lords (Lords of Appeal in Ordinary) sat in the House of Lords, but the creation of the new Supreme Court ensured that the most senior judges are now entirely separate from the Parliamentary process.

The façade of the building is a delight to look at with its stone carvings and friezes. Look carefully and you will see three separate narratives (the work of Henry Fehr in

the early 20th century). The first on the left shows Lady Jane Grey, the nine-day queen being offered the English crown in 1553. In the middle you see Henry III granting Westminster Abbey its Charter in the 13th century (Henry was responsible for a huge building project of the Abbey during his reign), whilst the panel on the right shows King John granting the Magna Carta in 1215.

The building is open to the public weekdays (9.30 am–4.30 pm) and visitors can observe cases in the public galleries when the courts are in session. Guided tours are given most Fridays during the year as well as in the summer months during the Court recess, for which a small charge is made. Details of this can be found on the website *www.supremecourt.uk*.

Just across the street from the Supreme Court is **Westminster Abbey [17]**, officially, the Collegiate Church of St Peter at Westminster. Today, it is probably best known as the setting of the marriage of Prince William to Catherine Middleton in April

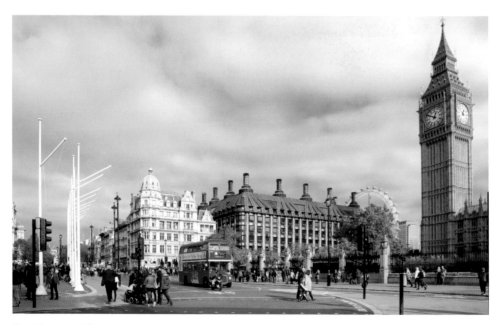

Parliament Square

2011, yet it has always been the venue for royal celebrations and coronations. Both the Queen's wedding to Prince Philip in 1947 and her coronation ceremony in 1953 took place within the Abbey, and two of her children were married here too. It is also the resting home of many royal personages. In fact, 14 queens and 13 kings are buried here, although in recent years royalty have had their funeral services in the Abbey and burials have taken place at Windsor.

The Abbey, was founded almost 1000 years ago by Edward the Confessor, England's king from 1042 to 1066. It was initially part of a monastery, built on a boggy area of land known as Thorney Island. The extremely devout Edward wanted to live near to the Abbey and oversee the church as it was being built, which accounts for the close proximity of the Palace of Westminster. It was here that the king not only resided but also met with his nobles and advisors. In time the Palace grew into the seat of Parliament, the site of the Law Courts and home to the Administration. As we have seen on this walk, the Administration is largely in the area around the Palace today, and although many of the Law Courts have moved further east, Parliament has remained in Westminster, in the very heart of London.

Most of what you see of the Abbey's exterior now dates to the 13th century and is Gothic in nature, as is much of the church interior. However, the towers at the west end were added in the 18th century (the work of Christopher Wren and Nicholas Hawksmoor), and are very different in style. If you go inside you will see how very high the ceilings are, and the wonderful job carried out by the artisans when building the graceful columns, the windows, nave and cloisters. Be sure to look out for the Shrine of Edward the Confessor, the intricate Cosmati pavement beside the altar and the poignant Tomb of the Unknown Warrior. Henry VII's Lady Chapel behind the altar has the most wonderful fan-vaulted roof and beside it you will find the tombs of Henry VIII's two daughters, Mary Tudor and Elizabeth I.

Within the main body of the Abbey are numerous monuments, memorials and tombs, which are often grouped together by profession or industry. Poets Corner, in the southern corner, may be of particular interest as it contains plaques, memorials

and graves of numerous famous authors, poets, musicians and dramatists including Chaucer, Shakespeare, Dickens, T.S. Eliot, Longfellow, the Bronte sisters, Kipling and Handel.

You will exit the church through the cloisters where the monks spent much of their day studying and working when the Abbey was part of a monastery. This will take you past the octagonal Chapter House and Abbey Museum, both of which are well worth a visit. The latter contains the Westminster Retable (the oldest surviving altarpiece from the 13th century), wax figures of royal personages such as Charles II and Queen Anne, and an imitation set of Crown Jewels used for the coronation of George IV. Before leaving the Cloisters if you glance across the courtyard you will see the massive flying buttresses supporting the Abbey, without which the structure could not sustain the weight of the roof span, and a typical feature of Gothic churches.

Outside, right beside the Abbey is **St Margaret's Church [18]**, originally founded to serve the lay people of the monastery, which was run in tandem with Westminster Abbey for centuries. It became the parish church of the House of Commons in the early 17th century when it was adopted by the Puritans, who disliked the ceremonial Westminster Abbey.

It is not surprising that the church is and has been a venue for political and society weddings. Both Samuel Pepys, the 17th century diarist, and Sir Winston Churchill were married here (in 1655 and 1908 respectively) as was Churchill's great-granddaughter, Clementine Hambro almost 100 years later in 2006.

Inside St Margaret's there are windows commemorating William Caxton, Britain's first printer who was buried here in 1491, Sir Walter Raleigh, historian and adventurer who was executed in nearby Old Palace Yard and buried here in 1618, and John Milton, (1608–74) poet, who was a member of the parish. The fabulous 16th century east window contains some of the best pre-Reformation Flemish glass in London and commemorates the betrothal of Katherine of Aragon to Henry VIII.

Across the street from the church you will see the familiar building of the **Palace of Westminster and the Houses of Parliament [19]**.

It is possible to visit Parliament and many do so by joining an organized tour (lasting 90 minutes), which is given by expert London Blue Badge Tourist Guides or Palace guides. On such a tour you will visit the Queen's Robing Room, the Central lobby and areas where MPs cast their votes, both Chambers of the Commons and Lords, and the oldest part of the Palace, Westminster Hall. There is also a self-guided audio tour available if you prefer to be more independent. For those who have joined either tour you may, for an extra charge, take afternoon tea on the Terrace Pavilion alongside the Thames; an unforgettable experience! For information about current charges look on the Palace website *www.parliament.uk*. Additionally, when Parliament is in recess during Easter and in the summer there may be artwork tours offered within the Palace of Westminster or nearby Portcullis House, where many MPs have their offices.

If you prefer, you can attend a debate in the public galleries when the House of Lords or House of Commons is sitting. You may also gain entry to the building through an invitation to a parliamentary event or an MP's wedding held in the crypt of St Stephen's.

Although the building appears really ancient, it actually dates to the middle of the 19th century and replaced the former building that was totally destroyed by fire in 1834. At the time of writing there has been a good deal of controversy about the future of the Palace as much of the building's fabric is crumbling and restoration work is vital. Not only will this be an extremely costly job but there is also the question as to where Parliament will convene whilst the essential works are carried out. Many proposals have been put forward to use other sites in an around Whitehall but to date no definite decision has been announced.

Very little remains of the pre-19th century palace but Augustus Pugin and Charles Barry built their Neo-Gothic building sympathetically around it. With over 1000 rooms, 11 courtyards and 100 staircases their palace is indeed a rambling building. **Westminster Hall [20]** still stands at its north end; a remnant of the very first palace, built by William the Conqueror's son, William Rufus, it has been on this same site and in use for 900 years! It is an enormous space with a magnificent, broad hammer-

beam roof and has been the venue for many events throughout its life; entertainment, feasting, political conventions, law courts, State trials (such as King Charles I and Sir Thomas More), lying-in-state of royals and senior politicians including Winston Churchill and Queen Elizabeth the Queen Mother, as well as the setting for public addresses by overseas statesmen and religious leaders.

Beside Westminster Hall in the **Elizabeth Tower [21]** is possibly London's most recognized site, **Big Ben.** In truth, Big Ben is the name given to the bell within the tower not the prominent clock face, and has been operating here since 1859. Although it has undergone restoration over the intervening years, the bell and the tower now require urgent attention so from the end of 2016 it will be out of commission for a few years whilst repairs are undertaken.

The tower itself was designed by Augustus Pugin and built in the Gothic Revival style. Historically called the Clock Tower it was renamed as the Elizabeth Tower in 2012 in honor of Queen Elizabeth II's Diamond Jubilee.

To many the tower is synonymous with London. It is in every tourist pamphlet, guidebook, advert and has featured in numerous TV shows and movies most notably *Thunderball, Dr Who, The Thirty-nine Steps* and *V for Vendetta.* To reach the bell you have to climb 334 steps to the belfry plus another 59 to get to the top of the lantern (the Ayrton light) and if you happen to be beside the bell when it chimes, especially at midday, you will find yourself quite deafened by the noise it makes! The chimes are renowned throughout the globe heralding the time every quarter of an hour. They also chime at New Year and on 11 November before the yearly Remembrance Day service held in Whitehall.

Weighing nearly 14 tonnes, the present bell replaced an earlier one that cracked during testing and had to be recast. The sheer size and weight of the bell meant that to get it up to the top of the tower it had to be winched on its side and it took over a day to put it in place. The bell was cast at the Whitechapel Bell Foundry in London's East End, which survives to this day, operating from the same site. Sadly, at the time of writing the future of the business is uncertain with the foundry currently under threat of closure.

Tours to visit the Elizabeth Tower and Big Ben are available through an MP or Member of the House of Lords (only to British citizens however), and need to be booked as much as six months in advance because of their popularity. Not only do you get some excellent views from the top of the tower but you will also have the opportunity to go behind the clock faces and to see the actual mechanism of the clock. Come on a Monday, Wednesday or Friday and you might even get to see the winding up procedure, surprisingly not fully automatic, even today.

If you happen to be standing in Parliament Square looking up at the clock face and see a group of workers in harnesses you will be witnessing the five-yearly 'clean' of the clock dials. Exciting to look at, this is when a group of workers abseil down from the Belfry to carry out their cleaning tasks.

The walk finishes here giving you the opportunity to find refreshments, take a walk beside the Thames, or to take the tube from **Westminster underground station, (Jubilee, Circle, District lines)** *opposite the Elizabeth Tower.*

ENVIRONS OF WHITEHALL & DOWNING STREET:

THE MALL

The Mall, was established after the Restoration in 1660 as part of the plans to transform St James's Park. Initially, it was used for the game of pelle melle, a cross between croquet and golf, and in time, became a fashionable promenade.

Almost 350 years later the road was redesigned by architect, Aston Webb, when he created a grand processional route up to Buckingham Palace. He was also responsible for the majestic new entranceway from Trafalgar Square, Admiralty Arch, built as a memorial to Queen Victoria from her son, Prince Edward and the nation.

The Mall is used in all State ceremonies, celebrations and as the official finishing post of the annual spring London Marathon. Most recently in 2016, it was the setting of the Patron's Lunch, a street party held for 10,000 on the occasion of the Queen's 90th birthday. It was the very first such party and celebrated the Queen's patronage over more than 600 charities and organizations.

The route itself is unmissable: a wide boulevard, with a red surface, almost like a carpet, and flanked by a double row of London plane trees. It is made all the more imposing by its lamp posts topped with galleons and the line of flag posts along its length.

In the early 19th century, Carlton House, the very opulent mansion of the Prince Regent, was located here. On acceding to the throne as King George IV, he ordered the demolition of his former home in order to fund the extravagant alterations he wanted to make at Buckingham House, later to become Buckingham Palace. Carlton

Runners on the Mall

House was later replaced by the very handsome and imposing Carlton House Terrace (designed by John Nash), and is home today to the Royal College of Pathologists, Institute of Contemporary Arts and the Royal Society.

PALL MALL

Running parallel to the Mall, Pall Mall is best known today for its gentlemen's clubs, mainly established during the 1800s, and still going strong – although membership may now extend to ladies too!

The Athenaeum was founded in 1824 as a meeting place for men and women who enjoy the life of the mind. It was designed by Decimus Burton, who included a golden statue of the goddess Athena outside its main entrance as well as an attractive Greek frieze high up on its façade.

The two adjacent buildings, the **Reform and Traveller's clubs,** are the work of Sir Charles Barry, famous for his design of the Houses of Parliament. It was in the Reform Club that Phileas Fogg took on a bet that resulted in his traveling around the world in 80 days, as in Jules Verne's novel of that name. The club's interior has appeared in two James Bond movies: *Die Another Day* (2002), and *Quantum of Solace* (2009) as well as the Jude Law, Robert Downey Jr movie of *Sherlock Holmes* (2009).

Further along the street is the **Royal Automobile Club** that moved to these premises in 1911. The spies, Guy Burgess and Donald Maclean lunched in the club before defecting to the Soviet Union in 1951.

The **Oxford and Cambridge Club,** whose members are alumni of the two world famous universities, is located nearby. The club, like its neighbors, offers both dining and lodging facilities and is comparable to staying in a comfortable, central London hotel.

At the far end of the street you reach **Marlborough House [22]**. This lovely brick-built 18th century mansion was constructed for Sarah, Duchess of Marlborough by Sir Christopher Wren. At the same time that Wren was working on Marlborough House, Sir John Vanbrugh was building Blenheim Palace in Oxfordshire for Sarah's husband,

The Athenaeum

the Duke of Marlborough. Vanbrugh's magnificent building was erected at the public's expense in recognition of the Duke's military victories overseas. As the Duchess couldn't abide Vanbrugh she insisted that Marlborough House bear no resemblance whatsoever to Blenheim Palace, accounting for the use of bricks rather than stone in the London property. Marlborough House remained in the family's hands until 1817 when it was purchased by the Crown.

Today, it is used by the Commonwealth Secretariat, and has been its HQ since 1965. It houses both the Commonwealth Secretariat and Commonwealth Foundation and has been the setting for a number of independence negotiations and many Commonwealth Conferences, including Summit meetings of Commonwealth Heads of Government.

The next building along the road is **St James's Palace [23]**. The striking, red-brick Palace was built during the Tudor period on the site of St James's Hospital, which had housed lepers in Medieval times. Henry VIII took it over in 1531 and it was a major royal residence for about 300 years until it was supplanted by Buckingham Palace in 1837, when Queen Victoria made it her new home.

Some of the original Tudor building still stands including the Chapel Royal, two State Rooms and the great Gatehouse, bearing Henry VIII's royal cypher HR. It was at the Palace that Mary Tudor signed the treaty surrendering Calais and later in 1588, her half sister, Elizabeth I, set out from St James's to give support to her troops at Tilbury, preparing to fend off the anticipated Spanish Armada.

A number of future Stuart kings and queens were born at St James's and it was here that Charles I spent his last night before his execution in January 1649. In more recent times, the Palace was home for a brief time to HRH Prince Charles and his sons, after the untimely death of their mother, Diana, Princess of Wales.

St James's Palace remains technically the seat of the Court to which ambassadors and other dignitaries are accredited, although nowadays they are actually received by the sovereign at Buckingham Palace.

ST JAMES'S STREET [24]

Due to its proximity to St James's Palace the street has always served the court and its courtiers. The area, known as St James's, is renowned for its specialist shops catering for gentlemen's needs such as tobacco, clothing, shoes, hats, men's grooming and hunting gear. Berry Bros. & Rudd, practically opposite the Palace Gatehouse has been resident on the street for over 300 years, and since it set up here has supplied royalty as well as wealthy and well-heeled customers with its fine wine and spirits. Like Lock & Co., Hatters, a few doors away, it remains a family business and both shops have been awarded two Royal Warrants, which entitles them to display the Royal Arms on their premises, stationery and livery. John Lobb,

bootmakers, is also a royal tradesman and proud owner of two Royal Warrants. Not only does it supply shoes to royalty but many film stars, singers, politicians, writers and businessmen have graced its premises throughout the years.

In addition to its bespoke shops, St James's Street is also famous for its gentlemen's clubs. White's, Brook's, Boodle's and the Carlton Club are all based in the street, yet they keep a very low profile. With no signs advertising their buildings it is almost impossible to know where they are located. However, each is housed in a beautiful period building and, similar to the clubs on Pall Mall, offers its members a place to stay as well as meet friends and colleagues in very comfortable surroundings.

Green Park underground station *(Victoria, Jubilee, Piccadilly lines)* is close by on Piccadilly beside the Ritz Hotel.

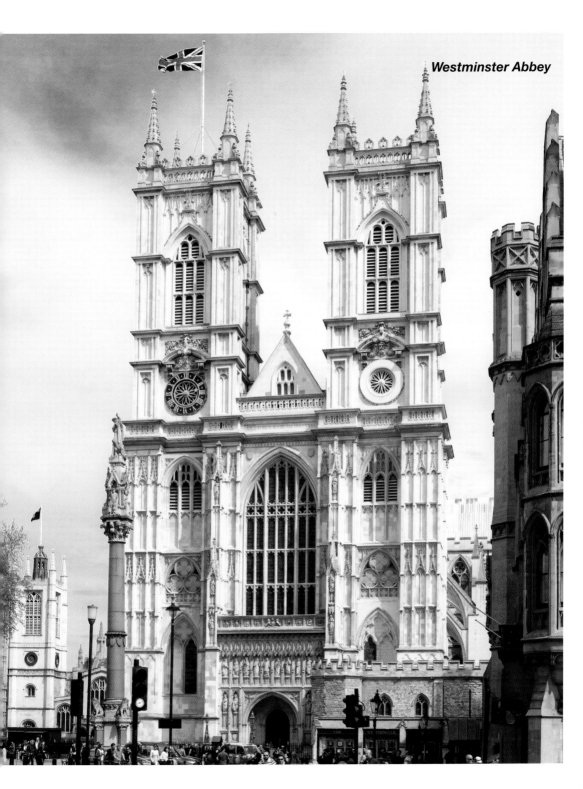

Westminster Abbey

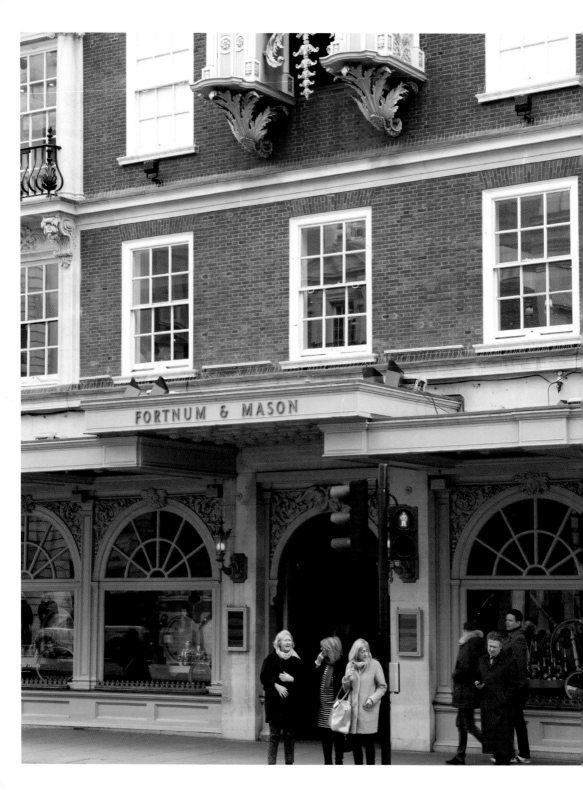

CHAPTER SIX

PICCADILLY

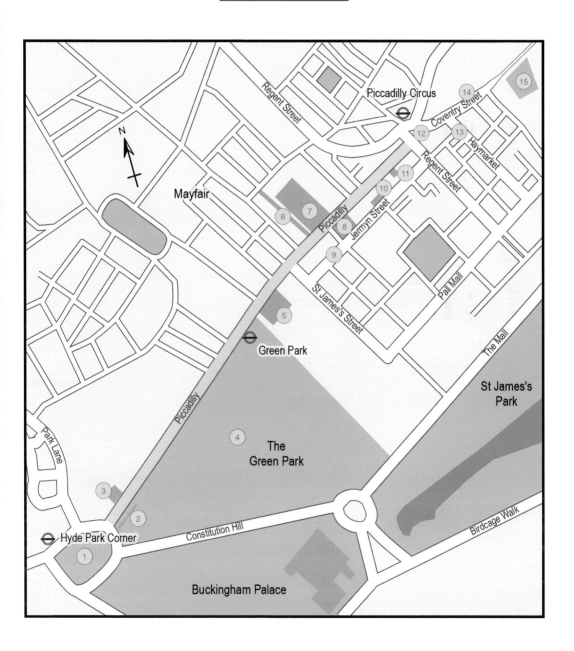

PICCADILLY

Piccadilly is located in the heart of the City of Westminster, one of 32 London boroughs, and home to many hotels, restaurants, department and designer stores. This busy east-west artery of London has been in situ since the 17th century, originally known as Portugal Street in honor of Catherine of Braganza, the Portuguese wife of King Charles II. The name Piccadilly is said to owe its origins to a stiff neck collar in fashion during the period, a 'piccadil' made by local tailor Robert Baker, who had a mansion in the street. Whatever the reason, the name stuck and Piccadilly remains one of London's best-known thoroughfares.

Since its beginnings, the northern side of the street was lined with large mansions owned by wealthy aristocrats, and an address here was highly prized. Today, just a few of these original buildings remain like Burlington House and the Albany, and they

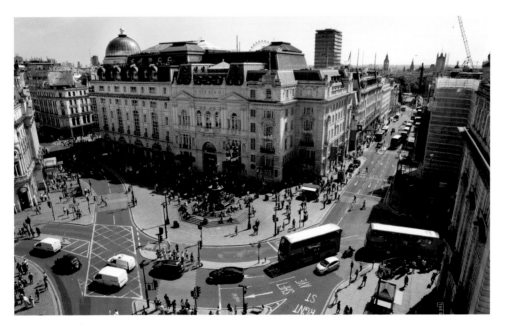

Piccadilly Circus

are interspersed between office buildings, hotels, shops and even an embassy. In the mid-1920s Princess Elizabeth, our present Queen, lived in a sizeable residence at 145 Piccadilly, (long since demolished and rebuilt as the Hotel InterContinental London Park Lane) and spent her early youth in the attic suite where she had a day and night nursery. The house had a very large communal garden where she would play and her nanny would also take her for regular walks in the nearby Mayfair streets and royal parks.

On the opposite side of the street close by The Green Park there have always been small, independent shops servicing Piccadilly's residents, and this practice still continues despite there being little residential accommodation along the street now.

As a main route between Knightsbridge and the heart of London's West End, being very close to two royal parks, and on the edge of Mayfair and St James's, it is not surprising that cafés, restaurants and bars abound or that you find a number of luxury shops and arcades along the street. **Bond Street**, with all its designer and independent shops branches off Piccadilly, and **Cork Street**, famous for its art galleries, is just a few moments walk away.

Our walk of Piccadilly begins at its western end beside Hyde Park Corner, and with a few slight detours, ends at Piccadilly Circus, often described as the hub of London.

The walk begins at **Hyde Park Corner underground station** *(Piccadilly line)*.

Take Exit 2 from the station onto the island at Hyde Park Corner.

HYDE PARK CORNER [1]

Officially Duke of Wellington Place, Hyde Park Corner is a hectic roundabout that scares many drivers whether local or visitors! It is bounded by the walls of Buckingham Palace, Constitution Hill (leading down to the Palace), Knightsbridge to the west, Park Lane to the north (beside Hyde Park), and the wide avenue of Piccadilly eastwards.

Continue straight along the path, down the stairs into the subway. (Note the walls – full of information about the Duke of Wellington, whose home, is nearby.) At the junction turn right, go up the stairs and you will arrive on the north side of Piccadilly. Stand outside the Hotel InterContinental London Park Lane and look across the road to:

RAF Bomber Command Memorial [2]

The Memorial was unveiled by the Queen in 2012, the year of her Diamond Jubilee. It commemorates the deaths of over 55,000 aircrew from the UK, Poland, Canada, Czechoslovakia and other Commonwealth nations and civilians of all countries who were killed in raids during World War II. Designed in Portland stone it incorporates a 2.7 metre (9 feet) high bronze sculpture by Philip Jackson at its center. A group of seven air crew are realistically depicted, appearing to have just returned from a bombing mission.

Now, turn left along Piccadilly until you reach:

Hard Rock Café [3]

The day I arrive at the Café and there is no queue outside I shall be very concerned! Every since it opened in 1971 the pavement outside the restaurant has been full of people and the restaurant is almost like a shrine to some of its clientele.

In the early 1970s two young Americans, Isaac Tigrett and Peter Morton, were living in London and homesick for hamburgers like those they ate back home. Not finding anything comparable they decided to open their own eatery in 1971, fitting it out as an American-style diner in an old Rolls Royce dealership. Despite only being given a short, six-month lease, right from the start their Café proved a great success, with rock stars and customers sitting side by side.

The Hard Rock Café

In 1973 Paul McCartney & Wings performed an impromptu concert at the Hard Rock Café before embarking on a UK tour. A year later, in 1974, the business sponsored a local football team and printed T-shirts promoting the Hard Rock name. Those left over after the game were given to loyal customers, but then people started to arrive at the Café hoping to purchase a T-shirt, sometimes in preference to eating the food! This led to the owners ordering more branded garments and selling them, ultimately outside the Café in a hut. More than 40 years on, the Café chain makes 40 per cent of its money from its retail business.

The Café went from strength to strength with Carole King writing her hit song, 'Hard Rock Café'. Eric Clapton was a regular customer in the late 1970s and asked Peter Morton to hang his guitar over his favorite bar stool, thus reserving his place. In no time at all, Pete Townshend had sent one of his guitars too and so the

tradition was begun of the Café's collection of musical instruments and other rock memorabilia. In fact, in the mid-1980s the Café bought out everything in Sotheby's rock memorabilia auction. Now the company is the proud owner of many rock stars' former possessions including John Lennon's glasses, Jimi Hendrix's Flying V guitar and Madonna's clothing from her Blond Ambition Tour in 1990, all on display in the Café's own rock'n'roll museum, The Vault, which as its name suggests is an actual vault (once part of Coutts Bank) in the basement of the adjacent Café shop.

Today, Hard Rock is an established global name with a range of restaurants, live music venues, hotels and casinos, and all-inclusive resorts. It is hard to believe that it all started here in Piccadilly, and that the brand is still so popular.

THE GREEN PARK [4]

Across the road you will see the railings and gates that surround The Green Park, which extends down to Buckingham Palace and St James's Palace. It is a most attractive open space with trees and parkland covering more than 16 hectares (40 acres), open to the public and right in the middle of town. The first records of the park date from the mid-16th century when the area was meadowland used for hunting and the occasional duel. After the Restoration in 1660, when King Charles II returned to the throne he purchased land that he named Upper St James's Park, between Hyde Park and St James's Park, so that he could walk between the two parks without leaving royal soil.

It was in this new park that he built one of the first ice-houses in the country, allowing him to give his visitors cold drinks. His daily walk in the park became known as his 'constitutional', which accounts for the naming of Constitution Hill that runs alongside the park.

By the mid-18th century the park had changed its name to The Green Park. It is said that this came about largely due to the king's own actions: known to be very fond of a pretty girl (indeed, he had a great number of mistresses throughout his life)

it is said that Charles II picked flowers in the park and gave them not to his Queen but to another young lass. Having been made aware of his actions the Queen was apparently so upset that she had all the flowers destroyed and would not allow any more to be planted. A delightful tale, and who knows, perhaps containing a modicum of truth. Interestingly, there are still no flowerbeds or shrubberies in the royal park more than three centuries later!

During the 18th and 19th centuries the Park was a popular place for ballooning attempts, public firework displays and as a duelling ground. A very great firework display was held here in 1749, organized by the Royal Family to celebrate the end of the War of the Austrian Succession. It was accompanied by music of the composer, Handel, who was commissioned to write it especially for the Royal Fireworks. Seventy years later, the Park was re-landscaped and trees were planted for the first time. Those trees are now very well established and provide excellent shade on a hot summer's day in London. The Park's paths are also very popular with joggers and runners who work in offices nearby.

The Ritz Hotel [5]

The first building you come to on leaving the Park is the Ritz Hotel, which is almost an institution in London! A five-star hotel, built in the early 20th century, it has always been a popular haven of the rich, film stars, royalty and politicians.

The building is unusual with a Franco-American exterior and Louis XVI interior, but it is opulence at its finest. Chandeliers, mirrors and gold leaf are in evidence throughout the hotel, and a room here can easily set you back hundreds of pounds per night.

The Ritz is especially known for its **afternoon tea**, served in the lavish Palm Court. Here you can sample the traditional menu at £50–55 or if you want something a little more special go for the Epicurean Tea, a three-hour affair including tastings of six rare and unique teas, sandwiches, scones and pastries, costing £95. Be warned of the strict dress code that states that gentlemen must wear a jacket and tie, and no

The Ritz Hotel

sportswear, jeans or trainers are permitted for either men or women. Afternoon tea is served at five intervals during the day between 11.30 am and 7.30 pm.

The hotel naturally has many associations with the famous and it would be impossible to mention all who have stayed here in the past century. Suffice it to say that many world leaders, movie stars, kings, queens, heads of governments and society personages have been patrons in their time. In the 1930s the future King Edward VIII was a regular client and practiced his dancing techniques here, the Queen Mother attended private parties at the hotel, King Zog I of Albania lodged here with all his family for a short time during World War II, J Paul Getty lived here in the 1950s, and in the latter part of the 20th century pop stars like the Rolling Stones

hosted parties in the Ritz. Most recently Lady Thatcher, (former Prime Minister) was convalescing at the hotel when she died following a stroke in April 2013.

The Ritz is such a London icon that it is not surprising that is has featured in a number of movies too. Neil Jordan's *Mona Lisa* (1986), starring Bob Hoskins, and *Notting Hill* (1999) with Hugh Grant and Julia Roberts contained several scenes set in the hotel.

MAYFAIR

Just before you reach Green Park underground station take any street on the left (north from Piccadilly) and you will arrive in **Mayfair**, one of the capital's wealthiest and most select areas. From the time it was developed in the early 18th century it has been home to nobility and the very wealthy and it is here in Mayfair that you find up-market hotels, clubs, casinos, art galleries, auction houses, bars and restaurants. It is especially famous for its high-end shopping with exclusive jewelry and fashion stores. The area is home to a number of celebrated hotels such as Claridge's, The Connaught, the London Hilton Park Lane, The Dorchester, The Westbury and Brown's.

The land from which Mayfair was developed came into the hands of Sir Thomas Grosvenor (from Cheshire) in 1677 when he made a fortuitous marriage to a 12-year old heiress, Mary Davies, and acquired more than 120 hectares (300 acres) of marshy farmland on the western boundary of London. This ultimately led to the Grosvenor family rising from country baronets to urban aristocrats. When the marriage took place in the late 17th century, the income from the Grosvenors' Cheshire land was more than double that received from Mary Davies's London estates, but only 100 years later it was the land in London that brought the most income and forever altered the nature of the Grosvenor wealth. Sir Thomas's descendants had become the richest noblemen in the kingdom. After establishing Mayfair, Grosvenor went on to develop Belgravia in the 1820s.

Mayfair has always retained its air of exclusivity, and an address here continues to be most prestigious. The area got its name from a fair held annually on 1 May from the 1680s until the early 18th century on the site of today's Shepherd's Market. Lasting 14–15 days it was a rowdy affair. Originally the first three days were devoted to cattle sales. The remainder of the fair was a time for revelry and feasting, often attracting the city's low life. There would be streets full of stalls offering freak shows, puppetry, wrestling matches and rope dances, with musicians and fiddlers weaving among the crowds.

Development of the area began in the latter part of the 17th century close to the present-day Piccadilly Circus. By the mid-18th century, practically the whole of the area we now call Mayfair was covered with housing (situated on six major estates, the largest being the Grosvenor). It also boasted wide, straight avenues, several noblemen's palaces (such as Burlington and Devonshire Houses), mews lined with stables and coach houses, and shops servicing the prosperous residents of the area. The majority of the houses were originally quite plain, but in the passage of time have been embellished by adding stucco, extra floors, and porticoes. Since World War II many of the houses have lost their residential status and are now used instead as offices, and numerous organisations have their base in this very fashionable district.

Burlington Arcade [6]

Piccadilly has several shopping arcades along its length but probably the best known, and certainly both the oldest and longest, is the Burlington Arcade. Its construction was commissioned in 1819 by **Lord George Cavendish** who had inherited Burlington House, next door. It is said he was tired of folk throwing their rubbish and oyster shells over his wall into his garden and hoped the Arcade would put an end to the practice. From the start the Arcade was intended for the sale of luxury items: jewelry, fashion accessories and the like and this has continued to this day. Merchandise here is seriously up-market and the exclusive accessories are

renowned for their craftsmanship and individuality. The almost 60-metre long (200 feet) arcade stretches between Piccadilly and Burlington Gardens and is protected by liveried guards known as 'beadles'. They are easy to recognise as they wear striking uniforms and are usually on duty near the Arcade entrance. When Burlington Arcade first opened the beadles were recruited by Lord Cavendish from his family regiment, the 10th Hussars. This is no longer the case but the men still act as enforcers of the Arcade's code of behaviour which includes no whistling, no playing of musical instruments, no carrying of large parcels, no running and no opening of umbrellas!

Despite these security measures an audacious jewelry heist took place here in 1964 when a speeding Jaguar Mark X sports car entered the Arcade. Six masked men jumped out of the car and smashed the windows of the Goldsmiths and

Burlington Arcade

Silversmiths Association shop stealing jewelry worth about £35,000. The robbers got away and the booty was never found!

Burlington House

Right next to the Arcade you come to Burlington House, home to the **Royal Academy of Arts [7]**. The house itself is quite magnificent; built in the Palladian style it was designed in the 18th century for Lord Burlington by Scottish architect, Colen Campbell. Looking distinctly palatial the main body of the house is set back from the road in its own courtyard in a very grand setting.

The Royal Academy was established in 1768 and a statue of the first president,

The Royal Academy of Arts

Joshua Reynolds, adorns the centre of the courtyard. Since its foundation the president has always been elected by the Royal Academy's membership. Many eminent artists have held the position in the intervening years including Sir Nicholas Grimshaw, Lord Leighton, Edwin Lutyens, John Everett Millais and American, Benjamin West. The current holder is the painter, Christopher le Brun.

On becoming elected to the Academy members donate a piece of their work to its collection. Consequently, it owns a stunning range of paintings, photographs, objects, sculptures and installations, many of which are on view to the public. The 18th century John Madejski Fine Rooms and the more recent 20th century Sackler Galleries, both display many treasures of the permanent collection. One of the most popular sculptures is the *Taddei Tondo*, Michaelangelo's marble sculpture of the Virgin and Child with the infant St John (1504–5).

From its beginnings the Academy has acted as a formal, independent art school and this still remains as the real basis of its existence today. It provides three-year post-graduate training annually for up to seventeen artists and is the only such course in Europe.

Regular exhibitions are put on here covering all manner of art and architecture, old and contemporary, for which a charge is applied. For up-to-date information look online to find out about current exhibitions and the events program. In 2015 Chinese artist Ai WeiWei's exhibition was remarkably popular. Recent exhibitions have also included Painting the Modern Garden: Monet to Matisse, David Hockney RA and Revolution: Russian Art 1917–1932.

Probably the most renowned event here is the annual **Summer Exhibition**, which has taken place since 1769. Artists, both new and established, submit works to be included in the exhibition and 1200 pieces are ultimately selected by the Selection and Hanging Committee of the Academy. Many of these artworks are for sale, allowing the public to buy art of both well-known artists and those new on the scene.

The building is open daily between 10 am and 6 pm (until 10 pm on a Friday), and has several excellent shops and restaurants within its grounds.

Moving on from the Royal Academy, cast your eyes across the road to Fortnum & Mason to look at the shop façade. Painted in its signature eau de Nil hue you will notice that there is a clock above the main entrance. If you manage to time things well and are standing here on the hour, you will see the figures of Mr Mason and Mr Fortnum appear, keeping an eye on the store they set up. These figures and the clock are relatively new (1964), and the bells were made at the Whitechapel Bell Foundry in the East End, the same business that cast Big Ben more than 150 years ago.

If you look up to the very top of the store you might just be able to catch sight of Fortnum's own bee colony. There are four main beehives and honey made in the colony is on sale within the store.

Fortnum & Mason [8]

This magnificent store has been operating since the early 18th century and on this site since 1773. Originally, William Fortnum, a royal footman to Queen Anne, along with his partner, Hugh Mason, sold candle-stumps (partly-used candles from the Royal Household), and a few groceries, but in no time his enterprise was recognized by the Queen, and as the Queen's Grocer, his shop became 'the biggest tuck-box in the world'.

Three centuries on the store continues to sell groceries, mainly high-end foods and always of the highest quality. It also has several floors devoted to gentlemen's clothing and equipment, ladies wear, luxury household and kitchenware and a fresh food hall in the basement. There are four dining areas: The Gallery, The Parlour, the Wine Bar and The Diamond Jubilee Tea Salon, offering a range of meals, snacks and afternoon tea.

Fortnum's tea remains famous the world over and you will find an enormous variety of different flavored teas from countries as far away as China, India and Russia to Cornwall in the southwest of England. The store has its own wonderful blends as well as rare varieties, and a good selection of green, black and white teas too.

Fortnum & Mason main entrance

Fortnum's has been selling a very wide range of other foodstuffs too since the mid-1700s. It was quick to seize the opportunity to cater for a new class of affluent middle class who were willing and able to spend their money at a time when international trade was growing, transport was becoming ever more reliable and London's trade made it such an appealing magnet. The store had solid links with the British East India Company (a mighty, powerful organization with its own army and policies), and thus the way was made easy for Fortnum's to establish itself as the store to find and buy goods unavailable elsewhere.

Over the years it has sold delicacies and exotic foods such as lobster, West Indian

turtle, truffles, and boar's head, thus marking it out as 'the' number one seller of exotic edible food. It also introduced the Fortnum's hamper used at shooting parties and at major social events during the 'Summer Season' such as the Oxford and Cambridge Boat Race, Ascot, Lord's, Henley, and tennis at Wimbledon.

From the early 19th century it created its own dedicated department catering for members of nearby gentlemen's clubs like the Athenaeum and Boodles and in the early 1900s when Captain Scott was exploring in the Antarctic, the store sent out provisions to him and his team of men.

Always entrepreneurial, the store also acted as a post office until the late 1830s. It had letterboxes for paid/unpaid letters that were picked up six times a day. Discounts were given to soldiers and sailors, who unsurprisingly, became some of the company's best customers and broadened the appeal of the store.

Tinned food appeared on Fortnum's shelves for the first time around the middle of the 19th century with Heinz baked beans on sale from 1886! Today, the store sells a huge range of specialist jams, honey, marmalades, biscuits and chocolates, as well as tea and coffee on the ground floor, and you can still purchase a Fortnum hamper in a range of sizes.

All the food is beautifully presented and it is hard to visit the store without buying at least a jar of jam or a tea caddy, packed in one of Fortnum's signature mint-colored bags.

JERMYN STREET

Unless you are wandering in the area you might never stumble across this excellent narrow street that runs parallel with Piccadilly, immediately behind Fortnum's. But what a shame to miss it! It is primarily a gentlemen's enclave – a place to find clothes for the town and country, for the hunt, footwear of the highest calibre, perfume and shaving equipment and even gourmet cheeses. Some of the shops here date back to the 17th and 18th centuries, many feature Royal Warrants above their shopfronts, and have been servicing courtiers, the nobility, rich and celebrated ever since that time.

On exiting Fortnum's on Piccadilly turn left into Duke Street St James's. At the junction with Jermyn Street turn right and walk along until you reach a statue beside the Piccadilly Arcade.

The statue, by Irina Sediecka, is of one of the late 18th/19th century's great dandies – **George 'Beau' Brummell** (1778–1840) **[9]**, a fashion icon of the time and copied by many. His wonderful attire: the top hat, top boots, cravat and coat show his fastidiousness with his 'look' and also give us an insight into how the rich and famous clothed themselves at the time. Brummell was originally close friends with the Prince Regent (later to become King George IV), but fell out with him, which had an impact on his own fortunes. However, as with many of our stars today, he was someone who had a great following and people applauded him for his style and wanted to be like him. It is rather fitting that his statue should be placed along Jermyn Street, which would have been a central part of his life.

Brummell had decidedly eccentric ways, taking an enormous amount of time to wash and dress and spending hours on his appearance. It is said that before dressing he bathed for two hours (unheard of at the time) and that it took him many hours before he was ready to leave the house. Even when he ventured out he would not step in the road for fear of dirtying his shoes, and always took a sedan chair to get about rather than be subject to wind or rain.

Now, backtrack a little, go past Fortnum's and walk along the street eastwards, passing by some menswear shops. Stop when you are opposite **Floris,** identified by its 18th century wooden shop façade with an elaborate coat of arms above. The shop has been in these premises since 1730 and is certainly one of the district's treasures. If you have time, go inside not only to sample their fragrances and colognes but also to view their perfumery behind the main shop. It is a real wonder and retains all the cabinets and furniture from the 18th and 19th centuries. It is in here that the in-house perfumery team creates new fragrances, all of which have to gain the approval of Edward Bodenham, ninth generation descendant of the

Floris family, affectionately known as the 'nose'. Edward learnt his craft from his grandfather whilst still a boy, although at that time the fragrances were blended in the basement underneath the shop.

The Floris family continues to run the shop and is very proud of their history and clientele. On display is a letter from Florence Nightingale written to Mr Floris (James) in which she thanks him for his 'beautiful sweet-smelling nosegays' whilst she was in the midst of setting up a training school for nurses at St Thomas's Hospital in Waterloo in 1863. Another highly prized possession is a receipted invoice dated December 1934 for fragrances bought by Winston Churchill itemizing two products, Special No. 127 and Stephanotis, which are still available in the Floris Classic Collection today.

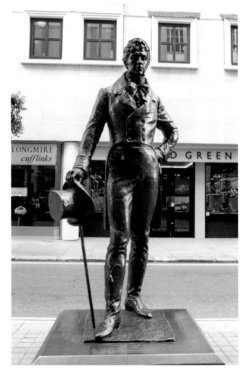

Beau Brummell

From the time that Juan Famenia Floris produced the very first fragrance nearly three centuries ago details of all the formulas have been written in a large leather-bound book and passed down through the generations, sitting in the vaults today. Floris is not only the oldest independent family perfumer in the world but also the only perfumer to hold a Royal Warrant from Her Majesty The Queen. In addition to its well-known products it also supplies a bespoke fragrance service using only the finest of ingredients.

Continue down the street and you are likely to be greeted by the aroma from nearby Paxton & Whitfield, the gourmet cheesemongers. With premises in Jermyn Street

since 1835 (though located at this site since 1896) it also has a long and notable history. Bearing Royal Warrants from both Her Majesty The Queen and His Royal Highness The Prince of Wales, it sells artisan British and European cheeses, hampers and gift packs, cheese accessories as well as wines, hams, pâtés and chutneys. If you are a cheese lover then this is certainly worth a visit.

On leaving the shop turn right and you will pass by a number of high-end luxury gentlemen's shoe shops and outfitters both traditional (Hawes & Curtis) as well as less conventional, such as Favourbrook. Browse if you want but our next stop is going to be a place of worship, St James's, Piccadilly.

You need to cross the street and enter the church through its back entrance. Walk straight through the lobby and make your way into the church through the doors on the right.

St James's Piccadilly [10]

To walk into such a quiet but glorious church right in the center of the West End is indeed a great treat. It is really hard to believe that life is so very frenetic out on Piccadilly yet here inside **Sir Christopher Wren's** 17th century church you can feel remarkably calm. Wren is renowned for building St Paul's Cathedral and many City churches after the 1666 Great Fire of London but rarely is his name associated with churches in the West End. However, records survive of his plans and he specifically wanted to build a church here that could accommodate 2000 people, all of whom would be able to hear the service and see the preacher.

A great feature of Wren's work was the introduction of as much natural light as possible. This accounts for the paucity of stained glass windows within the church today, although a large and beautiful stained glass window behind the altar was added in post-World War II restoration work.

The beautiful limewood reredos behind the altar as well as the marble carved font

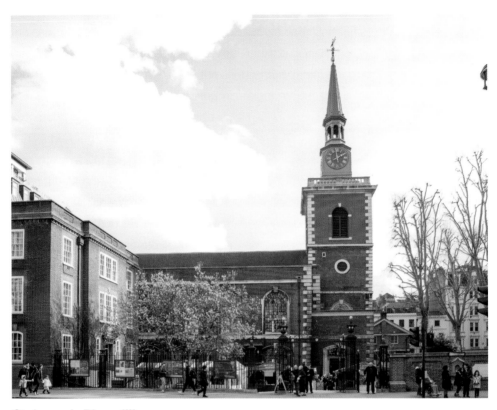

St James's Piccadilly

are both attributed to the Dutch wood-carver Grinling Gibbons, and it was in this very font that the poet William Blake was baptized in 1757.

If you walk into the main body of the church towards the altar and then turn around you will see the impressive organ, the work of Renata Harris. It is much in use both at services but also in concerts that are held in the church. Renowned for its excellent acoustics, many recitals take place here and concerts range from orchestral pieces to chamber music. If you're passing by on Monday, Wednesday or Friday lunchtime, drop in to a free recital (1.10 pm–2 pm), details of which can be found on St James's church website: www.sjp.org.uk.

In the courtyard outside the Piccadilly church entrance a market takes place every day (except Sunday); an arts and craft market appears between Wednesday and Saturday, a food market on Monday and antiques and collectibles on Tuesday.

Exit the church through the courtyard and turn right onto Piccadilly. Shortly you will reach the main entrance to Waterstones bookshop.

Waterstones bookshop (formerly Simpson's, Piccadilly) [11]

This is one of London's foremost bookstores with six glorious floors full of books ranging from fiction, history, children's books, science, travel, art and many first editions. The premises were originally built in 1936 as Simpson's, which was then both the largest and most modern menswear department store in the country. Designed by Joseph Emberton, the store was remarkable for its Modernism façade, fittings and wonderful travertine staircase, all of which remain today. The building has been awarded status as a Grade I listed building thereby protecting it from unplanned alterations, as listing building consent must be obtained before any changes are implemented.

The store has a café and bar on the top floor (5th View Restaurant) from where you get good views over Whitehall and Westminster. It is a great place to visit for cocktails, light meals and afternoon tea.

As you leave Waterstones you will see a very busy junction in front of you, impossible to miss because of the bright, moving advertising billboards.

PICCADILLY CIRCUS [12]

So, we are now at Piccadilly Circus – always buzzing with life, people, noise and dazzling lights! To many, this is really London's heart, a place to meet with friends, to people watch, to experience the capital city. Many celebrations occur here and it is

Piccadilly Circus at night

undoubtedly one of the West End's most recognizable hubs. It is a key junction with major roads radiating off it in every direction. Right bang in its center, placed on an island, is a statue of a winged figure surmounting an aluminium fountain. Views differ as to whom the figure represents, but generally it is referred to as **Eros**, the Angel of Christian Charity, even though it is said that the sculptor, Sir Alfred Gilbert, had intended it to be Eros's brother, Anteros, the God of Selfless Love. The latter would probably be the more fitting as the fountain is a memorial to the philanthropic 7th Earl of Shaftesbury, yet the name Eros seems to have stuck and it is used as a logo for London's free newspaper, *The Evening Standard.*

Piccadilly Circus was laid out in 1819 when Regent Street was developed and has been a busy interchange ever since. Its illuminated advertisements first appeared in the early 20th century and soon became a main feature of central London, similar to Times

Square in New York. Nowadays, the moving adverts are lit by LEDs and displayed over the northern side of the Circus only, curving around the building that leads into Shaftesbury Avenue. They are so very bright that the displays can even be seen quite easily from the sixty-seventh floor viewing gallery in the Shard at London Bridge!

This concludes the walk of Piccadilly and the closest underground station is **Piccadilly Circus** *(Bakerloo, Piccadilly lines)*.

ENVIRONS OF PICCADILLY:

HAYMARKET

Walking east towards Leicester Square you will pass by **Haymarket [13]** on the right, nowadays probably best known for its two splendid theaters, Her Majesty's and the Theatre Royal Haymarket. Both were originally constructed in the early 18th century and whilst the former has always had a tradition of staging opera and musicals, the latter has tended to concentrate on the spoken word and drama. Andrew Lloyd Webber's epic musical *Phantom of the Opera* has actually been playing at Her Majesty's Theatre for 30 years, making it the second-longest running musical on the entire London stage.

As Haymarket connects Piccadilly to Pall Mall and Trafalgar Square it is the busiest of thoroughfares. Prior to the introduction of motor vehicles in the early 1900s most travel was done on horseback or in a carriage or stagecoach and in order to carry out their work the animals would need to be fed. Haymarket, as its name suggests was a source of straw and hay for the horses and a market selling hay as well as fodder was located here from around the middle of the 17th century for about 250 years.

COVENTRY STREET & LEICESTER SQUARE

The following two streets, **Coventry Street [14]** and **Leicester Square [15]**, appear in yellow on the Monopoly Board where they cost £260 each. **Coventry Street** leads away from Piccadilly Circus opening out into Leicester Square and is largely full of shops and offices, the Trocadero shopping center and the Prince of Wales Theatre. Built towards the end of the 1600s the street was designed for commerce and entertainment. For much of the 18th and 19th centuries it was noted for its gambling houses and considered to be a somewhat unrespectable locale. Later it was known for its many large restaurants and food outlets. By the 1920s it was the focus of the nightclub scene, popular with the Prince of Wales (later Edward VIII) and his circle. Almost a hundred years later Coventry Street is scarcely known with crowds passing through it day and night, oblivious of its earlier usage and existence.

Leicester Square at night

Leicester Square, in contrast, has worldwide notoriety, mainly on account of its association with movies and cinemas. The centrally enclosed gardens (once part of Leicester Fields), are surrounded by three of London's major cinemas. On the east side is the Art Deco Odeon cinema whilst the Empire and Vue cinema complex overlook the Square on its north side. Movie premieres take place here regularly when stars, celebrities and even royalty arrive in the Square to be greeted by large crowds before walking along the red carpet.

To the south of the square is a permanent ticket booth, TKTS, a good place to pick up last-minute discount tickets for shows and plays. (Open daily 10 am–7 pm, Monday through Saturday, 11 am–4.30 pm on Sunday). You can purchase tickets using major credit cards, cash, theater tokens and some vouchers, but be warned, it

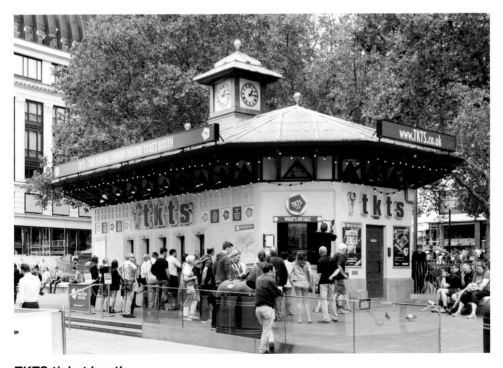

TKTS ticket booth

does not accept American Express cards or bank checks.

It doesn't matter when you visit the Square, it will always be full of people and feel exciting. It is noisy and brash, lined with bars, restaurants and souvenir shops and may well be hosting some event or festival. Just on the edge of Chinatown and Soho, it tends to stay lively well into the early hours of the morning, and is certainly never dull!

Leicester Square underground station *(Northern, Piccadilly lines)* is close by on Charing Cross Road.

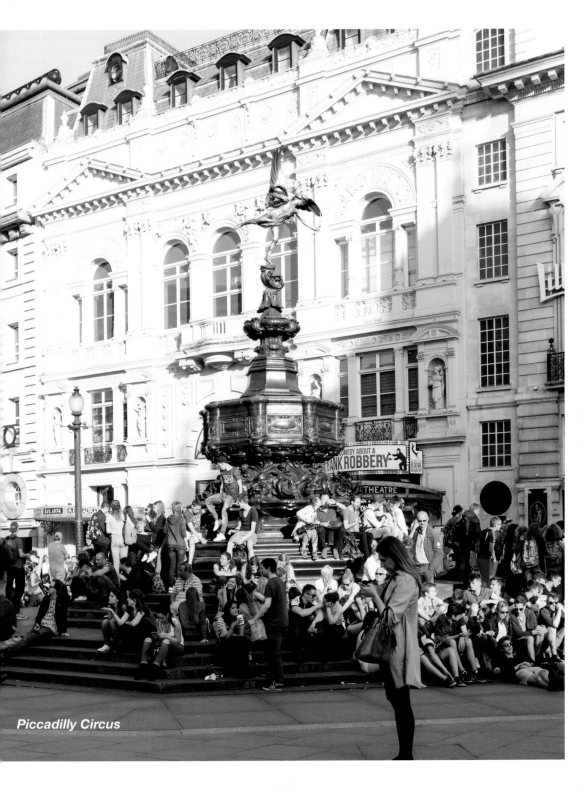

Piccadilly Circus

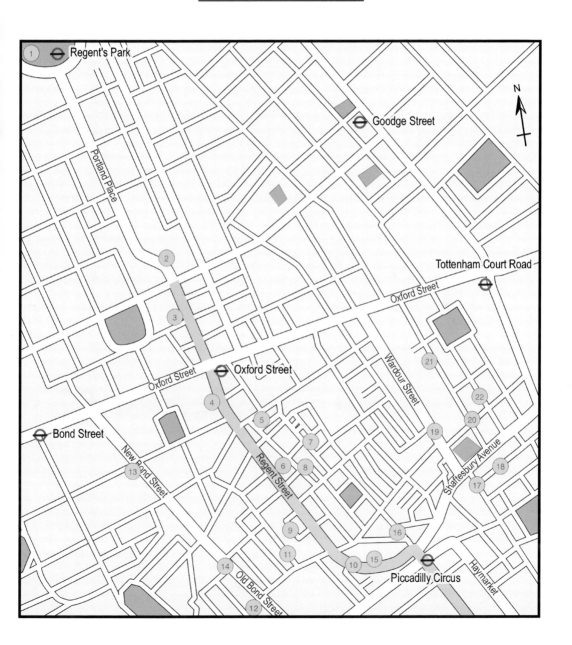

REGENT STREET

Until the first part of the 19th century, London was built without any street grid or pattern, and many streets took the route of earlier lanes, ways or paths from centuries long gone. Today, many visitors to the city are both enchanted and frustrated by its seeming lack of logical layout, but it is largely this that makes London so unique.

Regent Street, was the exception to the rule, having been specifically conceived by the Prince Regent's architect, **John Nash.** His plan was for a wide, graceful thoroughfare fit for royalty, connecting Marylebone Park (later, **Regent's Park [1]**), to the Prince's home at Carlton House, close to St James's Park. Nash, like his master, was prone to extravagance both in ideas and in expenditure, but it would be difficult to fault his vision. As the plot of Crown land to be developed was surrounded by existing properties, it meant that Nash was unable to construct a direct road, and took advantage of this in his design. This resulted in a wonderful vista framed by the church, All Souls, Langham Place, at the street's northern end along with the most elegant curve in the south. By the time it was completed in 1825, Regent Street had become a dividing artery between the cosmopolitan and less reputable Soho to the east, and exclusive Mayfair to the west.

Nash had envisaged a street with stylish architecture, full of sophisticated shops that would appeal to the upper classes, and this was what he built between 1811 and 1825. The shops were very smart, bespoke outlets and had great appeal to the growing affluent London population. As in his development in Marylebone Park, he built a number of stucco terraces, beautiful to look at but not very well constructed so that by the end of the century many of these needed to be rebuilt. Also, with new trends in shopping the small shops had become dated; people now were seeking larger stores that would carry a greater selection of merchandise. This meant that Regent Street underwent major renovations at the end of the 19th century, with its final completion in the 1920s, as work halted during and immediately after World War I.

One of the major features of Nash's original street had been the colonnade along

Festival of Lights in Regent's Street

the curved southern end, known as The Quadrant. Although this had provided shelter from the elements for shoppers, it became the haunt of 'ladies of the night', obviously not fitting for this upmarket district. This usage, combined with the fact that it had been poorly constructed, led to the colonnade's demolition in 1848.

Almost two hundred years on Regent Street remains a main shopping street but has diversified in its shopping provision. In addition to high-end jewelers such as Mappin & Webb you will find names like Hollister, Zara, the Apple Store, Aquascutum, Jaegar, Burberry, Brooks Brothers, Liberty, and the much loved toy emporium, Hamleys. Where Regent Street and Oxford Street cross at the northern end you find the fashion chains H&M, United Colors of Benetton, All Saints and Banana Republic. Regent Street is owned and administered by the Crown Estate that expects its retailers to

conform to the Regent Street brand of 'Quality, Heritage, Style and Success'. Major UK flagship stores are encouraged to have a presence here but retailers are permitted to trade in only one store in the street. The Crown Estate publishes a list of shops that are not permitted on its premier shopping street, which includes many service shops such as internet cafés, sex shops, hairdressers, tattoo parlors, newsagents, supermarkets, betting shops, nightclubs, discount stores, travel agencies and estate agents. In such a way it manages to retain Regent's Street's high-end appeal.

The street is also home to the University of Westminster, several hotels and many restaurants, and cafés. Since 1954 Londoners as well as throngs of visitors have made a trip to see the Christmas lights decorating the street. Numerous pop stars, and celebrities have turned on the Christmas lights and performed at the festivities, always a most welcome entertainment in mid-winter!

Back in 2004 Regent Street was the venue for a London Formula 1 event, something that many fans of the motor sport would like to see become an annual event, as in Monaco. However, the idea has been beset with problems as it would necessitate the closure of many of London's streets not just for the event itself, but for a period of time before and after, and in a city like London, that may not be either feasible or economic! But, the debate rumbles on.

Regent Street does however, play host to a number of festivals throughout the year: In January 2016 the first Lumiere London Light Festival was held, Summer Days takes place on Sundays in July (great for traffic-free shopping and pop-up activities), and in the autumn, there is NFL on Regent Street (enjoyed by all American Football fans), and the Regent Street Motor Show when more than 100 veteran cars are displayed on the street, and the street becomes a pedestrian-only zone for the day.

The street does not actually stop at Piccadilly Circus, but continues across the junction to the right of Eros. The sportswear store, Lillywhite's is on the left corner of the street, and if you walk along its length you will reach a group of statues in the middle of the road at Waterloo Place associated with the Crimean War of 1854–56. Here you will see a memorial to Florence Nightingale remembering her work in the

hospital in Scutari, where she became known as the 'Lady with the Lamp'. Go across the road (Pall Mall) and you will see a statue of King Edward VII on horseback and a tall column at the top of a flight of stairs. This is the Duke of York's column, in memory of George IV's younger brother, Prince Frederick, who was commander in chief of the army at the end of the 18th century. The statue was paid for by soldiers in the British Army who gave a day's pay each so that the Duke could be commemorated. His achievements included the founding of the Royal Military Academy at Woolwich (the forerunner of Sandhurst), the introduction of the smallpox vaccine to the army, and the supply of greatcoats to all ordinary soldiers. Yet, he was largely renowned for his indecisiveness; hence, the nursery rhyme, 'The Grand Old Duke of York'.

Carlton House, the sumptuous mansion of his brother, the Prince Regent, was sited close by and this marked the end of Nash's Regent Street.

The walk around Regent Street starts at its northern extreme and includes other famous shopping streets in the vicinity: **Carnaby Street, Savile Row,** and **Bond Street**, each with its own particular character. We shall begin at **Oxford St underground station, (*Central, Bakerloo, Victoria lines*)** by Exit 1, Regent Street north/Oxford Street east.

All Souls, Langham Place & the London headquarters of the BBC [2]

As you come up from the tube you are likely to find yourself amongst a huge crowd of people: shoppers, visitors, shop and office workers, as this is really one of the West End's major hubs. Turn right, walk a few metres and then look down the street to see the first of John Nash's architectural icons, the church of All Souls, Langham Place. It is wonderfully positioned at the end of Regent Street, disguising a dogleg in the road that links it to Portland Place and the Regent's Park. From where you are standing you see the church's prominent, round vestibule that is graced with the most impressive Corinthian columns, tower and spire. The curved glass building you

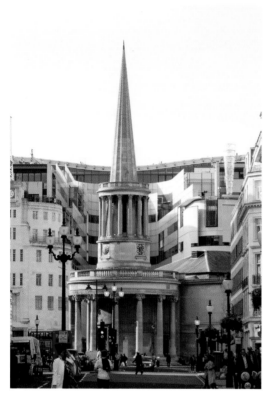

All Souls Church

see immediately behind it is the new extension to the **headquarters of the BBC,** and it too has a sculptured glass spire entitled 'Breathing' that looks like a huge listening glass. Not only an art feature, it is a memorial to journalists and news crews that have died in conflict areas. 'Breathing' complements the spire of the church as well as the radio mast spire that sits above the neighboring original 1932 BBC building. Come here at night for the most impressive views when the buildings and spires are all illuminated, which really highlights the northern end of the street.

Nash completed **All Souls Church** in 1824 and it has been a celebrated landmark of Regent Street ever since. It has wonderful acoustics and is renowned for the quality of its music and its organ. The church has its own orchestra, band and choir, and music is always part of Sunday worship. Its musical reputation and proximity to the BBC has accounted for it being used as a venue for many recorded concerts.

University of Westminster [3]

The University of Westminster is located on the west side of the street and operates out of a handsome building dating back to 1838, when the body was known as The Royal

Polytechnic Institution. It has undergone several rebirths in the intervening years and in 1992 was granted university status. When the polytechnic opened in the 19th century it had a remit to promote science and technology and was the original London institution to demonstrate photography. In fact, in 1841 Europe's first photographic studio was built on its roof and soon became a Victorian tourist attraction!

Famous alumni include fashion designer, Vivienne Westwood, the Nobel prize winner, Sir Alexander Fleming, Charlie Watts of the Rolling Stones, Nick Mason and Roger Waters of Pink Floyd, Christopher Bailey, Burberry's Chief Executive and Chief Creative Officer, actor Timothy West, Julian Metcalfe and Sinclair Beecham, founders of Pret a Manger, sculptor Sir Anthony Caro,and many politicians, MPs and public servants.

Regent Street architecture

Right from its inception Regent Street was renowned for the beauty of its architecture, and just a quick glance at the buildings today will confirm that this continues to be the case. As you walk along the road, stop every so often and survey the buildings, look at their height and scale as well as their decoration and detail. It is surprising what you see. In order to preserve the mixture of the present complementary Beaux-Arts façades the entire street is designated a conservation area and each of the buildings has Grade II listed status. This means that they are considered to be buildings of special architectural and historic interest, significant to the nation and thus subject to extra legal protection and control within the planning system. Work cannot be undertaken to either the exterior or interior without first making an application for listed building consent, so preventing an abuse of the street's appearance. Look carefully and you will see that the buildings are all quite individual yet each block offers up what appears to be a continuous front to the street. The elegance of the Quadrant at the southern end of the street and the way in which it unfurls as you walk down Regent Street is undoubtedly what gives the street its splendor. It is another of John Nash's vistas, so pleasing on the eye.

The Apple Store [4] close by Oxford Circus at 235 Regent Street, is an excellent example of an ornate frontage, which is best viewed (carefully!) from an island in the middle of the road. At the end of the 19th century, the Italian mosaic and glass-making company, Salviati, had premises here and chose to promote its business and wares by embellishing the store's façade with mosaics. The decorations are still very attractive and include two lions and four coats of arms representing the cities of London and Westminster and the Venetian islands of Murano and Burano (home to the company), as well as the names of cities where the firm's products could be found: Paris, Berlin, New York and St Petersburg.

Flagship stores: Liberty and Hamleys

This street of fashion was home to several large department stores during the 20th century, but as shopping trends changed a number of these disappeared. The one exception however is **Liberty [5]**, which is located on Regent Street, but has its main entrance in Great Marlborough Street. Open daily, the store is probably best known for its textiles and fabrics, and its famous 'Liberty Print' cotton garments are renowned the world over.

Housed in a quite unique and distinctive Tudor revival Arts and Crafts building, Liberty continues to offer the quality of merchandise that it became famous for when the store opened in 1875. Its owner, Arthur Lasenby Liberty, a lover of Eastern culture and art, sourced objects and fabrics of the highest standard from the Far East and began to transform the appearance of London's fashion and household merchandise. He was responsible for introducing beautifully designed clothing, greatly inspired by the Art Nouveau designers, which came to rival the Paris fashion houses.

Inside, the store is celebrated for its oak wood paneling, wooden balconies and stained glass and has a far less impersonal feel than other larger department stores in Oxford Street. Although mainly concentrating on fabric and clothing Liberty's range is wide including oriental rugs, cosmetics, accessories, stationery, haberdashery, curtains, bedding and wallpaper.

Liberty

A little further along Regent Street you reach what many children think is the greatest shop in the world, **Hamleys [6]**. Its seven floors are like heaven to kids and adults alike and are full to the rafters with a huge and varied selection of toys.

William Hamley, its original owner, had always wanted to run a toy shop and on coming to London from Cornwall in 1760 he opened Noah's Ark in High Holborn. The shop with stocked with every toy imaginable as Hamley wanted it to be the very best toy shop in the world. Then, as now, children flocked to visit and wondered at its displays. It became so successful that it was soon a household name with customers from every walk of life including the aristocracy and royalty. Following his death the store was run by William's descendants, who in 1881 moved it to its present location on Regent Street, greatly extending its premises.

Although no longer in the family's hands today, Hamleys is very much a British institution (and also the oldest surviving toy shop in the world) attracting several million visitors a year. It is the proud owner of a Royal Warrant as a 'Toys and Sports merchant', first awarded by the Queen over 60 years ago. In fact, her own children's toys were purchased from Hamleys and quite possibly the tradition has been passed down to their own children today.

The Regent Street shop remains Hamleys' flagship store with entire sections and floors devoted to stuffed animals and teddy bears, board games, electronic games, train sets and Scalextric, dolls, jigsaw puzzles, Lego, as well as much much more. Any visit is sure to delight but the run up to Christmas is possibly the best time when

Hamleys

marvelous window displays appear and the entire store becomes wonderfully magical.

Just around the corner from Hamleys is a street that was at the heart of London in the Swinging Sixties:

CARNABY STREET [7]

Entering the street under an iron archway emblazoned with its name, you are under no illusion as to where you are! Carnaby Street, despite having 'grown up' is still very much on the tourist route and retains its iconic appeal. Its role now is far more mainstream, full of small fashion shops but not as 'alternative' as they were back in the 1960s when Lord John, Mary Quant, and Irvine Sellars sold their clothing here. Carnaby Street was possibly the most hip place to be during the flower power and

hippie era, and its stylish clothing and celebrity visitors meant that thousands would regularly descend upon the street. Many of the top pop stars including the Beatles, the Kinks and Jimi Hendrix were kitted out here by John Stephen, aka 'The King of Carnaby Street' and it would not have been unusual to bump into any member of the Rolling Stones or The Who in the street. Even in the 1970s and 1980s the area was like a magnet for youth subcultures and was teeming with punks and goths.

Carnaby Street first appeared towards the end of the 17th century and was then full of small houses. In the 1820s it had its own market; following World War II the area became the center of the rag trade and was full of sweatshop tailors working for Savile Row on the other side of Regent Street. As the tailors moved out the premises were turned into fashion boutiques selling the popular mod and hippie clothing. After its heyday the street became a little neglected and for a while ignored.

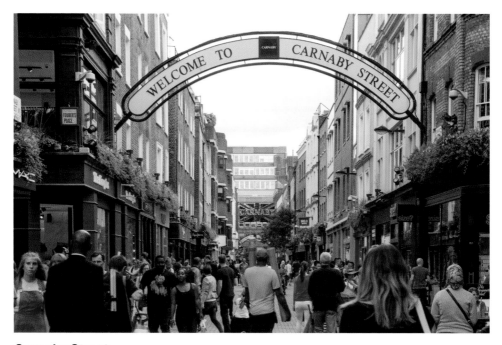

Carnaby Street

This has all changed in recent years and Carnaby Street has reinvented both itself and the surrounding streets (Little Marlborough Street, Newburgh Street, Marshall Street, Foubert's Place, Ganton Street, Beak Street and Kingly Street) into a shopping district with an array of intimate shops, restaurants, cafés and pubs. **Kingly Court [8]**, reached through a tiny opening off Carnaby Street links it with Kingly Street and offers three floors packed full of small designer shops, and is a real foodie center. This is the place to come for global food: Peruvian, fusion Asian, Caribbean, Italian and Japanese food as well as cocktail bars, Cahoots and The Rum Kitchen. It is a lovely setting around a courtyard and eating is alfresco during the summer months.

Exit Kingly Court onto Kingly Street where you will see some excellent examples of early 18th century Georgian housing.

Turn left along the street, right at the junction (Beak Street) and continue walking until you return to Regent Street. Cross over the main street, turn left and take the next turn, Heddon Street.

HEDDON STREET FOOD QUARTER [9]

For food aficionados this is a hidden paradise with an interesting variety of restaurants offering some excellent cuisine. Lodged just behind Regent Street, it has to be the ideal place to take time out from shopping, relax and take some refreshment. The quarter is especially noted for IceBar London where not only the glasses, but also the bar, walls and tables are all made from Swedish ice. Customers are given 40-minute sessions in the bar – plenty of time to sample the wide range of cocktails and yet not long enough to get too cold!

The Food Quarter is home to Gordon Ramsay's Heddon Street Kitchen, Moroccan Momo, as well as Aubaine with its French brasserie food, tibits, vegetarian delicacies and Piccolino, contemporary and traditional Italian cuisine.

Walk to the end of the street (it is actually a crescent and you will return to Regent Street).

Now if you look to the right you begin to see **the Quadrant [10]**, the street's stunning curve, and appreciate the vision of John Nash in building such an architectural masterpiece.

Here we take a slight detour into Mayfair. Turn right into the next road along Regent Street, Vigo Street, and within a few moments London's foremost men's tailoring enclave is on your right.

SAVILE ROW [11]

Internationally acclaimed for its extremely high quality hand-made and individual tailoring, Savile Row is also a wonderful example of 18th century Mayfair's fine housing, although many of the buildings have been altered with glass frontages to accommodate tailors' basement studios in the intervening years. The area, once full of fruit trees, was developed between 1731 and 1735. Numbers 1, 22 and 23 owe their design to the celebrated architect, William Kent (responsible for Horse Guards on Whitehall), whilst the remainder were designed by Henry Flitcroft as part of the Burlington Estate, and much influenced by the Palladian style of architecture.

It was not until the turn of the 19th century that tailors established their shops here. Prior to this the street had been home to affluent military men and their spouses, as well as the playwright, Richard Brinsley Sheridan and politician/statesman, William Pitt the Younger. Unfortunately, none of the early Savile Row tailor shops exist today, although Henry Poole & Co has been resident here since the middle of the 19th century. It is said that it was Poole who created the dinner jacket, having made a smoking jacket for the future Edward VII in 1860, and tailors have been fitting out monarchy, foreign leaders, the military and world famous stars ever since.

In 1969 no. 3 Savile Row became the Beatles' 'Apple Corps' offices and it was on its roof that the group recorded their final live performance in January 1969. The adjacent building (no. 1 Savile Row) is home today to the gentlemen's outfitters and tailors to the military, Gieves & Hawkes, and it is indeed a very attractive 18th century townhouse. From 1870–1912 these were the premises of the Royal Geographical Society and at the time the street was noted as much for adventure and travel as for tailoring! David Livingstone's body was actually laid out in state at the Society's premises on his death in 1873, prior to his burial at Westminster Abbey.

Since the latter part of the 20th century the street has gone through a certain amount of modernization both in its shop appearances (larger windows and window displays) and in the designs on offer. Classic tailors like Hardy Amies, Henry Poole & Co, and Gieves & Hawkes, have been joined by Ozwald Boateng, Richard James, Jeff Banks and Alexander McQueen. A controversial newcomer in 2007 was the US fashion label, Abercrombie & Fitch. The street's tailors put forward arguments to prevent Abercrombie from taking up residence, pointing out that its leisurewear products were out of keeping with the 'bespoke' nature of Savile Row's tailoring, where a two-piece suit hand-made on the street is likely to take at least fifty hours to complete. In contrast, Abercrombie's clothing is factory-made and mass-

Gieves & Hawkes

produced. At least, Abercrombie's shops (they have since opened a children's store at no. 3 Savile Row too), are quite discreet, carrying no garish signs, and almost a decade on the brand seems to have become tolerated, if not entirely accepted by Savile Row's traditional shopkeepers.

Return to the junction of Vigo Street and Savile Row.

You will see directly across the street a very beautiful Georgian building, sporting several Royal Warrants on its façade, the premises of Ede & Ravenscroft, London's oldest tailor shop. It is renowned for selling classic and contemporary menswear and specializes in ceremonial and legal attire in its other branches around London.

Now, turn right into Burlington Gardens. Pass by the impressive neoclassical building on your left, part of the Royal Academy but originally built as the Headquarters of the University of London, and then the Burlington Arcade (see Chapter 6). Bond Street is ahead of you at the junction.

BOND STREET

Although referred to as Bond Street it is in fact, two streets: **Old Bond Street [12]** and **New Bond Street [13]**. You are standing by the former, which stretches south (left) towards Piccadilly and as its name suggests, is the older street, having been developed in 1680. New Bond Street was built some 50 years later, and leads into Oxford Street. Both streets are lined with designer shops, perfumers, high-end jewelers and top fashion houses. It is an entire area of luxury and expensive shopping and includes names like Cartier, Jimmy Choo, Alexander McQueen, Tiffany & Co, Smythson, Prada, Michael Kors, Ralph Lauren, Chanel and Hugo Boss, amongst many others.

Ever since Bond Street was developed by Sir Thomas Bond in the early 17th

The Royal Arcade

century, it has served the requirements of the local aristocratic and wealthy population with its provision of the most exclusive, high-status shops. Bond (1620–1685) a landowner with properties in south London as well as in the north of England, was made a baronet in 1658, and was Comptroller for the household of Queen Henrietta Maria, King Charles II's mother. Of interest perhaps is Bond's family motto: *Orbis non sufficit,* meaning 'the world is not enough' – later to be used as the title of a movie centered around his namesake, James Bond. Quite apt, as 007 would not be out of place shopping in Bond Street.

New Bond Street is particularly famous for its two auctioneers, Bonhams and Sotheby's, and both open to the public for sales and viewings. The area is full of art galleries too, some on New Bond Street, with a concentration located in nearby Cork Street.

Roughly halfway along the street (where it is pedestrianized) you will see a bench seating two familiar figures: Franklin D. Roosevelt and Winston Churchill. The 'Allies' bench **[14]** is the work of sculptor Lawrence Holofcener and shows the two great statesmen in the midst of conversation. It is unusually realistic and very popular with tourists who jostle with each other to sit down between the two men and have their photo taken. The landmark was a gift in 1995 from the Bond Street Association (shopkeepers and businesses of Bond Street) to mark 50 years of world peace.

Now, retrace your steps back to Regent Street, and walk along the curve towards Piccadilly Circus. On the left towards the end of the bend you will see Regent Street's newest hotel, Hotel Café Royal.

Hotel Café Royal [15]

The legendary Café Royal restaurant and bar began life in these premises in 1865 and throughout most of its existence was the most fashionable place to be seen and to meet up with London's top social set. With an exceptionally plush interior as well as excellent dining and wine cellar, its allure was so great that for well over a century it was frequented not only by writers and playwrights, artists, and actors but also politicians, rock stars and even royalty. Two future kings of England (Edward VIII and George VI) were patrons of this wonderful Parisian-styled café in the early part of the 20th century, and several decades later, the Café Royal became a haunt too of Diana, Princess of Wales.

Oscar Wilde and Aubrey Beardsley were often to be found at the Café where they and other bohemian writers and artists would be seen in deep discussions. It was at the Café that Wilde was actually advised by his friend, the literary agent, Frank Harris, to drop his proposed libel charge against the Marquess of Queensberry; advice he failed to take, which resulted in his subsequent trial at the Old Bailey, conviction of sodomy and imprisonment at Reading Gaol.

View of Westminster from the Café Royal dome penthouse

During the 1950s the venue became famed for its boxing matches and diners would attend a black tie dinner before the events began. At that time Muhammad Ali was a regular face at the Café. Interestingly, it was not a new association with boxing; practically a century earlier in 1867, the Queensberry Rules for Boxing were set down here by the Earl of Lonsdale and the Marquess of Queensberry.

In the 1970s, singer/songwriter, David Bowie, used the Café to 'retire' his alter ego, Ziggy Stardust. The glittering event was a party of the stars and became known as 'The Last Supper'.

Despite its previous fame the Café Royal restaurant lost popularity over the years and finally closed its doors in 2008. New owners acquired the premises and after a complete overhaul the Café Royal Hotel opened as a luxurious five-star hotel. With more than 160 guest rooms and suites, the restaurant's history is still evident in its

Oscar Wilde Bar, the Café Royal's original Grill Room. Extreme care has been taken by the proprietors in its recent refurbishment, and once again it is decorated in the Louis XVI style. The Hotel's bar and restaurant are open to non-residents and it is undoubtedly a splendid location for afternoon tea or an early evening cocktail.

At the end of the Quadrant you will reach Piccadilly Circus. Regent Street continues to the right of the statue of Eros and leads down towards Pall Mall, The Mall and St James's Park (see Whitehall & Downing Street chapter).

Turn immediately left at the Circus into Sherwood Street and stop outside Brasserie Zedel **[16]**.

Regent Palace Hotel

The hotel, constructed in 1914, just opposite Eros and sited on a triangular piece of land behind Regent Street (on Piccadilly Circus's northern side) was the largest hotel in Europe at the time it was built. It was the most striking building, faced in terracotta and with a green slate roof. With its wonderful Beaux-Arts design, grand exterior and sumptuous interior furnishings the hotel was likened to grand transatlantic liners of the day. Although not quite in the same class as the Ritz Hotel on Piccadilly, it nonetheless, offered many luxuries and provided maids to run baths for the hotel guests as well as to serve them tea.

The hotel underwent some changes in the 1930s when the architect, Oliver Bernard developed the basement area in the Art Deco style with designs considered by some of the press to be a little 'naughty'. At this time there were two popular bars, The Chez Cup Bar and Dick's Bar as well as a very capacious dining room.

Sadly, the hotel went into decline in the latter part of the 20th century and when its closure was announced in 2004, it was feared that the beautiful 1930s basement interiors would be lost forever. However, the Crown Estate, having embarked upon its redevelopment of Regent Street, was able to ensure that the basement furnishings

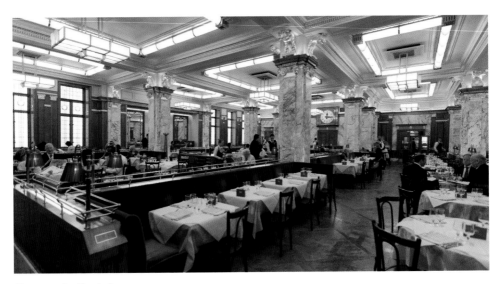

Brasserie Zedel

were not only kept but also sensitively restored. Today, the premises, occupied by **Brasserie Zedel**, are indeed a testament to its former 1930s decor and opulence. Wonderful, reasonably priced French brasserie food is served in the vast mirrored and columned dining hall, which is more reminiscent of Paris than London! Dick's Bar is now Bar Americain, with a definite Art Deco theme, whilst the Chez Cup Bar has become Crazy Coqs Cabaret and Bar whose program ranges from classical music to jazz, theater, comedy and even literary events. To ensure you don't miss what's on check the restaurant's website (*www.brasseriezedel.com*).

Upstairs on street level there is a delightful café where on a warm day you can sit outside and watch the world go by. The nearest underground station is **Piccadilly Circus *(Piccadilly, Bakerloo lines).***

ENVIRONS OF REGENT STREET:

SHAFTESBURY AVENUE

Shaftesbury Avenue must be the most acclaimed and well-known street for its abundance of theaters and nightlife. It is also the artery that separates Soho on its northern side, from Chinatown to the south.

Shaftesbury Avenue is named after the 7th Earl of Shaftesbury, Anthony Ashley-Cooper, a major Victorian philanthropist who worked tirelessly to improve the plight of the poor working classes. He campaigned furiously to outlaw women and children working in the coalmines and also for regulation in the employment of boy chimney sweeps. His funeral in 1885 was held at Westminster Abbey, and the surrounding streets were filled with London's poor and decent workers such as flower girls,

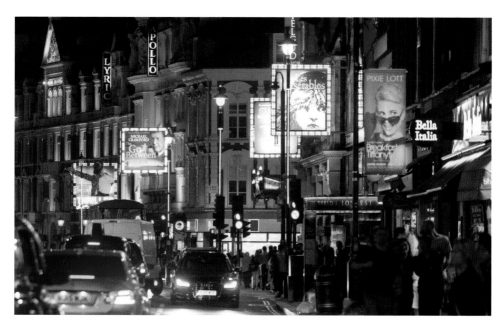

Shaftesbury Avenue at night

crossing sweepers and costermongers who wanted to pay their respects to the man they so admired. It was on account of his continual pressing for better treatment that he was nicknamed the 'Poor Man's Earl'.

Shaftesbury Avenue is rarely quiet, day or night, but it gathers momentum as dusk falls and theatergoers arrive on the scene. It was not so many years ago that there was a formal dress code for a visit to the theater but those days have long passed, and now anything goes.

As you walk along the right side of the street you cannot help but see four theaters opposite: the Lyric, Apollo, Gielgud and Queen's. Dating to the late 19th/ early 20th century they were designed by the noted theater architects of the day WGR Sprague, CJ Phipps and Lewin Sharp, and are wonderful examples of opulent Victorian and Edwardian decoration and architecture. Seating between 775 and 1200 people in their lavish auditoriums, each theater has its own particular style and character and theater productions have themes ranging from straight drama through to comedy, farce, Shakespeare and musicals. In fact, *Les Misérables* has been showing at the Queen's Theatre since 2004 (after an 18 year run at the Palace Theatre nearby), making it London's longest-running musical of all time.

Shaftesbury Avenue sits in the very heart of London's theaterland, considered to be the largest concentration of theaters in the world. More than 40 mainstream theaters are located here and numbers swell even more when the fringe and alternative theaters are added. Tickets for all performances are available at theater box offices, online or you can

Wardour Street sign

queue for tickets on the day at the half-price ticket booth in Leicester Square.

Nowadays, most ownership of London's theaters comes under the umbrella of several theatrical groups such as, Andrew Lloyd Webber's Really Useful Group, Cameron Mackintosh's Delfont Mackintosh Ltd, The Ambassador Theatre Group and Nimax.

CHINATOWN

Turn right opposite the Queen's Theatre into **Wardour Street [17]** and in seconds you find yourself right in the heart of Chinatown with its array of Chinese signs, shops and restaurants. Take the next turning off to the left (by the imposing gateway) into **Gerrard Street [18]**, which is the heart of the district. Here you will be engulfed in wonderful aromas, as the street is simply brimming with restaurants. There are Chinese bakeries, herbalists, grocers and supermarkets selling many unusual oriental foods and spices. Look out for the pair of stone lion statues, a gift from the People's Republic of China, and the Chinese pagoda in Newport Place.

Before World War II the Chinese community was based in East London in Limehouse, which had been its home for over a century. Heavy bombing throughout the war meant that many homes and businesses were totally destroyed and this resulted in the move westwards into the West End. Finding low rents offered on properties in the streets south of Shaftesbury Avenue, Chinese entrepreneurs began living and trading in the area and this was the beginning of Chinatown as we know it today. Present day Chinatown spreads over a much greater area, extending north from Leicester Square to Shaftesbury Avenue encompassing Lisle Street, Gerrard Street, Dean Street and Newport Place. Look up at any street sign in the area and you are sure to know you are in Chinatown as they are written in both the English and Chinese scripts.

Come here any day of the year and the neighborhood is bursting with tourists, restaurant-goers, as well as its resident Chinese community. It is especially vibrant

around the time of the Chinese New Year when you can expect to see fireworks, lion and dragon dances, sample local cuisine and take part in many celebrations.

Now, return to Shaftesbury Avenue, cross the road and walk down the northern side of **Wardour Street [19]** into Soho.

SOHO

Much has been written about the seamy side of this London 'village' and for many years its reputation was tarnished by sleaze and prostitution, but to a great extent Soho has reinvented itself in the past 50 years. Still known and regarded as London's red-light district, it is also renowned for its thriving publishing, music and media businesses and as being a center of the gay scene. Certainly, on first glance it is much less seedy than it once was; now the narrow streets are simply full of wonderful specialist shops such as The Algerian Coffee Stores and Gerry's Wines and Spirits, but also many cafés, bars, pubs, patisseries and restaurants. **Old Compton Street [20]** is regarded as Soho's high street, and doesn't appear to be much different from many others around the UK. That is not to say that you won't find sex shops and peep shows in and around the streets here, but they are far fewer in evidence than in times gone by.

Stroll along any of Soho's streets after dark and the atmosphere changes. Once the theaters have shut, people come out to dine and the clubs and bars are in full swing, you will see an entirely different side to the area. This is when Soho really comes alive and continues to buzz until well into the early hours of the morning. Anything goes here, and you can easily find theater, comedy, cabaret and jazz in and around Soho's enclave. The Soho Theatre on Dean Street **[21]** is a popular venue as is the well established and much loved, Ronnie Scotts's Jazz Club on Frith Street **[22]**.

Closest tube stations to Soho are: **Piccadilly Circus *(Piccadilly/Bakerloo lines)*, Leicester Square *(Northern/Piccadilly lines)*, Tottenham Court Road *(Central/Northern lines)*, Oxford Circus *(Central/Victoria/Bakerloo lines)*.**

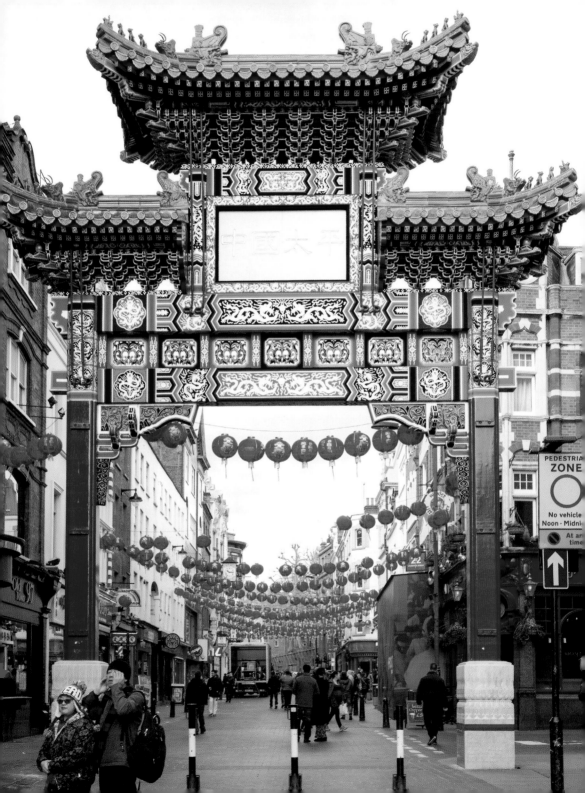

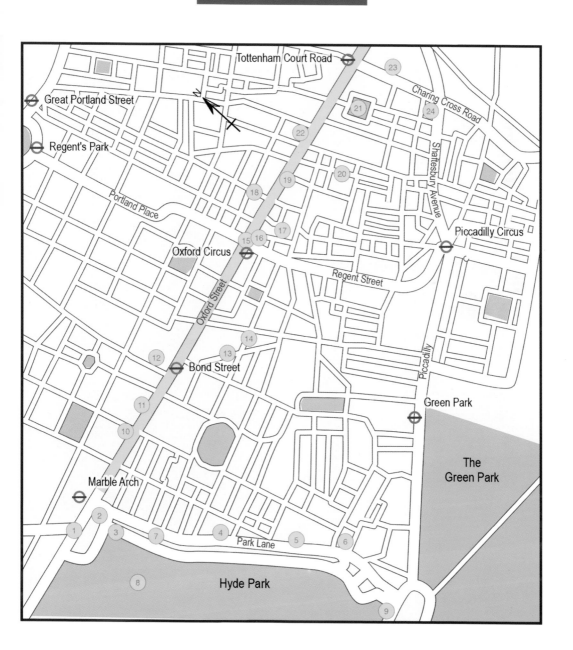

OXFORD STREET

Oxford Street requires little introduction as it is surely one of the most renowned shopping streets in the world. The 1.9 km (1.2 mile) street is lined with all manner of shops ranging from popular high street brands like Zara, Gap, Next, Boots and H&M, to the music emporium HMV as well as the well-known grand department stores, Selfridges, House of Fraser, Debenhams, and John Lewis. These sell everything from cosmetics, beauty products and perfume to clothing, household and electrical goods. In addition, M&S, renowned for its clothing, lingerie and food departments and Primark, for its up-to-date affordable fashion clothing, maintain a presence at either end of the street with their large flagship stores. Oxford Street stretches between Marble Arch in the west and Tottenham Court Road to the east, has four underground stations along its length and is undoubtedly a shopper's paradise.

As it is such a busy area many would like to see it fully pedestrianized and it is probably only a matter of time before this might come about. In fact, London's recently elected Mayor, Sadiq Khan, is in favor of making the street traffic-free and has pledged its pedestrianization by 2020. Time will tell!

Already the street is prohibited to cars but taxis and red buses are plentiful, which is greatly appreciated after a day's shopping.

Until the development of the land here in the 18th century, the street was the main and

Selfridges

highly congested route from the west of England and Wales, known as the Waye to Uxbridge. Drovers brought their dairy herds across country for slaughter at Smithfield Market on the edge of the City of London. Only in 1756 when the 'New Road' was built (see Chapter 2) did the situation start to improve. Within 50 years much of the land that lay south of the New Road was developed for housing by the Earl of Oxford. Those living in the area naturally required shops and Oxford Street soon fulfilled their need becoming a busy, thriving shopping street (taking its name from the landowner, the Earl of Oxford).

Initially it was filled with drapers, cobblers and furniture shops, but as shopping habits changed in the latter part of the 19th century many of these shops were replaced by larger department stores: Marshall & Snelgrove (later, Debenhams), John Lewis, and then Selfridges in the early 20th century. Over the years some of the stores closed and became reinvented as smaller retail units, but the ethos of the street as a major retailer has endured. The eastern side of the street after Oxford Circus is now known mainly for its high street brands and souvenir shops, language schools and offices.

In contrast, most of the department stores are located at the western end of the street that has a more exclusive feel; being close to Hyde Park, to Mayfair and many of the luxury Park Lane hotels.

Our walk begins at **Marble Arch underground station** *(Central line)* and finishes at St Giles Circus at **Tottenham Court Road station** *(Central, Northern lines).*

Exit the station and turn right into Oxford Street. Cross the road by the Odeon Cinema onto the traffic island and stop beside the floor plaque commemorating the Tyburn Tree.

Tyburn Tree [1]

For many centuries this was the site of the notorious Tyburn gallows – where traitors, religious martyrs and criminals were executed from 1196. The Tyburn tree stood right in the center of the road and became a local landmark. It was placed there towards the end of the 16th century to act as a deterrent to criminals, and was erected in such a way that mass executions could be carried out as the 'tree' was formed of a horizontal wooden triangle held up by three legs (with a leg at each corner). In 1649, it was used to hang twenty-four people simultaneously, brought to Tyburn in eight separate open ox-carts. The prisoners were held beforehand at Newgate Gaol in the City of London and traveled here via St Giles in the Fields (by Tottenham Court Road) and Oxford Street. Crowds, wearing their best clothing to attend the executions, would line the street and cheer on the prisoners. Often the short, three-mile trip took three hours as the carts were inclined to stop off at inns en route so that the convicts could have a last drink or two and prepare themselves for what was to come.

Initially, bodies of the condemned would have been buried close to the gallows, but in later times, anatomists and surgeons claimed the bodies for dissections and sometimes this would lead to disputes with the crowds who feared such ungodly practices.

Execution days were considered by many as a day out, and the apprentices were actually given a day off work to attend. Hanging was always a popular event and people were even prepared to pay a fee to get a direct view! Temporary stands were built to accommodate the visitors and thousands would descend upon the area to watch the gruesome affair. Occasionally a stand would collapse and people would be hurt, some even killed. William Hogarth in his satirical print *The Idle 'Prentice Executed at Tyburn* (1747) illustrates a group awaiting execution, which depicts the scene all too well.

The practice of hanging at Tyburn was finally brought to an end in 1783 with the execution of highwayman John Austin. During the period that hangings took place here two notable executions were carried out: **Thomas Culpeper** (courtier to King

Henry VIII and named adulterer of Henry's fifth wife, Catherine Howard), and **Oliver Cromwell**, Lord Protector of the Commonwealth (1653–1658), taken from his place of rest in Westminster Abbey, and given a posthumous execution on the site. It is unknown how many died here but the name 'Tyburn' ultimately became associated with capital punishment and it was common to refer to one's execution as 'dancing the Tyburn jig' or 'taking a ride to Tyburn'.

Now turn south to see a large ceremonial stone monument:

Marble Arch [2]

This grand triumphal marble archway was modeled on the Arch of Constantine in Rome. Although originally built to stand outside Buckingham Palace it was moved in 1851 to the north-east corner of Hyde Park, and has remained in the vicinity ever since. For a little over 100 years until the late 1960s, the three rooms within the building were used as a police station, initially for the Royal Constables of the Park, and later for the Metropolitan Police. It was from the roof that the police would monitor events down at Speakers' Corner in the park and rush out if their assistance was needed.

PARK LANE

Today, Marble Arch marks the northern end of **Park Lane**, the road that connects Oxford Street to Hyde Park Corner and Buckingham Palace. It is a major route that runs beside **Hyde Park**, and is renowned for its many upmarket hotels such as the London Hilton Park Lane, The Dorchester, and Grosvenor House hotel. Just within the park, in its north-east corner, is **Speakers' Corner [3]** a site which since the 1800s has been renowned for free speech. As popular today as it was in the 19th century when Marx, Lenin and George Orwell spoke to their followers, it is still the place to come and listen to passionate orators.

If time allows, it is worth a slight detour south along Park Lane.

As the second most valuable property on the Monopoly board, Park Lane really should not be missed! It is one of the capital's prettiest streets, constructed as a wide boulevard, and containing a number of buildings of great architectural merit that look out across the leafy expanse of Hyde Park.

Once a rural path running beside Hyde Park, the road's development initially began in the 18th century when large villas and mansions were erected. It was about this time that the 'village' of Mayfair took shape just to the east of Park Lane. The Duke of Westminster's exclusive housing development catered especially for the upper echelons of society, offering very smart housing and shops, so an address on Park Lane was very much sought after. Almost 300 years later, this remains true and Park Lane continues to be a decidedly stylish part of town, so close to all of London's amenities, yet standing slightly apart from the everyday bustle of its shops and crowds.

Grosvenor House hotel

During the 19th century the street was dominated by enormous privately owned homes. Their owners were undoubtedly most affluent and powerful, and included both aristocrats and millionaires and even, William Gladstone, a British Prime Minister! Nowadays, there are far fewer large family houses and mansions; some have entirely disappeared, replaced by apartment blocks with super-expensive penthouses, whilst others have been rebuilt, sometimes as offices or even as car showrooms. BMW, Mercedes Benz, Lotus and Aston Martin all have a presence on the road, reflecting the clientele who either live in or visit the area.

By the early 20th century, two five-star, state-of-the-art hotels, the Grosvenor House **[4]** and the Dorchester **[5]** replaced the former mansions on their sites, and over the course of the century many other luxury hotels established themselves on the street too. Most are found towards its southern end close to Hyde Park Corner, where the 28-storey **London Hilton Park Lane [6]** dominates the skyline.

The Dorchester, opening in 1931, was built to be the 'perfect hotel' and had every modern convenience, including telephones, soundproofed walls and draught-proof windows. The public spaces were vast, and in the basement there were Turkish baths and garages. The ballroom was the talk of the town, with mirrored walls set with sparkling studs. Throughout this period the Dorchester remained synonymous with all that was most fashionable and opulent in British society. Even during the war years guests returned to the hotel; having been constructed from reinforced concrete, it was thought to be the safest hotel in London, so much so, that some of the Cabinet Ministers moved in for the duration.

One or two of the great literary and political society hostesses of the time including Emerald, Lady Cunard, even moved their dinner parties to the hotel, and General Eisenhower, who had originally set up home at Claridge's, was given two rooms on the first floor (now, the Eisenhower Suite).

The Dorchester has been consistently popular throughout its existence. Famous sports personalities, actors, writers, statesmen, singers, musicians, business moguls and every type of celebrity have stayed at the hotel taking advantage of its great

comfort and luxury. It was here at the hotel in July 1947 that the engagement between Princess Elizabeth and Prince Philip was announced and later, it was the venue for Prince Philip's stag party.

Not far from the Dorchester, in the gardens between the hotel and Hyde Park (at the Oxford Street end of Park Lane) is a somewhat unusual memorial that symbolizes and remembers the role that animals have played during wartime. Unveiled by the Princess Royal in 2004, the **Animals in War Memorial [7]**, designed by English sculptor David Backhouse, is made up of a 21 metre (70 foot) curved Portland stone wall inscribed with elephants, carrier pigeons and camels. A pair of heavily-laden bronze mules approach the gap

The Dorchester

in the wall, whilst on the other side of it, there are two statues of a dog and horse, contemplating a more hopeful future.

Immediately opposite is **Hyde Park [8]**, one of London's great Royal Parks, and an extremely popular venue throughout the year. With its beautiful Serpentine Lake, lido, gardens, art gallery, wide open spaces, and horseriding routes it is a wonderful green space right in the center of town. Many events and festivals are hosted in the park including the annual Winter Wonderland festival and British Summer Time Hyde Park.

The southern end of the street brings you to one of London's major traffic roundabouts, **Hyde Park Corner [9]**. Its central island is awash with military memorials as well as the imposing Wellington Arch. Roads radiate off towards

Animals in War Memorial

Knightsbridge, Victoria, Buckingham Palace and Piccadilly and as the traffic never stops it is not the place to come if you're a nervous driver.

Return to Oxford Street and turn right. After a short walk you will see M&S [10] on the left side of the street.

M&S is an enduring brand, having begun as a market stall in Leeds, in the north of England in 1884, with a slogan of 'don't ask the price, it's a penny'. Within 20 years the stall had become a shop and from then on the business went from strength to strength, with M&S merchandise being celebrated for quality and reasonable prices. Throughout the 20th century M&S stores appeared in nearly every high street in Britain, and stand-alone food shops, Simply Food, opened in 2001.

M&S's store adjacent to Selfridges is one of two in Oxford Street (the other is located on the east side of Oxford Circus). Both are the company's flagship stores, selling men, women's and children's clothing, high-quality cashmere and lingerie, as well as household goods and food. The stores are extremely popular with both overseas and British customers and renowned for their high-grade products and excellent customer service.

Immediately adjacent to M&S you will find:

Selfridges [11]

It is impossible to conjure up the excitement that was felt just over 100 years ago when **Harry Gordon Selfridge** opened his department store on Oxford Street. The builders had been on the site for several years and the store had been anticipated, but no store of such a size and breadth had ever been marketed to such an extent before in London. Selfridge was a real showman, and had great passion and amazing energy for everything to do with life and his store. Oxford Street, for the first time experienced a real deluge of publicity and marketing and it was very successful.

Selfridge wanted his store to be a place that his customers could stay for the whole day, browsing in the numerous departments, being pampered in the hair salon, dining at one of the restaurants or enjoying a peaceful moment in the 'quiet' room. He also wanted to ensure that his shoppers had access to celebrities, be it film or tennis stars, who would give demonstrations on site and maybe even provide personal lessons in their sport. He had a particular fondness for the latest technology (the store pioneered the sales of telephones and TVs), and he was at the forefront of aviation, displaying Louis Bleriot's aeroplane within the store, and even running an Aviation Department headed by an aviator (later to become Britain's senior test pilot during World War II).

His innovative idea to have a 'Bargain Basement' appealed to many and meant the store catered for every customer, whatever their means.

Selfridge was a legend in his own lifetime; a workaholic, with a weakness for women and gambling. He loved a good time and certainly lived a lavish and extravagant lifestyle. After the death of his wife in 1918 he got through an enormous amount of money that subsequently left him penniless at the end of his life. A sad ending perhaps, but his legacy, in the form of Selfridges, still prevails and remains one of London's most popular stores. The present Canadian owner, Galen Weston, bought the store in 2003 and continues to offer the public the service and quality of merchandise that Selfridge first introduced when the store opened its doors in 1909.

Turn left from the store and opposite Bond Street station turn into:

GEE'S COURT & ST CHRISTOPHER'S PLACE [12]

The narrow alley leading off Oxford St into Gee's Court could very easily be missed as you walk along the street but it is worth a slight detour. As you enter you will see a plaque on the wall with a brief account of the area and its shops and then you pass by several fashion shops on either side before the passage fans out into a square full of pavement cafés and restaurants. St Christopher's Place leads north off the square and is also lined with boutiques and independent shops and bistros. Such a wonderful sanctuary amidst the activity of Oxford Street and a great place to wind down and relax!

St Christopher's Place

SOUTH MOLTON STREET & BROOK STREET [13]

This is a pedestrianized street on the opposite side of the road just after Bond Street Station. Full of interesting small designer shops and restaurants, it is also a convenient cut-through from the main shopping street into Bond Street and Mayfair. If you walk to the end of the street at the junction with **Brook Street**, you will see an excellent example of Georgian housing in front of you, previously home to two celebrated musicians: George Frideric Handel and Jimi Hendrix. They actually lived in neighboring apartments but 200 years apart! Their homes are now open as **Handel & Hendrix in London [14]** and give a superb insight into the lives of these two very different musicians. Hendrix lived for a short period in the late 1960s in an upstairs flat at no. 23, and here you can see where he entertained his friends, where he wrote new music, rehearsed and gave interviews to the media.

Handel, in contrast resided at no. 25 for 36 years, occupying two floors of the house so you will be able to see his bedroom as well as his dining room where he would hold informal recitals. This landmark address is where Handel composed some of the greatest music in history including *Messiah*, *Zadok the Priest* and *Music for the Royal Fireworks,* and is where he died on 14 April 1759.

Just a short walk along Brook Street will bring you to Claridge's, one of London's most exclusive, luxurious hotels. This is an excellent venue for afternoon tea, or for fine dining at its Michelin-starred restaurant, Fera at Claridge's.

Return to Oxford Street and turn right. As you walk along you will see on the left-hand side of the road:

Department stores

The three large stores you pass by, John Lewis, Debenhams and House of Fraser, all carry a very wide range of merchandise and cater for every age and type of

Hendrix's guitar

customer selling designer as well as high street clothing, homewares, accessories and cosmetics. All open daily, although Sunday hours are limited to 12 pm–6 pm.

John Lewis's policy of being 'Never Knowingly Undersold' means that if you buy a product here and find the same item cheaper elsewhere, they will refund the difference; a great slogan and very popular with its loyal customer base. John Lewis Oxford Street is the flagship store although you will find Peter Jones on the Kings Road, Chelsea and other John Lewis branches at Canary Wharf and in Stratford, by the Olympic Stadium.

OXFORD CIRCUS [15]

Oxford Circus has its own underground station and is where Oxford Street and Regent Street meet and as such is an extremely busy area. At Christmas time it is really a wonderful place to be as both streets have striking overhead lit decorations and the area takes on a magical quality. As a youngster I remember being driven up here just to see the 'lights' and it was the greatest treat to see the latest decorations. In fact, the street has celebrated the festive season with decorations and entertainment for 57 years and many famous celebrities (including Kylie Minogue, Emma Watson, Leona Lewis, Robbie Williams, Jessie J and the Spice Girls) have opened the season by 'switching on' the lights. It is a wonderful spectacle held on the street and usually

The Argyll Arms

accompanied by an evening of live musical entertainment.

Just beyond the Circus on the right is a small turning, **Argyll Street**, beside one of the tube station entrances. Immediately you will see an historic pub, the **Argyll Arms [16]**, which is one of a chain of London pubs run by Nicholson's. The pub dates from the 19th century and is a typical example of a Victorian pub with stunning etched glass partitions, carved ceiling and wooden interior. Like many such pubs it has several individual rooms, all accessible to the bar, but each with its own unique atmosphere. Due to its position the pub can get quite busy but if you pop in either side of lunchtime you are likely to be able to find a seat and experience one of London's more interesting and attractive watering holes.

Almost opposite the Argyll Arms is the famous 'Ace Variety theater of the World':

London Palladium [17]

In the 1880s the site of today's theater was home to Hengler's Circus. The current building was erected in 1910 and from its beginnings presented variety, a form that it has continued to offer to audiences right up to the present day. In fact, it has hosted the annual Royal Variety Show so many times that its name is practically synonymous with the event.

In 1931 the London Palladium saw the emergence of a group of comedians who together formed what became to be known as the famous Crazy Gang and occupied the theater between 1931and 1939.

During the mid-1950s the London Palladium became familiar to many millions in the country on account of its weekly television variety show, *Sunday Night at The London Palladium*. Apart from variety, the theater was also a venue for pantomime in its early years, and then concerts. It was in 1964 that Judy Garland and her daughter Liza Minnelli performed together on the Palladium's stage before a standing room only house. It was Minnelli's first public stage appearance with her mother.

From the 1980s in particular, the London Palladium become associated with large-

London Palladium

scale musicals: *The King and I, Barnum, Singin' in the Rain, La Cage Aux Folles, Show Boat, Oliver!, Chitty Chitty Bang Bang, The Wizard of Oz, A Chorus Line,* and *Cats.* Now owned by Andrew Lloyd Webber's Really Useful Theatres Group, the theater continues to stage large-scale musicals and the *School of Rock* transferred here from Broadway in October 2016.

Return to Oxford Street.

Look across the street as you walk along and you will pass by Great Portland Street and Great Titchfield Street. These mark the entrance into what is regarded as the

West End's **Garment District [18]**. Only a block behind the fashion stores of central London's main shopping street you discover fashion showrooms and wholesalers, many of which display signs saying 'Trade Only'. These businesses service the retail outlets and much of their clothing will ultimately appear in the high-street fashion shops nearby. However, the area is changing: rents are steadily increasing causing the garment showrooms to move out of the district, replaced by galleries, cafés and even hotels. The area is far less frenetic today than it was in its heyday when the streets were bustling, full of people pushing around garments on metal clothes rails to be distributed either to nearby shops or put on trucks to be delivered elsewhere in the country. Nonetheless, it is still interesting to walk around the district and look in the showroom windows to see the very latest in fashion.

Continue walking along Oxford Street. Look over to your right at Ramillies Street where you will see the **Photographer's Gallery** *(open daily). Stop outside M&S.*

The Pantheon – M&S [19]

This flagship store is called the Pantheon in memory of a building that was originally on the site. Unfortunately no evidence remains today of the 18th century popular entertainment center, but with its enormous rotunda (said to be one of the largest rooms constructed in the country at the time) and central dome it must have been a very grand venue. The Pantheon opened in 1772 and was immediately popular for its masquerades and concerts, but its success was short-lived and it then became an opera house. It later became a theater, then a bazaar before becoming a wine merchant's showroom. Almost a century later it was demolished and the site was purchased and developed by M&S for their new store.

Continue walking eastwards and then take the second turning on the right into:

BERWICK STREET & SOHO [20]

Berwick Street was developed in the 1730s in an area that had previously been open fields. By the end of the century much of the surrounding roads had been constructed and **Soho** was established as a residential village. As a result of religious persecution in France many French Huguenots (famous for their silk and weaving skills) decided to leave their homes and settled here. They were later joined by émigrés from Italy, Greece, Russia and Ireland and Jews from Eastern Europe. Such a diversity of races led to the area becoming most cosmopolitan, and it remains so to this day. A visit to Soho Square, with its French Protestant Church and St Patrick's Church is a good testament to this. Services at the latter cater for many local Catholic residents and workers with special masses held for the indigenous Spanish and Portuguese communities. Further evidence of the foreign influence in Soho is seen in street names such as Greek Street, and by the very great variety of cuisines on offer within its neighborhood.

Berwick Street is a narrow street and runs south from Oxford Street to Shaftesbury Avenue and is lined with small independent shops and boutiques giving it a real village feel. W Sitch & Co, dealing in antique lighting, has had its home on the street since the 1870s and proudly boasts of being Soho's oldest shop. Another longstanding outlet is Borovick Fabrics, reflecting Berwick Street's association with the fabric, textile and clothing industries. Borovick is especially renowned for stocking somewhat 'outlandish' fabrics and accessories such as lamé, stretch satin and sequins – extremely appealing for use in productions staged in London's theaters.

For well over 100 years shopkeepers and stalls have been manufacturing and selling fashion clothing from the street and in the early 20th century it was the center of the rag trade. Living in fairly squalid conditions, often on the shop premises, many of the locals worked as trimmers, buttonholers, embroiderers and suit and gown makers. It was a hard life but there was a great deal of conviviality both in the sweatshops and on the street. Merchandise would be sold at Berwick Street market and often for considerably less than in the Oxford Street stores, so in the early 20th century this is where young working girls came to buy their silk stockings and new

outfits. It is unlikely that you will find the former here today but there are still a number of fabric shops beside the market. Currently, undergoing various changes, Berwick Street Market opens Monday–Saturday and perhaps is now best known for its street food, specializing in salads, falafels and burritos.

Berwick Street has great associations with the music industry too and you will come across a number of independent record stores in the vicinity. Penned the 'Golden Mile of Vinyl' in the 1980s, Sister Ray, the vinyl and CD outlet, still maintains its presence here and remains the largest shop of its type in the West End.

Today, Soho is a real hub of the media and music industries with 20th Century Fox Film Co, Paul McCartney's MPL Industries offices, and the British Board of Film Classification all located in **Soho Square [21]**. It is also celebrated for its gay scene, prostitutes and sex shops, although this side of Soho is diminishing and many of the porn shops have disappeared with fancy new restaurants and cafés springing up in their place.

Return to Oxford Street, turn right and just past Wardour Street stop and look across the road.

100 Club [22]

If you look carefully you should be able to see the club's sign and the entrance door to London's oldest jazz club, the 100 Club. In 1954 it was taken over by Humphrey Lyttleton and called Humph's until the early 1960s. Over the years it has changed its music genres from blues, to reggae, rock and punk music in the 1970s when the Sex Pistols, the Clash and Siouxsie and the Banshees appeared. The 1990s saw the indie explosion with performances by Oasis and Suede. Today, it remains at the cutting edge of new music, supporting up-and-coming artists in its program.

The **Marquee Club** was another club along Oxford Street in the 1950s and 1960s. Located nearby M&S it was where the Rolling Stones made their debut in 1962. It was an extremely popular music venue that launched many bands and rock artists'

careers. Its long list of famous performers includes Long John Baldry, Manfred Mann, The Who, the Yardbirds, Moody Blues, Spencer Davis, David Bowie, Rod Stewart, Pink Floyd, Joe Cocker, and Black Sabbath. The club moved premises several times in its lifetime but finally closed its doors in the 1990s.

*Continue to the end of Oxford Street where the walk ends at **Tottenham Court Road underground station (Northern, Central lines)** on the right.*

ENVIRONS OF OXFORD STREET:

CHARING CROSS ROAD

Charing Cross Road was completed in the 1880s, built as a major route to connect the southern end of Oxford Street with Trafalgar Square and Charing Cross railway station. For many years its northern end had been overrun with slums and tenement buildings and the area had been badly neglected. Its fortunes changed with the construction of the road as it became increasingly more respectable, attracting new businesses, theaters and shops.

Running beside Soho, Covent Garden, Leicester and Trafalgar Squares, the street has many different characters. The north is dominated by bookstores whilst the south sits in the heart of tourist London – home to theaters, restaurants, cafés, clubs and bars. It is forever busy with noisy traffic and throngs of people, all the more so at night when theatergoers are on the scene.

Charing Cross Road came into the spotlight in the late 1980s largely as a result of the film, *84 Charing Cross Road*, starring Anne Bancroft and Anthony Hopkins. It was the tale of American Helene Hanff's 20-year correspondence and close relationship with Frank Doel, the chief buyer of an antiquarian bookstore, Marks & Co. Doel and his staff attended to her thirst for knowledge and passion for unusual and rare British

Quinto and Francis Edwards bookshop

literature, and she subsequently developed a very close rapport with them, regaling the workers with stories about her life in Manhattan and sending food parcels, and birthday gifts to compensate for post-war shortages in England. Sadly, the two never got to meet as Doel died in 1968. However, Hanff later traveled to London in 1971 and visited the shop, which by then had ceased trading. Today, the premises are home to a McDonald's restaurant and all that remains to remind you of their story is a small, round plaque outside the building.

After World War II, Marks & Co was one of many bookstores along Charing Cross Road, and even today there are still a good number selling second-hand and

antiquarian, rare books and first editions, like Quinto, Koenig Books, Henry Purdes and Any Amount of Books. Although the number has dwindled in recent years (largely due to competition from the internet and to rent increases), the much-loved **Foyles** remains, having just built itself a new flagship store beside its original shop.

When brothers, William and Gilbert Foyle, opened their shop in 1929, William described it as 'the world's first purpose-built bookshop'. Within no time it had established itself as a literary landmark, offering lectures and book events and William's daughter, Christina introduced her very successful Foyles Literary Luncheons in 1930.

Foyles now carries over 200,000 titles in its new six-floor building and claims to be the largest UK bookshop to have opened to date in the 21st century. It also boasts a department devoted to music and printed music. If you get weary of browsing through its 6.5 km (4 miles) of shelves you might want to take time out at the fifth floor café.

Practically opposite the store you will see:

DENMARK STREET [23]

Often referred to as 'Tin Pan Alley', on account of its similarity with New York's music enclave at the end of the 19th and early 20th century, it was full of recording studios in the 1950s and 60s as well as music publishers such as New Musical Express and Melody Maker. In those days, bands and artists like the Kinks, Elton John, the Rolling Stones and the Sex Pistols hung out here and were frequent users of the recording studios. For many years Denmark Street was packed with musicians, rockers, and punks who frequented its cafés and bars, especially 12 Bar Club and Enterprise studios. However, due to the major Crossrail development currently transforming the roads surrounding the street, Tin Pan Alley's future is now in question. On the positive side, the local council is eager to retain the music tradition of the street and although allowing modernization and refurbishment of the buildings, has agreed with the developers for leases to be solely awarded to music industry businesses.

Music shops in Denmark Street

Fans of J.K. Rowling's *Harry Potter* books will recognize the street as the location of the Leaky Cauldron pub.

Return to Charing Cross Road and turn left. Stop at Cambridge Circus and look across to:

The Palace Theatre [24]

This grand and striking building began its life as an opera house in the 1880s but was not a success and changed hands within a year. Shortly after the turn of the century it was

named the Palace Theatre and began presenting large musical productions, a practice that continues until this day. It has been host to many long-running shows including *The Sound of Music, Cabaret, Jesus Christ Superstar and Les Misérables*. Most recently (July 2016) *Harry Potter and the Cursed Child* opened at the theater. Hailed as great family entertainment and with rave reviews it appears destined for a long, successful run.

Continue along Charing Cross Road to Leicester Square underground station (Northern, Piccadilly lines).

The Palace Theatre

Selfridges

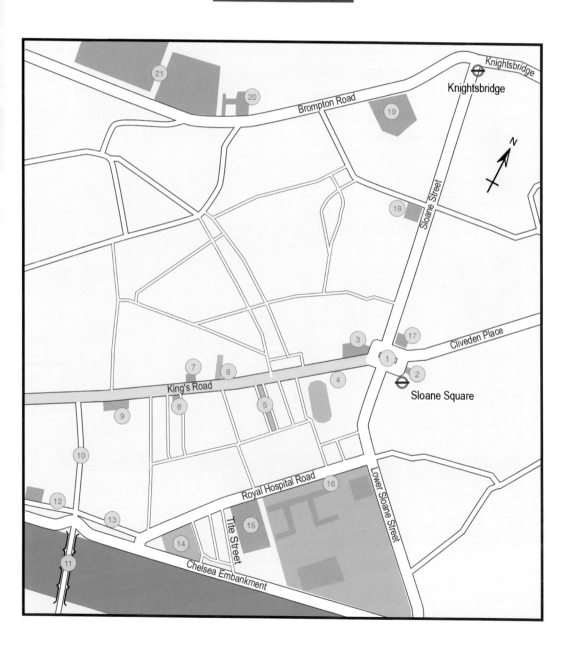

KING'S ROAD

To many the King's Road conjures up Ferraris, Aston Martins, sports cars, *Made in Chelsea*, 20-somethings, and the 'Sloane set' (rich, upper class young ladies who hang out in the area). It oozes with luxury and wealth, borne out by the shops you find along the street and in the neighborhood. That having been said, it is a very long road and its character and appearance chops and changes along its length. Stretching between leafy Sloane Square in the east and the World's End and Fulham to the west, the road is a good example of many London districts, where rich and poor live almost cheek-by-jowl.

The King's Road, is aptly named because in the 1660s it was the private route and carriageway taken by King Charles II to Kew Palace (west of London), and was only open to the king or his entourage. It was almost 200 years before it became a public road in 1830. At the time, the area was away from the center of London and decidedly rural in character. Close to the river Thames, but with a small population, it was really little more than a riverside settlement surrounded by market gardens. Because of its distance from central London and its enviable position

Sloane Square

beside the river it attracted the aristocracy and royalty: King Henry VIII, and his Lord Chancellor, Sir Thomas More, built substantial homes here in the mid-1500s, thus giving Chelsea the nickname, 'Village of Palaces'.

However, by the 19th century travel between the center of London and Chelsea was a dangerous affair due to the highwaymen who frequented these parts and so people would band together in groups to deter the scoundrels.

Today, as you wander in the area you will see many English Heritage historic blue plaques affixed to walls and houses that remind us of how many famous artists, philosophers and even film directors and actors have lived or worked in Chelsea and around the King's Road, cementing its claim to fame and celebrity. During the 19th and 20th centuries the area was filled with writers such as Thomas Carlyle, Leigh Hunt, Oscar Wilde, T.S. Eliot and American, Henry James, as well as artists, Dante Gabriel Rossetti, John Singer Sargent and James McNeill Whistler. More recently, it has been home to members of the Rolling Stones, as well as to Catherine, Duchess of Cambridge before her marriage to HRH Prince William in 2011.

From the mid-1950s it was a street with a wow factor; A young person's paradise, with its trendy fashion shops and bohemian clientele. First, Mary Quant's shop appeared, on the corner of Markham Square, later, in the early 1970s, Vivienne Westwood and Malcolm McLaren's store at the World's End. In the Swinging Sixties the King's Road was one of London's most exciting, thriving districts where music blared out, all manner of clothing was worn and acceptable. Bell-bottom trousers, miniskirts, high platform shoes and boots were all the rage, and young people flocked here on the weekends mincing up the street in their ever-more shocking gear. Within a decade the area had moved into the **punk** era that was all the more outrageous. The World's End, at the westerly end of the King's Road became a haven for punks and Malcolm McLaren became manager to the Sex Pistols, Britain's early punk rock band. Unlike the hippy culture of the sixties, punks wore clothing similar to bikers, with leather jackets, jeans, T-shirts and sported chains and spike-stud leather wristbands, and stood out against more conventional attire of the day. Since that time the street

has become less shocking, yet still is a marvelous location for people watching: see au pairs and nannies wheeling along their charges in buggies, locals taking their designer dogs for a walk, groups of affluent young people enjoying a glass of wine or lunching together in the Duke of York Square's restaurants and bars. It is still the same road but the atmosphere has changed, and other areas in the capital have taken over the radical and more bohemian role of earlier decades. With seriously pricey designer boutiques, the King's Road attracts a certain clientele, yet there are also many high street names in the street, which means that you should find something to buy here whatever your budget.

King's Road is often the shorthand used for **Chelsea.** It is part of the Royal Borough of Kensington and Chelsea, and runs alongside the river Thames to the south. It is bounded by Fulham Road and South Kensington to the north, Sloane Square to the east and Fulham to the west. It contains some of London's most expensive properties and is renowned throughout the globe for the following:

- The annual Chelsea Flower Show
- The Chelsea Pensioners at the Royal Hospital
- The Chelsea Physic Garden
- Chelsea's artists and writers – especially the Pre-Raphaelite Brotherhood
- Chelsea Football Club at Stamford Bridge
- Chelsea Buns, (a currant bun popular with royalty and sold at the Chelsea Bun House near to Ranelagh Gardens in the 18th and early 19th century).

The following walk is intended to introduce the King's Road and its nearby streets, to delve a little deeper into its character and to account for its continuing attraction as a major London destination.

We begin outside **Sloane Square underground station** *(Circle, District lines)* and as the walk is circular, will return here at the end of the tour.

SLOANE SQUARE [1]

You are standing looking into the very fine square that is dominated by its central fountain and London plane trees and is named after **Sir Hans Sloane** (1660–1753), a local resident, scientist and philanthropist. Sloane, was first and foremost a physician to royalty. He also had a great enthusiasm, in fact a passion, for everything connected with natural history. Whilst living overseas in Jamaica he amassed an amazing collection, some 71,000 objects, of coins, antiquities, books and prints, animals and plants, which when he died, he bequeathed to the nation for £20,000. In order to raise the necessary funds the government ran a National Lottery and the collection subsequently became the basis for the **British Museum** when it first opened in Bloomsbury in 1753.

Not only remembered for his interest in the natural world, he is also renowned for his introduction of a chocolate recipe into England. Sloane was a doctor who proposed using natural substances as medicines and whilst he lived in the Caribbean he was introduced to a drink made from cocoa by the locals. It wasn't until he mixed it with milk that he found it could be quite appetizing. It was this recipe that he had prepared to be sold as medicine by apothecaries once he had returned home. By the 19th century the chocolate makers, Cadbury, adopted the recipe to produce their own chocolate products. Sloane's name continues to be remembered not only in the Square but also in streets within the area.

The **Royal Court Theatre [2]** is right beside the station. Cross into Sloane Square to look at it. This is one of London's best local theaters, known as the 'writers' theater', and has been presenting plays here since 1888. The works of many of today's celebrated authors, Caryl Churchill, Mark Ravenhill, Martin McDonagh and Simon Stephens, have been performed at the Royal Court; the theater also prizes itself for giving time to new and contemporary writers, whose works are often socially and politically challenging, thereby helping to raise both the subject matter and the writers' profiles.

In the early 20th century a number of George Bernard Shaw's plays were performed

with great success, putting the theater on the map. After a period of closure due to war-time damage, the Royal Court reopened in 1952 when it showed both classics as well as some rather avant-garde material. This was to bring it into conflict with the Lord Chamberlain, the man responsible both for theater licencing and with the authority to censor plays that were deemed inappropriate. John Osborne's *A Patriot for Me* was one such play but the theate got round the ruling by turning itself into a private members' club for its run. Osborne's earlier play *Look Back in Anger,* had given rise to the phrase, 'Angry Young Men', describing the new type of drama and class consciousness.

Royal Court Theatre

The tradition of such writing continues and plays can now be seen in two theaters on the site, the main theater downstairs, and the more intimate space above. There is also a small café area and shop in the basement, ideal for a snack before or after a performance.

Peter Jones [3]

On the opposite side of the Square you will see a glass curtain walled building that houses the department store, Peter Jones. A John Lewis store, it carries a wide range of merchandise such as clothing, furnishings and furniture and electrical goods. Like its sister store in Oxford Street it is popular with the public for its 'Never Knowingly Undersold' policy, that promises to refund the difference if you buy a product in the store and find the same item cheaper elsewhere.

Walk along the south side of the square (Peter Jones will be on your right), passing

by some of the area's high-end shops until you reach an archway with 'Duke of York Square' signposted. Turn left into the square.

DUKE OF YORK SQUARE [4]

Here you are confronted with a modern square full of luxury retail outlets and restaurants, so it is hard to imagine the site's prior usage. Built at the turn of the 19th century as a school for the children of soldiers' widows, it became a Military Barracks in 1909, and later a Territorial Army base. The land and buildings were sold off in 2003 and the site was revamped as Duke of York Square, and a new public space developed. The very fine school/barrack buildings are listed, Grade II*, on account of their significant historic and architectural interest, and the **Saatchi Art Gallery** now has its home within the beautiful neoclassical Duke of York's Headquarters building.

The Gallery opens daily (10 am–6 pm) and admission is generally free, apart from temporary exhibitions. Come here to see the most contemporary, innovative and perhaps, radical works, that are unlikely to be found in the more conventional galleries. The Gallery mainly displays art works of new, aspiring artists and it is through this exposure of their art that many of them are able to launch their careers and will later be offered shows by galleries throughout the world.

Charles Saatchi, after whom the Gallery is named, was born in Iraq and moved to London with his family at the age of four. He and his younger brother, Maurice, went on to found the very successful advertising agency, Saatchi & Saatchi that became famous for coining the phrase, 'Labour isn't working' for the Conservative Party during their victorious 1979 election campaign. By the 1980s Saatchi & Saatchi had made the brothers millionaires and had become a global name. Until his high-profile divorce in 2013, Charles's third marriage was to the celebrity cook, author and journalist, **Nigella Lawson.**

Charles has been an avid collector of cutting edge art and supported the movement of the Young British Artists (YBAs) like Damien Hirst, Tracey Emin, Sarah

Royal Avenue

Lucas, and Rachel Whiteread. He opened the first Saatchi Gallery displaying their art in St John's Wood in 1985, moved to the South Bank in 2003, and on to Duke of York Square in 2008.

The large piazza by the gallery has a few well-placed cafés suitable for watching the world go by, and if you sit here long enough you may well see a celebrity or two.

To continue the walk turn left up the street.

Be sure to look at the shops, some designer, some everyday high-street names. The buildings you pass by are a lovely mix of old and new, and turnings that lead off the King's Road contain some very fine (undoubtedly, expensive) houses. Shortly you will come to **Royal Avenue [5]** on the left. It is actually a square (albeit long and rectangular in shape), with housing on two sides, lined with a tall row of trees and with a central area filled with gravel. Royal Avenue is quite majestic and leads down

to the **Royal Hospital** (which we will come to later in the walk). It is one of two places believed to be the fictional London home of James Bond. Unfortunately, Bond's author, Ian Fleming, never disclosed the actual address, but from his description, it is thought that Bond could have lived here or possibly in **Wellington Square,** the next turning along the street.

Other real-life residents have included Richard Rogers (architect of Lloyd's of London and the Pompidou Centre), and US film director, Joseph Losey. Losey lived at no. 30 when he fled the American McCarthy era witch-hunt. It is said that he used a vacant property opposite his home to film scenes of his film, *The Servant* (1963) starring Dirk Bogarde, James Fox and Sarah Miles.

Mary Quant

A little further along, across the street, on the corner of **Markham Square [6]** is where fashion trendsetter, Mary Quant, opened her shop in the 1950s. Now a coffee shop, it was once the most popular boutique and was where the newly 'liberated' sixties women, followers of Twiggy and devotees of the miniskirt, came to buy their clothes. Although the shop disappeared long ago, Quant is still remembered for her part in the fashion revolution, and the miniskirt lives on!

The Pheasantry [7]

Another building to look out for on this side of the street is the Pheasantry. About 30 metres (100 feet) away, it stands out amongst its neighbors for its stunning façade and arched entranceway with caryatids. Surprisingly, it now houses a Pizza Express restaurant yet it has had a most interesting history.

Apparently there was a building on the site in the 1760s, but the current structure was erected probably about a hundred or so years later. At that point in time, it was rented to Samuel Baker, who set himself up as a supplier of pheasants to the gentry.

The Pheasantry

Although the business lasted less than 15 years, the name Pheasantry stuck and the building has been known as such ever since, even when it was replaced by another building in the late 19th century.

The new property was owned by a French family, the Jouberts, who specialized in cabinet making, upholstery, gilding and decoration (you can still see their name and trades listed on the walls of the present building in the courtyard). The fancy chateau-like building was their choice, somewhat grand for the area at the time.

The house remained in the family until the 1930s, although by then they had rented out most of the upper floors as studios. The last member of the family, Felix Joubert, was actually responsible for providing some of the miniature furniture for Queen

Mary's dolls' house (on display at Windsor Castle).

Shortly after the turn of the century, part of the building was taken over by a ballet academy run by Russian Princess Seraphine Astafieva (1876–1934), who trained Anton Dolin, Dame Alicia Markova and Margot Fonteyn. In time the cellar became a club and restaurant that was popular with actors and artists living in and around the area, but after the death of the owner in 1966 it closed down and the building became run-down and neglected. Proposals were made to turn it into an hotel, but it was a long and protracted process and ultimately the plan was dropped and the premises underwent restoration and refurbishment.

During the 1970s the Pheasantry ran a nightclub and disco and many unknown artists played their early gigs here including Queen, Lou Reed and Hawkwind. Once again today there is a cabaret club in the basement where live music is played daily and it remains a popular venue.

Continuing your walk you will pass by the **Chelsea Potter [8]**, an inn named after local ceramics artist William de Morgan, the founder of the Chelsea Arts Pottery (1872). During the 1960s the pub was a favorite of the Rolling Stones and Mick Jagger (who lived nearby) as well as Jimi Hendrix.

Just a little further down the street you reach a sturdy white and redbrick civic building identifiable by its clock and central roof belltower.

Chelsea Old Town Hall [9]

Built in the early 1900s as a Town Hall, it is now primarily a marriage venue although it also hosts a number of events such as antique fairs and art exhibitions in its splendid main hall. It has always been a popular wedding location with many famous people taking their wedding vows here including the footballer, Patrick Vieira; celebrity chef, Marco Pierre White; filmmaker, Michael Winner and Prince Pavlos of Greece. Records of births, marriages and deaths in the borough going back to 1837 are still kept on the premises, including the birth certificate of Beatrix Potter, who lived nearby. In

1969 Judy Garland's fifth and final marriage, to nightclub promoter Micky Deans, was held here.

In 2014, an enormous crowd of journalists massed outside the building in the belief that actor and film director, George Clooney and his fiancée, local barrister, Amal Alamuddin, were to be married inside. In fact, the pair were far from Chelsea at the time and took their marriage vows in a luxury resort in Venice.

A marriage of significance that took place within the building in 1928 was that of American divorcee, Wallis Spencer, to her second husband, Ernest Simpson. It was because of this event and later divorce, that she was prevented from becoming Edward VIII's queen, leading to his subsequent decision to abdicate from the throne in 1936. Edward and Wallis married in 1937 and moved overseas to Paris, as the Duke and Duchess of Windsor.

Chelsea Old Town Hall, main hall

Leaving the Town Hall you soon reach **The Ivy Chelsea Garden**, a sister restaurant to the renowned Ivy restaurant in Covent Garden. Although a relative newcomer to the area, it is already a popular haunt of many of Chelsea's wealthy and famous residents.

As mentioned at the outset of the walk, the King's Road extends west to Fulham and if you are interested in seeing the famous Bluebird Restaurant, Vivienne Westwood's World's End shop or taking a tour of Chelsea's football ground at Stamford Bridge (by the Fulham Road), then continue walking straight along the street. Our route however, will take the next road on the left, Oakley Street, down to the river and Chelsea Embankment.

ALBERT BRIDGE, CHEYNE WALK AND THE CHELSEA EMBANKMENT

Oakley Street [10] is full of typical late Georgian and early Victorian stucco houses, dating to the mid-19th century. If you're not in too much of a hurry do take time to look at the architecture of the terraces as some very splendid features are displayed. Look out for the black, cast-iron railings, semicircular fanlights and central keystones above the doors, as well as the iron balconies, windows and classical architectural features such as the triangular pediments. All were built at the outset as residential housing and were most probably lived in by one family (with a bevy of servants). Today, many have been divided up into flats and will be sought after for their position so close to the river and to the King's Road. You will see two blue plaques along the street: one at no. 87, home of Oscar Wilde's mother, Lady Wilde; another at no. 56, where the Antarctic explorer, Captain Scott lived. Two other former residents of note are the actress, Dame Sybil Thorndyke (no. 74) and footballer, George Best (no. 87).

Stop at the end of the street opposite the **Albert Bridge [11]**, named after Queen Victoria's husband and consort. It is one of the capital's most attractive and pretty bridge crossings. Built in 1873 as a suspension bridge to connect Chelsea with Battersea on the southern side of the river, it has always been very popular and it is

Albert Bridge at night

especially beautiful at night when it is lit up.

The busy road that runs immediately beside the river is the **Chelsea Embankment** and if you turn left at this junction and follow the road you will arrive in Parliament Square.

Tucked behind it you find **Cheyne Walk**, that stretches both east and west of Albert Bridge. Until the Chelsea Embankment was constructed in the mid-19th century, Cheyne Walk ran directly alongside the river and water lapped up to the doors of the riverside homes. It has always been an appealing location and many famous people have been and are still associated with it. It was here that King Henry VIII had his magnificent riverside house. He gave it as a wedding gift to his last wife, Kateryn Parr and subsequently it was home to Anne of Cleves, Henry's fourth queen. In the early 18th century, Sir Hans Sloane bought the manor house, and spent his retirement years living there until his death in 1753.

The **western side of Cheyne Walk [12]** was where writers Mrs Gaskell, Bram Stoker (of Dracula fame), and Hilaire Belloc once lived. It was also home to the suffragette, Sylvia Pankhurst, engineers Marc and Isambard Kingdom Brunel, famous historian and satirist,

Sign showing location of Henry VIII's manor house

Thomas Carlyle, and artists, James McNeill Whistler and J.M.W. Turner.

Carlyle Mansions, the handsome red-brick apartment block here, even earned itself the title 'Writer's Block' on account of its residents: Ian Fleming, T.S. Eliot, American Henry James and Somerset Maugham. At the time they lived here Chelsea was not a select and wealthy area but one that attracted up-and-coming artists and writers, trying to establish themselves, who took inspiration from the tranquility of the locale. During the 20th century, Rolling Stones band members Mick Jagger and Keith Richards both lived in and around Cheyne Walk. More recently footballer Sol Campbell owned a penthouse flat within Carlyle Mansions.

The **eastern side [13]** of the street also has a long list of famous residents. In the mid-1800s, no.16 was home to Dante Gabriel Rossetti and became a meeting place for members of the Pre-Raphaelite Brotherhood, all of whom lived nearby. After

Rossetti's wife died he kept a small, exotic menagerie consisting of parakeets, an armadillo and wombats within the house and garden. He was friendly with both the author of *Alice in Wonderland*, Lewis Carroll, and the book's illustrator, John Tenniel, and it is believed that it was on one of Rossetti's wombats that Tenniel modeled his dormouse for the Mad Hatter's Tea Party.

As you turn left down Cheyne Walk you will notice blue plaques to Algernon Swinburne and Dante Gabriel Rossetti at no.16, and George Eliot at no.4, but there have also been a host of other well-known residents in this row of such elegant housing. In the early 20th century no.10 was where Prime Minister, David Lloyd George lived, although the house now belongs to Gerald Scarfe, the cartoonist and husband to actress, Jane Asher. Recently no.4, with its wonderful views of both the river and bridge, has been bought by the ex-mayor of New York, Michael Bloomberg.

*Walk along the street and take the left fork at the junction. This is **Royal Hospital Road** and you want to cross it to be on the right side of the road next to the brick wall. Turn right into Swan Walk and a little beyond you will see the entrance to the Physic Garden, Chelsea's very own 17th century beautiful botanic garden.*

ROYAL HOSPITAL ROAD & CHELSEA PHYSIC GARDEN [14]

It's advisable to check online before your visit as the Garden is not open every day, and the opening hours can also change depending upon the season.

This is an absolutely fascinating place to visit, especially if you are interested in learning about plants and herbs used for medicinal purposes. The Physic Garden, despite extending over only a fairly small area, is filled with a great variety and number of plants. From the time it was set up in 1673, it constructed separate, discrete areas for different plant species, and is proud to possess a rock garden dating back to 1773. In recent times it has established a Garden of World Medicine as well as a new Pharmaceutical Garden.

The garden is in fact the second oldest botanical garden in the country. Initially established as the Apothecaries' Garden, its main role was to teach apprentices how to identify plants. In time, it exchanged and shared information with other botanical gardens worldwide, and before long had begun a global seed-exchange system, a role that continues to this day. The Chelsea Physic Garden now opens to the public five days a week during its main season (March to October) and free, guided tours are given daily. There is a shop where you can pick up Physic Garden seeds, specialist plant books and gifts, and the Tangerine Dream Café for refreshments. When the weather is fine you can sit outside and savor the very pleasant atmosphere of the microclimate within the walled gardens.

Exit the Gardens, turn left into Swan Road and then turn right onto Royal Hospital Road.

You might like to make a small detour when you reach **Tite Street** to see the house (no. 34) where Oscar Wilde lived with his wife Constance from 1885 until his conviction for 'gross indecency', and ultimate imprisonment in 1895.

The street is famous too for being home to three late 19th/early 20th century artists, Augustus John, James McNeill Whistler and John Singer Sargent (nos. 33 and 31). A glance at the grand houses here and their proximity to the Thames easily explains the street's popularity and why it became an artists' enclave.

National Army Museum [15]

This museum is the principal authority on the history of the British Army and contains a wonderful collection of artifacts associated with the Army's role throughout the world, today and in centuries gone by. At the time of writing it is closed for a major transformation but is due to reopen in 2017.

Some examples of what you might see inside include the skeleton of Napoleon's

horse Marengo, Florence Nightingale's paper lantern (c.1855), an amputation saw used to remove the Earl of Uxbridge's leg at the battle of Waterloo, and a section of the Berlin Wall (1989). Clothing, photographs, uniforms, and arms are all displayed in the museum, giving an insight into both the role played by soldiers and the situations they encounter.

On exit from the museum turn right. Shortly you will reach the Royal Hospital Chelsea, home to the Chelsea Pensioners.

Royal Hospital Chelsea [16]

Although called a hospital, it is actually a retirement home for ex-soldiers who are commonly called Chelsea Pensioners. The stunning building was commissioned at the end of the 17th century by the king, Charles II, to accommodate wounded and elderly soldiers and was the work of the celebrated architect, Sir Christopher Wren (responsible for St Paul's Cathedral). It has often been said that the king's mistress, Nell Gwynne, inspired him to build the Royal Hospital, but there is little actual evidence for this assertion. However, it does illustrate that the king felt that soldiers who had fought for their country should in turn be looked after, and that tradition continues today.

During the week (between 10 am and 4.30 pm), visitors are allowed to wander in the grounds and into some of the rooms within the Hospital buildings. This is an ideal way not only to see how the veterans live, but also to talk to them and hear some of their marvelous stories. You should be able to visit the Great Hall (but not at lunchtime when it is in use), Regimental Museum and beautiful Chapel as well as the spacious grounds. If you prefer, you can take a guided walking tour led by one of the Chelsea Pensioners, but you will need to book this up to a month in advance online.

It is easy to recognize the residents from their blue day uniform, or possibly the red ceremonial uniform with tricorne hat and white gloves (worn on public occasions).

Chelsea Pensioners

If you like to see a bit of pageantry then try to organize your visit on a Sunday morning (April–November), when you will be able to see the Governor's Parade at 10.45, just before the Sunday Chapel service. This is when a small group of the veterans, decked out in full ceremonial uniform, are inspected by the Royal Hospital's Duty Governor and Duty Officer, in the central courtyard, Figure Court.

The grave of Baroness Margaret Thatcher, Conservative Prime Minister 1979–90, is in the Hospital grounds close to the Infirmary named after her, and which she had officially opened in 2009.

Ranelagh Pleasure Gardens & the Chelsea Flower Show

The Royal Hospital was built on the grounds of a former 18th century pleasure garden, Ranelagh Gardens. This is now the site of the Royal Horticultural Society's **Chelsea Flower Show** that takes place annually every May. Ranelagh, at the height of its popularity not only boasted tree-lined walks and a canal but also had an enormous ornate rotunda, some 45 metres (150 feet) wide where entertainments took place, like the May Ball and Masquerade parties. Just like its predecessor, the Chelsea Flower Show attracts huge numbers of people, eager to see the latest gardening ideas, show gardens, floral displays, sculptures or simply to gain ideas for landscaping and planting their own gardens. During the Show the grounds are covered with designer gardens, marquees and sculptures, transforming the normally serene and tranquil gardens facing the river Thames.

Stand at the Chelsea Flower Show

Leave the Royal Hospital through the London gate and cross over Royal Hospital Road into Franklin's Row. Follow this road until you reach the King's Road close to the Duke of York Square. To return to Sloane Square turn right and you will see the underground station ahead of you.

ENVIRONS OF KING'S ROAD:

SLOANE STREET

Leading north off Sloane Square is one of the areas most prestigious and expensive roads, Sloane Street. On its western corner is the Sloane Square branch of Tiffany & Co, a clue to the class and wealth of local residents and also an example of the type of shop to expect along this street.

Initially, the land here belonged to Hans Sloane. When he died in 1753 he left most of it to his elder daughter, Elizabeth, who went on to wed Charles, who was to become the 2nd Baron Cadogan. From that time on the lands she inherited were handed down to their heirs and became known as the Cadogan Estate. After the death of the 2nd Baron, his son, another Charles, took over the estate and promptly granted a lease to architect Henry Holland to develop the 36 hectare (90 acre) site as a 'new town', Hans Town. The street layout, the classy squares and housing he created are largely in evidence today, and are a pleasure to visit.

Being so close to the royal court, the housing was aimed primarily at the upper classes who were keen to move into the area. Most of the development, including Sloane Street and Sloane Square, was completed by 1800 and with its neoclassical architecture it was immediately regarded as one of London's most stylish districts. With the exception of 123 Sloane Street, most of the original Georgian buildings no longer exist, having been replaced towards the end of the 19th century. The southern part of the street today is characterized by its red-brick Dutch buildings, and although the majority are apartments,

a number close to Sloane Square are still entire houses. In contrast, the northern end of the street is mainly modern, residential, portered apartment blocks, many of which on the western side are owned by Dubai's ruling Al Maktoum family.

Sloane Street is not only famed for its housing but also for the magnificence of **Holy Trinity Church [17]** which is just a short stroll from Sloane Square. The poet and conservationist, John Betjeman, called it 'The Cathedral of the Arts & Crafts Movement', and when you enter the church you will understand why. The skill of the artisans in creating its stained glass, metalwork, and sculpture cannot be underestimated and Edward Burne-Jones's Great East Window is simply stunning.

Manufactured by William Morris and Co it was the largest stained glass window ever made by the company, and when the church was under threat of possible demolition in the 1970s, this window was one of the main reasons for saving it.

Holy Trinity was consecrated in 1890 to a design of John Dando Sedding, a proponent of the Arts and Craft Movement. He was greatly influenced by the works of Augustus Pugin (famous for his work at the Palace of Westminster), which is obvious when you look around the church. Paid for by the Earl of Cadogan, no expense was spared at Holy Trinity, which is why there is an abundance of bronze, alabaster, marble and porphyry here as well as magnificent altar candlesticks, ironware gates and aisle chandeliers (electroliers). Although the roof was totally destroyed in World War II the

Holy Trinity Church Great East Window

church remains essentially as it was designed and some areas that Sedding had left plain to be decorated at a later point, have never been altered.

Prayers are held daily on weekdays, and there are regular weekly services too. Further information about services, concerts, festivals, talks and other events is available at *www.holytrinitysloanesquare.co.uk*.

As you walk north along the street towards Knightsbridge, the wealth and exclusivity of the area becomes ever more obvious. A long stretch of well-tended gardens on the eastern side (which are private gardens for the terraced housing in Cadogan Place behind), as well as the impressive embassies of Denmark, Iceland and Peru and several grand, opulent hotels, confirm that Sloane Street is still one of London's most desirable locales. **The Cadogan Hotel [18]** on the corner of Pont Street, has been located here since 1887 and was the scene some eight years later of the arrest of writer Oscar Wilde, who went on to serve a two-year sentence of hard labor at Reading Gaol. The incident was immortalized by the poet, Sir John Betjeman, in his poem, *The Arrest of Oscar Wilde at the Cadogan Hotel*. The hotel has links to another famous name – Lillie Langtry, actress and mistress of the future king, Edward VII. She lived next door to the hotel until her house was incorporated into the Cadogan, and then became resident there living in her old rooms.

As Knightsbridge grew in the late 1800s, the northern end of Sloane Street developed into a shopping district serving the wealthy residents, especially catering to their fashion needs. Although you no longer see hosiers, hatmakers and tailors here, the street is bursting with major designer brands and is where the leading world fashion houses are based. It is a most select shopping district that, because of its very fine merchandise, attracts customers from across the globe.

KNIGHTSBRIDGE & BROMPTON ROAD

The junction where Sloane Street meets **Knightsbridge** is marked by the chic and popular department store, **Harvey Nichols,** as well as one of the exits to

Knightsbridge underground station *(Piccadilly line).* Knightsbridge is mainly known for its grand hotels, casinos, Michelin-star restaurants, bars and nightclubs, and is very much the domain of rich playboys and the seriously rich. It runs south of Hyde Park, and east towards Hyde Park Corner, Piccadilly and the West End.

Over to the west you find yourself in **Brompton Road**, home to one of the world's best-known stores, **Harrods [19]**. Taking up a whole block, it is Europe's largest department store, boasting over a million square feet of selling space. Harrods can easily be a day's outing, giving you time to browse in its 330 departments and to sample some of its myriad of dining possibilities (such as Caviar House Oyster and Seafood bars, Bentley's Sea Grill, Rotisserie, The Georgian Restaurant, Asian cuisine, The Champagne Bar and the Ice Cream Parlour). Its motto: *Omnia, Omnibus, Ubique* (All things, for all people, everywhere) means that it carries an enormous variety of stock, all of it of the highest quality. Not only does it sell fashion items, toys, electronic goods, home appliances, jewelry and luxury gifts, but it has the most wonderful Food Halls which are stacked high with exotic produce from every continent. The displays alone are worth a visit, and the fish counter is simply a work of art.

Since the store began trading in the 19th century, it has always been held in the highest esteem by its patrons and is renowned for its superlative customer care. It has always been proud to be able to supply whatever the customer wanted – a promise it kept when Noel Coward received an alligator from the store as a Christmas present!

Harrods

Actually, the breadth of Harrods's service is astounding; up until the 1960s (when the annual practice of debutantes being presented to Court ended) it supplied everything a debutante needed for the London social season and presentation at Court, including a chauffeured limousine to take the young woman to Buckingham Palace. Also, for many years it held yearly contracts to regulate and wind clocks within three miles of the store.

Certainly, Harrods is the place to shop for gifts. It still offers its customers a wide selection of luxury groceries, wine, spirits, biscuits and tea as well as stationery goods, beauty products and confectionery and once purchases are made, the customer receives one of the store's green signature carrier bags, itself a lovely memento of a visit.

Twice a year, the store holds a sale, in summer and winter. With wonderful bargains, the visitor numbers swell, and as many as 300,000 people have been known to enter the store on the first sale day alone.

Despite changing hands several times since Charles Harrod opened his business here in 1849, the store's ethos of providing the very best service and merchandise has not altered. Harrods has always been at the forefront of retailing and in 1898 became the first store to introduce a moving staircase (escalator), providing anxious customers with a glass of brandy when they reached the top!

Harrods's imposing terracotta exterior is easily recognizable and as the store opens daily it is almost impossible to leave it out of one's itinerary. Adjacent to Knightsbridge underground station, on many bus routes and with nearby car parking, it is hard to find a reason not to go.

The rest of Brompton Road is mainly lined with shops, cafés and restaurants, until you reach its western end with the beautiful and quite magnificent **Brompton Oratory [20]**. The church houses a community of priests, the Congregation of the Oratory of St Philip Neri in London who continue to live the life set out by its ruler in the 16th century, but it is also a Catholic parish church with a quite magnificent interior.

Brompton Road then veers off to the left but if you continue into Thurloe Place and

Cromwell Gardens you reach the excellent **South Kensington Museums [21]**, open daily and with free entrance. As they are all very popular it is advisable to get here as early as possible if you want to avoid the crowds.

Right by the museums is the entrance to **South Kensington underground station** *(Piccadilly, Circle, District lines).*

TRAVEL IN LONDON

To travel around London you will need to use one of the following: a **Visitor Oyster Card, Oyster Card,** a paper **Travelcard** or a **contactless payment card.** Both VisitLondon and Transport for London (TfL) explain the systems in detail on their websites *www.visitlondon.com* and *www.tfl.gov.uk* but a brief summary is given below:

A **Visitor Oyster Card** for use on the Underground (Tube), bus, DLR, London Overground, tram and many National Rail services in London, can be purchased in advance of your visit and delivered to your home address. The card costs £3 (non-refundable) plus postage, and you select how much credit to add to it. Alternatively, you can buy it on arrival at Gatwick and Stansted airports and onboard Eurostar trains to London. The card gives special offers and discounts during your stay for a number of London restaurants, attractions, shops, Thames Clippers river buses and on the Emirates Air Line cable car. There is a daily price limit on the card so once you have reached it there is nothing more to pay.

An **Oyster Card** works in a similar way to the Visitor Oyster Card, but cost £5 (refundable), is only obtained in the UK and does not include any special promotions or offers. Cards are available from Visitor Information Centres (at Heathrow and Gatwick Airports, Paddington, King's Cross, Euston and Victoria mainline railway stations, and Liverpool Street and Piccadilly Circus underground stations), and at Oyster Ticket Stops in many newsagents and shops.

Contactless Payment Cards are debit, credit or pre-paid cards and may be used as payment for a ticket up to a £30 limit. There is no need to use a PIN or a signature. If your contactless card has been issued outside the UK you should first check if your bank charges transaction fees for usage on the London transport system.

Paper Travelcards, like Oyster Cards, can be used on the underground, bus, DLR, London Overground, tram and many National Rail services in London. They will cover certain zones (London is divided into Zones 1–9) and lasts for one day only. As with a Visitor Oyster Card you will obtain discounts on various river-boat services and

also on the Emirates Air Line cable car.

A seven-day Travelcard is also available but can only be loaded onto an Oyster Card.

NOTE:
- When using Oyster Cards and Contactless Payment Cards you **must** touch the yellow card reader at the gates at the start and end of your journey or you could get charged a **penalty fare.**
- On **buses and trams** you only need to touch the yellow card reader at the **start** of your journey.

Only Oyster Cards or Contactless Payment Cards can be used on buses. No cash is accepted.

Credit can be added to your Oyster or Visitor Oyster Card at the touchscreen ticket machines in Underground, London Overground, DLR and some National Rail Stations, at Oyster Ticket Stops, from Visitor and Travel Information Centers and Emirates Air Line terminals.

Transport for London (TfL) Buses

These are mainly the classic double-decker red buses that London is renowned for, and are good to use around the center of town. Information about timetables and routes is available on the TfL website, but it may be useful to know that bus numbers 11 and 15 run past most of the tourist hotspots:

- 11: From Liverpool Street via the City to Victoria, Sloane Square, the Kings Road to Fulham Broadway
- 15: From Trafalgar Square to Blackwall via Tower Hill and Aldgate

Private Tourist Buses

There are several hop-on/hop-off services offered with live commentary in English as well as recorded information in a number of languages. Ranging in price between £25 and £30 this can be a good way to see many of the sights if you are only in London for a short time.

Black Taxi Cabs and Minicab services

You will see black cabs everywhere (unless it is raining hard!) and fares are determined by the length of the journey and time of day. Other cab services include Uber, Addison Lee as well as local minicab hire, details of which can be found online.

Santander Cycles

This is certainly a cheap way to get round London. You can hire a Santander Cycle for as little as £2, ideal for short trips. You just need to take a credit or debit card to the docking terminal and follow the instructions on the screen. The first 30 minutes of each journey is free and longer journeys cost £2 for each extra 30 minutes. Refer to the TfL website *www.tfl.gov.uk* for more detailed information about the self-service bicycle hire scheme.

WEB ADDRESSES BY CHAPTER

Chapter ONE: Portobello Road & Notting Hill

www.thelondonnottinghillcarnival.com	Notting Hill Carnival
www.museumofbrands.com	Museum of Brands, Packaging and Advertising
www.portobelloroad.co.uk	Portobello Road market
www.electriccinema.co.uk	Electric Cinema
www.portobellostarbar.co.uk	Portobello Star Bar
www.picturehouses.com	Gate Cinema, Notting Hill
www.bodosschloss.com	Bodo's Schloss
www.stmaryabbotschurch.org	St Mary Abbot's Parish church
www.virginlimitededition.com	The Roof Gardens
www.designmuseum.org	Design Museum

Chapter TWO: Baker Street & Marylebone

www.tfl.gov.uk	Lost Property Office
www.royalparks.org.uk	The Regent's Park
www.sherlock-holmes.co.uk	Sherlock Holmes Museum
www.madametussauds.co.uk	Madame Tussauds
www.ram.ac.uk	Royal Academy of Music
www.stmarylebone.org	St Marylebone Parish Church
www.dauntbooks.co.uk	Daunt Books
www.wallacecollection.org	The Wallace Collection
www.marylebonevillage.com	Marylebone Village

www.hdwe.co.uk	Howard de Walden Estate
www.abbeyroad.com	Abbey Road Studios
www.insideabbeyroad.withgoogle.com	Abbey Road Studios tour

Chapter THREE: The Angel, Islington

www.islington.gov.uk	Chapel Market
www.businessdesigncentre.co.uk	Business Design Centre
www.almeida.co.uk	Almeida Theatre
www.unionchapel.org.uk	Union Chapel
www.littleangeltheatre.com	Little Angel Theatre
www.stmaryislington.org	St Mary's Parish Church
www.kingsheadtheatrepub.co.uk	King's Head Theatre pub
www.camdenpassageislington.co.uk	Camden Passage
www.canalrivertrust.org.uk	The Regent's Canal
www.sadlerswells.com	Sadler's Wells Theatre
www.exmouth.london	Exmouth Market

Chapter FOUR: Strand & Fleet Street

www.reallyusefultheatres.co.uk	Adelphi Theatre
www.vaudeville-theatre.co.uk	Vaudeville Theatre
www.nimaxtheatres.com	Vaudeville Theatre
www.savoytheatre.org	Savoy Theatre
www.fairmont.com	Savoy Hotel
www.coventgarden.london	Covent Garden
www.royalchapelsavoy.org	The Queen's Chapel of the Savoy

www.somersethouse.org.uk	Somerset House
www.courtauld.ac.uk	The Courtauld Institute of Art
www.stmarylestrand.org	St Mary le Strand church
www.raf.mod.uk	St Clement Danes church
www.justice.gov.uk	Royal Courts of Justice
www.twinings.co.uk	Twinings
www.stdunstaninthewest.org	St Dunstan-in-the-West church
www.cityoflondon.gov.uk	Prince Henry's Rooms
www.innertemple.org.uk	Inner Temple
www.middletemple.org.uk	Middle Temple
www.stbrides.com	St Bride's Church
www.cityoflondondistillery.com	City of London Gin Distillery
www.stpauls.co.uk	St Paul's Cathedral

Chapter FIVE: Whitehall & Downing Street

www.london.gov.uk	Trafalgar Square – events
www.lnydp.com	London's New Year's Day Parade
www.hrp.org.uk/banqueting-house	Banqueting House
www.gov.uk	PM's office, 10 Downing Street
www.lwm.org.uk/visits/churchill-war-rooms	Churchill War Rooms
www.supremecourt.uk	The Supreme Court
www.westminster-abbey.org	Westminster Abbey
www.westminster-abbey.org/st-margarets-church	St Margaret's Church
www.parliament.uk	Palace of Westminster

www.thecommonwealth.org	Marlborough House
www.royal.uk	St James's Palace

Chapter SIX: Piccadilly

www.rafbf.org	Bomber Command Memorial
www.hardrock.com	Hard Rock Café London
www.royalparks.org.uk	The Green Park
www.theritzlondon.com	The Ritz Hotel, London
www.grosvenorestate.com	The Grosvenor Estate
www.royalacademy.org.uk	The Royal Academy of Arts
www.fortnumandmason.com	Fortnum and Mason
www.florislondon.com	Floris
www.paxtonandwhitfield.co.uk	Paxton and Whitfield
www.sjp.org.uk	St James's Church Piccadilly
www.tkts.co.uk	Leicester Square Theatre Ticket Booth

Chapter SEVEN: Regent Street

www.royalparks.org.uk	The Regent's Park
www.allsouls.org	All Souls Church Langham Place
www.libertylondon.com	Liberty
www.hamleys.com	Hamleys
www.carnaby.co.uk	Carnaby Street
www.newwestend.com	Regent Street, Bond Street
www.hotelcaféroyal.com	Hotel Café Royal
www.brasseriezedel.com	Brasserie Zedel

www.sohotheatre.com	Soho Theatre
www.ronniescotts.co.uk	Ronnie Scott's jazz club

Chapter EIGHT: Oxford Street

www.royalparks.org.uk	Hyde Park, Speaker's Corner
www.dorchestercollection.com	Dorchester Hotel
www.marriott.com	Grosvenor House Hotel
www.grosvenorestate.com	The Grosvenor Estate
www.animalsinwar.org.uk	The Animals in War Memorial
www.marksandspencer.com	M&S
www.selfridges.com	Selfridges
www.stchristophersplace.com	St Christopher's Place
www.handelhendrix.org	Handel & Hendrix in London
www.nicholsonspubs.co.uk	Argyll Arms, Oxford Circus
www.reallyusefultheatres.co.uk	London Palladium
www.berwickstreetlondon.co.uk	Berwick Street
www.the100club.co.uk	100 Club, Oxford Street
www.foyles.co.uk	Foyles

Chapter NINE: King's Road

www.royalcourttheatre.com	Royal Court Theatre
www.saatchigallery.com	Saatchi Gallery
www.chelseaphysicgarden.co.uk	Chelsea Physic Garden
www.nam.ac.uk	National Army Museum
www.chelsea-pensioners.co.uk	Royal Hospital Chelsea

WEB ADDRESSES BY CHAPTER

www.rhs.org.uk	Chelsea Flower Show
www.holytrinitysloanesquare.co.uk	Holy Trinity Church
www.cadogan.co.uk	Cadogan Estate
www.harrods.com	Harrods
www.bromptonoratory.co.uk	The London Oratory

GLOSSARY

Historical Periods

Roman	AD43–410
Tudor	1485–1603
Stuart	1603–1714
Georgian	1714–1837
Victorian	1837–1901
Edwardian	1901–1910

Art and Architectural Terms

Adamesque: The neo-classical architectural style attributed to the three Adam Brothers, John, Robert and James during the latter part of the 18th century. With reference to ancient civilizations their style integrated both architecture and interiors, including the furniture, furnishings, walls and ceilings.

Art Deco: An architectural and decorative style of the 1920s and 1930s using vibrant colours and patterns.

Art Nouveau: A popular style between 1890 and 1910 often characterised by its curves and swirling decoration.

Arts & Crafts: A movement that gathered momentum in the late 19th and early 20th centuries, in response to the mass produced goods of the Industrial Revolution. It promoted a return to skilled quality craftsmanship, of simple design, using local materials.

Baroque: A flamboyant and monumental architectural style in fashion around 1600 to 1750.

Beaux-Arts: A style used in British department stores in the late 19th and early 20th centuries. It originated in France and featured classical forms, and rich ornamentation.

Edwardian: Styles mainly in use during the reign of King Edward VII (1901–1910), such as Gothic Revival, Neo-Georgian, Baroque Revival.

Georgian: The style of art and architecture between 1714 and 1830 during the reigns of George I, II III and IV when classical proportions were introduced into all types of buildings.

Gothic: Referring to the style of the Middle Ages and renowned for its pointed arch, rib-vaulting and large windows. Covering the period from around 1180–1520 and divided into Early English Gothic, Decorated and Perpendicular styles.

Italianate: This style of architecture was most prevalent in the early-to-mid-19th century, used in secular buildings and based on palatial homes in Renaissance Italy.

Louis XVI style: Referring mainly to style of furniture and furnishings, it moved away from earlier more fussy, ornate designs and introduced straight lines instead of curves and swirls.

Modernism: This art and architectural style of the 20th century discarded adornment and used modern materials in a minimalist fashion. It is typified by the use of reinforced concrete, iron, steel, metal and glass

Palladian: Properly formulated elegant and classical architecture introduced into England from the early 17th century.

Pre-Raphaelite Brotherhood: A group of mid-19th century British painters who, in opposition to the Royal Academy's historical art teaching of the period wanted to reintroduce the style and essence of Italian artists before the time of Raphael.

Queen Anne revival: Characterized by a cross-gabled or hipped roof, the style was popular in the late Victorian period. Graceful buildings often constructed in red-brick or terracotta boasting towers, turrets and patterned masonry.

IMAGE CREDITS

Page 18, Notting Hill Carnival © Nora Julianna Kovacs licensed under CC BY 2.0

Page 19, Notting Hill Carnival © 'Blue is the Colour' by 'A Pillow of Winds' is licensed under CC BY 2.0

Page 36, The Roof Gardens © The Roof Gardens

Page 37, The Roof Gardens © The Roof Gardens

Page 40, Sherlock Holmes Statue © The Sherlock Holmes Museum 221b Baker Street, London, England www.sherlock-holmes.co.uk

Page 47, The Sherlock Holmes Museum © The Sherlock Holmes Museum 221b Baker Street, London, England www.sherlock-holmes.co.uk

Page 50, Madame Tussauds © Madame Tussauds London

Page 88, Sadler's Wells Theatre © Philip Vile

Page 102, The Edmond J. Safra Fountain Court at Somerset House © Jeff Knowles

Page 117, Fountain Court in Middle Temple © The Honourable Society of the Middle Temple

Page 127, West End Live Festival 2015, Trafalgar Square © Pamela Raith

Page 128, West End Live Festival 2015, Trafalgar Square © Pamela Raith

Page 134, Inside the Banqueting House © Historic Royal Palaces

Page 142, Churchill War Rooms © IWM

Page 150, Runners on the Mall © Westminster City Council

Page 158, Piccadilly Circus © Pamela Raith

Page 178, Piccadilly Circus at night © Westminster City Council

Page 180, Leicester Square at night © Westminster City Council

Page 187, Festival of Lights in Regent's Street © Westminster City Council

Page 193, Liberty © Liberty

Page 202, View of Westminster from the Café Royal dome penthouse © Dome Penthouse

Page 223, Hendrix's Guitar © Handel House Trust Ltd

INDEX